Encyclopaedia
of
Drawing

Encyclopaedia of Drawing

materials, technique and style

Clive Ashwin

NORTH LIGHT CINCINNATI, OHIO

For my sons, Trevor and Peter

Jacket illustrations
Front top: Jenny Powell/Spectron Artists
left (above): Rubens/British Museum
left (below): Charles/Keene
right (above): Constable/Victoria and Albert Museum
right (below): J. A. Vince
Back: Jack Reaser drawing for North Thames Gas Board advertisement

Distributed in North America by
North Light, an imprint of
Writer's Digest Books
9933 Alliance Road
Cincinnati, Ohio 45242

ISBN 0 7134 0133 8

Printed in Great Britain

Contents

Preface

This book is intended to be of use and value to anyone who draws or uses drawings for whatever purpose. I have not confined the text to technical information in the strictest sense of the term, and there are two reasons for this approach. The first is that, interesting as they are, the physical and chemical nature of drawing materials and media are simpler than in any comparable art, and would hardly justify another complete book on the subject. Anyone who wants more detail about these aspects of drawing should consult James Watrous' excellent study *The Craft of Old-Master Drawings* (Wisconsin, 1957), supplementing it with material from other technical manuals of art materials.

The second reason why I have not restricted the content to technical information in the narrow sense is that the creation, use and appreciation of drawings is deeply dependent upon cultural and historical tradition. That is to say, the way in which we draw and the way in which we perceive drawings depends, to a great extent, upon what we have been educated to expect from drawing as a means of recording and communicating information, feelings and opinions. Consequently, in order to understand our own drawings and the drawings of others we must be prepared to think about the cultural and historical circumstances which have shaped our attitudes and tastes.

There are many artists and teachers who feel convinced that the practice of an art should be carried on in isolation from broader cultural and historical considerations; that these considerations might even vitiate or destroy the creative impulse; and that all arts, including drawing, should be pursued in a completely spontaneous and intuitive way, without the involvement of deliberate thought. Although this approach to creative activity might work for some teachers and for some artists, its general validity is called into question by the very fact that some of the finest creative spirits in all the arts have at the same time been profoundly interested in the theoretical and cultural character of their art. One has only to read the writings of figures as diverse as Leonardo, Delacroix, Van Gogh and Mondrian to become convinced that, far from being incompatible with free artistic creativity, deliberate and rational thought about the nature of art can provide an important complement to the artist's other sources of stimulus and inspiration. More than in any other field of activity, this is true of the art of drawing, for drawing

approaches most closely the act of thought itself, being the most direct and immediate record of the artist's private deliberations.

I have throughout the text used the word 'draughtsman' to denote someone who produces drawings of any kind and for whatever reason. Although the term is generally accepted in art-historical literature as meaning simply 'one who draws', it is unfortunate that, in the popular mind, it has a close or even exclusive association with engineering drawing. This is a regrettable state of affairs, since it leaves the man in the street without a word which is crucial to thought about and discussion of the subject of drawing. An attempt a few years back to establish the noun 'drawer', comparable with 'painter' and 'sculptor', to mean 'one who draws' unfortunately came to nothing.

As well as being regrettable, the problem is symptomatic of a fundamental cultural defect. This is that historically drawing has tended to be regarded as primarily an ancillary of other activities, such as painting, sculpting and designing, rather than as a pursuit which might justify the total life work of a gifted individual. It is for this reason that, even today, artists of immense ability who more or less confined their activities to drawing, such as Charles Keene or Aubrey Beardsley, are widely regarded as belonging to a different league from, let us say, Pissarro or Whistler.

The present work is, as far as I have been able to ascertain, the first full-length encyclopaedia or dictionary of drawing to have appeared in any language. In order to provide it with a degree of comprehensiveness I have had to supplement my personal knowledge and experience as a draughtsman from numerous other sources, literary and personal. Although there are innumerable books on *drawings*, in the sense of studies and monographs about the drawings of a particular artist or school of artists, there are remarkably few useful books about *drawing* as a general phenomenon. Amongst the notable exceptions I would include Joseph Meder *Die Handzeichnung, ihre Technik und Entwicklung* (Vienna, 1919), recently translated and published as *The Mastery of Drawing* (New York, 1978). The best modern book in English is Philip Rawson *Drawing* (London, 1969). Walter Koschatzky *Die Kunst der Zeichnung* (Salzburg, 1977) contains a splendid collection of illustrations, and James Watrous *The Craft of Old-Master Drawings* (Wisconsin, 1957) has never been excelled for its comprehensive coverage of technical questions. In the course of writing this book I have read an enormous number of works relating to the teaching of drawing, and many of these have contributed to my view of

the subject. Some are listed in detail in my thesis *The teaching of drawing in general education in German-speaking Europe 1800–1900* (PhD, University of London, 1980), published as *Drawing and Education in German-speaking Europe 1800–1900* (UMI Research Press, Ann Arbor, 1982). I have not neglected books by artists and teachers of drawing for, whilst they might make no claims to comprehensiveness or scholarly balance, they often contain ideas which are original and fascinating. As examples, one might mention Vernon Blake *The Art and Craft of Drawing* (London, 1927) and Kimon Nicolaïdes *The Natural Way to Draw* (Boston, 1941).

When my text was substantially complete I had the opportunity to see the excellent exhibition entitled 'Drawing: Technique and Purpose' held at the Victoria and Albert Museum, London, from January to April 1981. I was already familiar with many of the works contained in the exhibition, but it did bring to my attention a number of examples which I recognised would make valuable additions to this book as illustrations.

Notwithstanding the assistance which I have derived from such a wide range of sources, I feel confident that the present work is substantially original in content, approach and structure, and does not replicate any other book. I am grateful to a number of friends and colleagues who have read and commented upon the manuscript or sections thereof, especially Stephen Calloway, Joseph Darracott and Tony Dyson, and I am glad to have been able to incorporate into the text many of their suggestions and observations. Finally, I should like to thank Thelma Nye of Batsford Books, who invited me to undertake the project and who has been a valued source of advice and encouragement.

Note

The articles are arranged in alphabetical order. Cross-references are printed in **bold type**.

ABSTRACTION

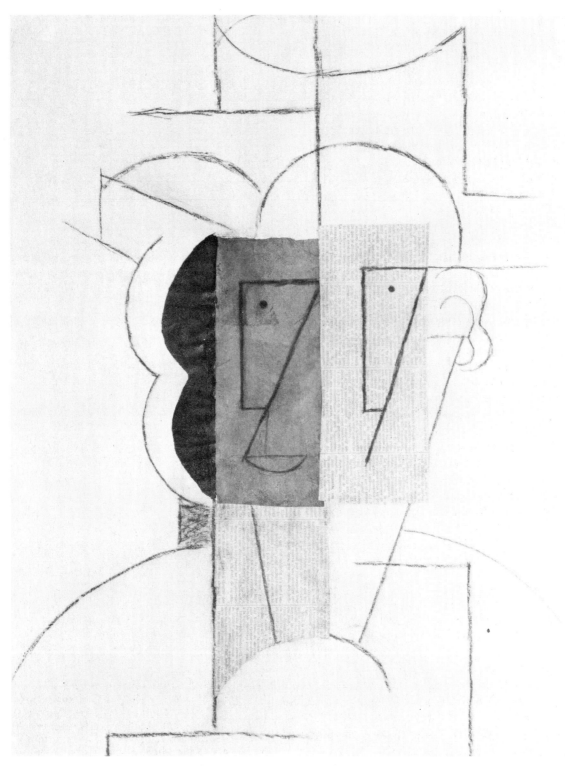

ABSTRACTION

The expression 'abstraction' or 'abstract art' is normally used to denote art works which do not appear to refer descriptively to concrete objects or situations. The forms, lines and tones in a work of abstract art are conceived as either a set of self-justifying relationships, or, if they denote anything at all, refer to the artist's mood or emotional state. There is a great deal of unnecessary mystery surrounding abstract art. In a sense, all drawing involves a degree of abstraction, since drawing depends upon finding visual equivalents by interpreting the visible world into a series of graphic signs and symbols. When drawing a head, for instance, we may ignore many of its most obvious characteristics—its physical volume, variegated colours, varieties of texture, warmth, etc—and reduce it to a single continuous contour on a flat piece of paper. This line is taken to symbolise the boundary in space where, in perceptual terms, the head terminates and is replaced by the surrounding space. Small children quickly become so adept at creating and interpreting linear drawings that we fail to appreciate what a high degree of abstraction is involved in the most simple act of drawing.

There is, however, a distinction to be made between figurative or representational drawings, in which the content can immediately be recognised as describing objects or situations familiar to or imaginable by the spectator, and what we have now learned to recognise as abstract art. Abstract drawings can be divided into three broad groups.

First, we have what might be called 'abstracted' drawings. Here the artist begins from an observed, remembered, or invented motif, such as a figure, a landscape or a still life, and by means of a process of selection, omission, simplification, elaboration and variation, produces an image which might bear only a tenuous resemblance to his starting point. The descriptive function of the drawing declines in importance in favour of a concern with pictorial structure or graphic symbolism. Good examples of this approach are the drawings made by the Cubists c 1909–12. In most of these drawings the motif is still identifiable, albeit with difficulty, but the emphasis is upon the crystalline or grid-like structure of the image.

OPPOSITE
Pablo Picasso: *Man with a hat.*
December 1912 Charcoal and ink with collage on buff paper, 62.2 cm × 47.3 cm *Collection, The Museum of Modern Art, New York.* Purchase Copyright SPADEM, Paris, 1981

11

Secondly, there are abstract drawings which are the result of the artist attempting to make a direct and spontaneous statement about his personal emotional state by finding abstract lines, tones and forms which express his mood or psychic condition. This is in fact a form of **Expressionism**, and its earliest manifestations are to be found in the drawings of the Russian artist Kandinsky about 1910. Its later continuation can be found in the work of the Abstract Expressionists after the Second World War.

Finally, we have calculated combinations of geometric forms which do not originate in an observed motif and which concentrate upon the creation of a coherent pictorial structure rather than on the expression of a transitory mood. This kind of drawing, which has been called 'non-objective', is best exemplified in the work of Mondrian and the Russian Constructivists.

All three of the abstract idioms outlined above are open to the draughtsman willing to experiment with new approaches to drawing. Abstracted drawing can start from the search for *vectors*—lines of continuation in which a direction found in one part of the motif can be picked up and continued in another, or from the progressive simplification of forms into their elements. Even the drawings of a figurative draughtsman like Cézanne go a long way in this direction. Abstract Expressionism requires the creation and maintenance of a certain mood or psychic state, otherwise the drawings will become laboured, pretentious and unconvincing. It is most suited to a fluid medium such as ink or even household paint used with a large brush and on a

David Bomberg: *Acrobats.* About 1913 Chalk, 47 cm × 57.1 cm *Victoria and Albert Museum, London*

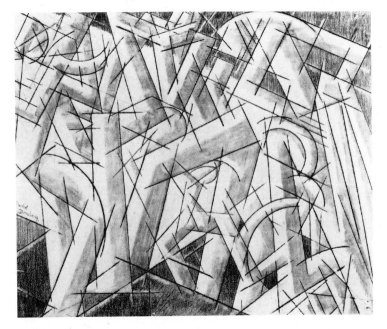

12

large surface to permit freedom of gesture. Non-objective drawings can start from the most simple graphic motif, such as a square, an arc, or a division of the drawing surface. This can then be extended, varied and developed in numerous ways.

It must be stressed that these and other drawing approaches are not to be regarded as a collection of fancy-dress costumes which can be donned or discarded at will, so that one can be a photo-realist in the morning, a Constructivist after lunch and an Abstract Expressionist in the evening. They represent no more than a number of doors which are well worth opening to see if there is anything of value for us personally on the other side. In some cases the experience will add something to one's identity as an artist, or even establish a whole new avenue of development; in others it will remain little more than an interesting experiment.

Naum Gabo: *Sketch for a relief construction.* 1917.
Pencil on paper, 18 cm × 14.2 cm
Tate Gallery, London

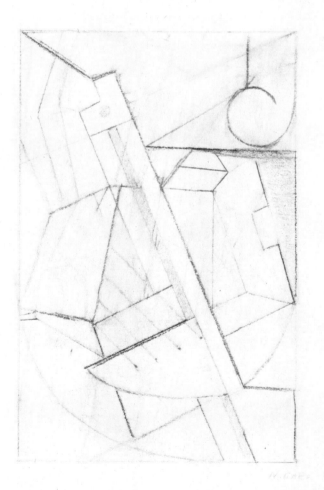

13

ABSTRACTION

Barnett Newman: *The Name.* 1949
Ink, 61 cm × 38.2 cm *National
Gallery of Art, Washington*

Frank Stella: Untitled. 1964
Graphite pencil and wax crayon on
graph paper, 43.2 cm × 55.8 cm
Stella's meticulous drawings provide
a firm foundation for his rich
exploitation of colour. *Collection,
The Museum of Modern Art,
New York.* Gift of the artist

14

ACADEMIC DRAWING

Until the late fifteenth century drawing was taught almost exclusively in the tradition of workshop training, and the intention was vocational in the sense that an apprentice learned to draw as a part of his total preparation for the profession of painter, sculptor or craftsman. Around 1500 a number of loosely organised schools were founded, first in Italy and later in other parts of Europe, for the purpose of enriching and complementing the intellectual development of young artists through the study of theoretical subjects such as anatomy, perspective, proportion and architecture. These institutions called themselves 'academies', taking their name from the philosophical school run in ancient Athens by the Greek philosopher Plato (429–347 BC). The academies were at first attended by both vocational students and amateurs, and the only practical activity undertaken was drawing. Other practical disciplines such as the crafts of painting and sculpture continued to be taught in the workshop or studio under the guidance of an experienced 'master'.

Agostino Veneziano (engraver):
Baccio Bandinelli's academy in Rome.
1531 Engraving
Kupferstichkabinett, Berlin-Dahlem

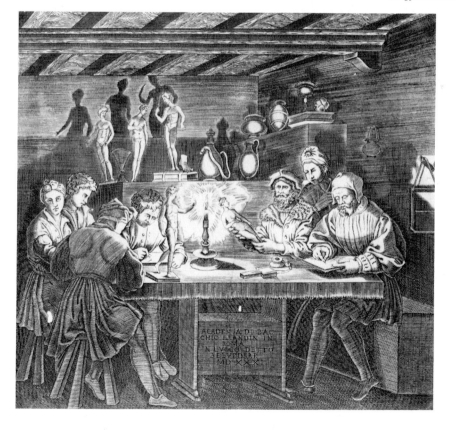

15

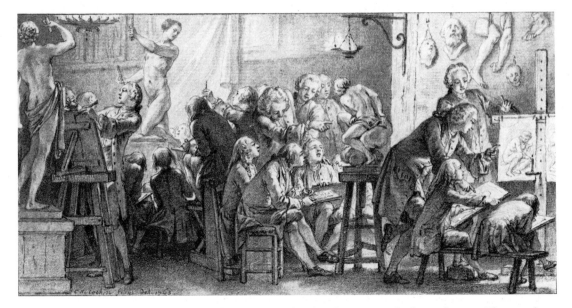

Charles-Nicholas Cochin: *Academy students drawing.* 1763
Pencil, 10.4 cm × 20.6 cm
Kuperstichkabinett, Berlin-Dahlem

Drawing at the academies took three forms. The student would begin by copying from prints and drawings by other artists. This process of copying from the flat was followed by drawing from plaster casts of sculpture and architectural ornament; and the advanced student went on to what was regarded as the most difficult practice of all: drawing from the nude life model. Competence in life drawing was regarded as the most difficult skill to acquire and the most valuable as a foundation to all other forms of artistic practice. In French the word *académie* came to mean a fully worked drawing of the life model, usually holding some heroic or expressive pose.

Academies were founded all over Europe and the USA, and in time came to wield an excessively conservative influence on the development of art. By the end of the nineteenth century the word 'academic' was normally used to imply criticism. At its worst, academic drawing tended to be insensitive to real draughtsmanlike qualities; the figure often filled the paper so completely that there was insufficient space to convey its setting in depth, and anatomical detail was obtrusively over-modelled. In the eyes of its critics, perhaps the worst feature of academic drawing in the bad sense is that it tears the life model out of its visual context and leaves it stranded in a spatial limbo.

AIDS

In a sense almost all drawing involves the use of aids, since even for the most rudimentary drawings tools can be regarded as artificial extensions of the draughtsman's hand.

16

Many teachers and theorists would begin to make a distinction at the use of such devices as the eraser and the airbrush, although these are in fact no more than additional methods of developing the drawn image, comparable with the use of the pencil or the pen.

In speaking of drawing aids, one usually intends to refer to methods of assisting the artist's processes of perception. One of the most ancient and rudimentary aids is the plumb line, which enables the draughtsman to compare directions and locations with the vertical. A more sophisticated aid is the viewing grid or screen, which has been in use for several centuries. This consists of a wooden frame across which wires are stretched vertically and horizontally at regular intervals. The draughtsman places his eye in a fixed position and views the motif through the grid. The subject as it is subdivided by the wires of the grid can then be transferred to a piece of squared-up paper. A similar viewing device can be constructed by engraving or painting fine lines on a sheet of glass.

Albrecht Dürer Artist conducting an experiment with a perspectival grid
Woodcut, 12.2 cm × 17 cm

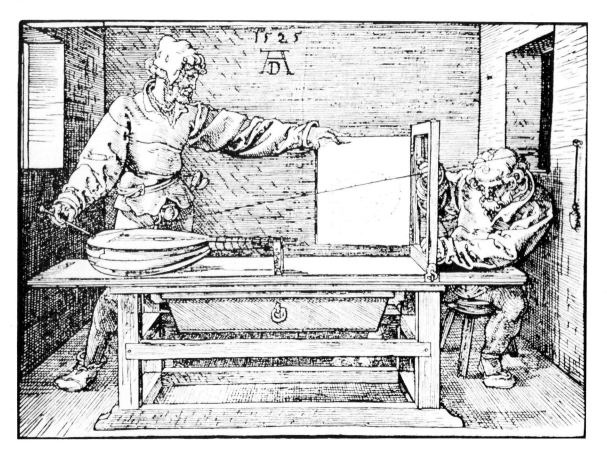

17

Camera obscura by Jones, London.
Late eighteenth century Mahogany
and glass,
20.3 cm × 10.2 cm × 8.9 cm
Science Museum, London

In their efforts to understand and record the visual world, the artists of the Renaissance explored many means for reducing the complexities of a three-dimensional subject to the two dimensions of the surface of a drawing. In addition to various forms of viewing grid there was the *camera obscura* (literally: 'dark room'). The principle of the camera obscura is that a light-tight enclosure, which can be as small as a portable box or as large as a room, is provided with a small aperture in one of its surfaces which receives and projects the view outside. This hole may be fitted with a lens in order to intensify and clarify the beams of light entering it. In the case of the smaller versions, the hole may be located in one of the vertical surfaces. The image is received and reflected by a mirror located on the surface facing the aperture, and projected on to a translucent sheet fitted to the upper surface, permitting the draughtsman to copy or trace the image opposite the aperture. In the larger versions, the aperture and lens may be located in the horizontal surface or roof. The external view is reflected by means of a mirror or lens and projected through the aperture on to a horizontal table. This

18

J. F. W. Herschel: *Temple of Juno, Grigenti, Sicily* Sketched by means of Wollaston's camera lucida. 1824 Pencil, 11 cm × 16 cm *Science Museum, London*

may be covered with paper, enabling the artist to draw around the forms, thereby producing an almost photographically correct account of the scene outside. The principle of the camera obscura is in fact the same as that of the photographic camera, with the difference that in the case of the photographic camera the image is recorded by means of a light-sensitive chemical rather than by the draughtsman's hand. A popular alternative to the camera obscura was the *camera lucida* (literally: 'light room'). This consisted of a prism mounted over a drawing board. By placing his eye against one surface of the prism, the draughtsman could see the reflected image of the landscape superimposed upon a view of his drawing surface. This enabled him to trace the forms of the scene before him directly onto the paper.

During the seventeenth and eighteenth centuries a so-called 'Claude glass' was carried by many landscape artists and travellers. This consisted of a small concave mirror with a darkened surface. The Claude glass reduced and simplified the tonal and colour range of any scene reflected in it, providing it with a painterly quality much admired by connoisseurs of classical landscape painting such as that of Claude Lorraine (1600–82), hence the name of the device.

Perhaps the most important modern addition to the range of draughtsman's aids is the photograph, which found its way into the professional equipment of many artists shortly after its invention in the 1820s. A wide variety of artists have used photography as an ancillary, often with great effect. Outstanding examples are Delacroix, Sickert and Francis Bacon. A distinction should however be drawn between the use of photography as an aid and its use as a source comparable with other sources such as nature itself.

Camera lucida as part of a portable drawing outfit. Early nineteenth century Brass, glass and mahogany. Box 30 cm × 20 cm × 3 cm, pillar 22 cm *Science Museum, London*

19

In recent years there has been a revival of interest amongst many contemporary draughtsmen in drawing aids, including the use of the plumb line, and there is much to be gained from the intelligent use of suitable aids. The use of aids creates problems when, instead of facilitating the artist's process of perception, they act as an interference or blockage. For example, drawings done from what is called 'photo-reference' often result in a drawing which looks exactly like what it is—namely a drawing *of* a photograph. The photographic image does not capture everything which is available to the human eye, but reduces visual forms to a limited and often monotonous sequence of tonal gradations. Consequently a draughtsman who depends too heavily on the use of photographic sources runs the risk of producing flat and monotonous imagery which is uninformed by the sense of depth, volume and movement which we perceive in real life. A similar risk is run in drawings done with the assistance of a viewing grid or plumb line: they can result in images which have an excessively map-like quality, lacking in depth and volume.

AIRBRUSH

Very few conventional drawing media are capable of producing an even gradation of tone, which is usually simulated by varying the weight and spacing of hatching or by varying the amount of pigment in a wash. The airbrush, which was invented in 1893, has been developed specifically to answer this need. Its mechanical principle is that a jet of air is passed through a reservoir of liquid pigment. The air forces the pigment through a tiny nozzle, producing a fine, controlled spray. There are numerous variations on this principle, and in the most sophisticated models it is possible to produce an enormous variety of effects, including continuous gradations of tone, lines and dots.

The *forte* of the airbrush is its ability to produce even gradations of tone and colour comparable in quality with the continuous tone of the photographic image. These gradations can be given precise edges by the use of masking laid over certain sections of the drawing. This has made it especially useful in the drawing of machine parts for technical illustration, and it has also been adopted by commercial and fine artists who wish to create an impression of unblemished evenness of surface.

It should also be remarked that the airbrush has itself created a taste for certain graphic effects which owe little to

See colour plate *Cutaway tyre* by Hugh Dixon facing page 96

observation of nature. It is for example possible to draw metal objects with a surface sheen and brilliance which one never finds in nature. This is not in itself a bad thing, but the draughtsman should be aware of the distinction between visual information which is gathered from observation and graphic formulae which owe their origin to the availability of certain technical aids.

ALEATORIC (or ALEATORY) DRAWING

The adjective aleatoric is derived from the Latin word for a dice player, and is intended to denote works which deliberately involve a degree of chance. Perhaps the most famous examples of aleatoric drawings are those produced by Marcel Duchamp when he dropped lengths of string on to pieces of paper and drew around the resulting configurations. However, the principle of the exploitation of chance has much earlier origins than this, and can be seen in Leonardo's advice to artists to study random smudges and marks on walls, as it can in Alexander Cozens' system of developing landscapes from blots.

The interest in chance effects is without doubt related to the psychoanalytic theory that the artist is never in complete control of his creative processes, but is motivated and guided by forces which emanate from the unconscious mind. Since these forces are the result of inheritance and random life experience they are not accessible to voluntary control, and are therefore manifestations of chance.

See also **Automatism**.

Alexander Cozens: Plate 13 of *A New Method of Assisting the Invention in Drawing Original Compositions of Landscape.* About 1785 Aquatint, 24 cm × 31.5 cm *Victoria and Albert Museum, London*

21

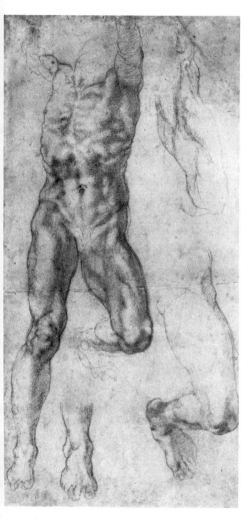

Michelangelo: Four studies of a crucified man. Red chalk, 40.6 cm × 20.7 cm
British Museum, London

OPPOSITE **Leonardo da Vinci:** Studies of the head and shoulders of a man. 1510 Pen and ink, 28.7 cm × 19.6 cm *Royal Library, Windsor. Reproduced by gracious permission of Her Majesty the Queen*

ANATOMY

There are two main reasons why drawing has had a close historical relationship with anatomy. The first is that in the early days of scientific anatomy, drawing played a leading role in the analysis and understanding of the human body, and artists of considerable distinction, notably Leonardo da Vinci, devoted a great deal of time to what was very much a scientific pursuit. The second reason is that the Western humanistic tradition treated the human figure as the supreme medium of artistic expression. Both of these reasons are, to a certain extent, valid today, in that we still need the medical illustrator to undertake tasks too sensitive or complex for the camera, and in spite of the advances of abstract art many artists remain preoccupied with the depiction of the human figure with all its expressive possibilities.

However, the old tradition of teaching anatomy to art students by means of the rote learning of the Latin names of muscles and bones, or of 'ideal proportions' has now been more or less abandoned, and not without some justification. The bad consequences of the old tradition were that it encouraged the student to draw what he *knew* rather than what he *saw*, and that it infected drawing with mistaken ideas of 'rules' and 'correctness' which conflicted with expression. Many draughtsmen of excellence were, like Claude and Turner, not particularly good at drawing the figure according to anatomical norms, or, like William Blake, more interested in inventing a personal brand of anatomy which did not conform to scientific accuracy.

For the majority of contemporary draughtsmen, the most useful kind of anatomy takes the form of an enhanced or intensified response to the human figure as a subject, and the avoidance of certain traps which result from our everyday habits of perceiving it. To take one example, we naturally attach greater psychological importance to some parts of the body, such as the face and the hands, since we use them as a means of communicating ideas and emotions. The result is that we have an instinctive tendency to exaggerate the size of these parts or to work them in greater detail than other parts of the body. If our intention is to produce a sound observational drawing, this creates a problem by throwing the figure out of proportion. A classic case is a drawing of the head in which the face has become too large in relation to the whole mass of the head and hair. This kind of distortion can, of course, fit in with what the draughtsman wishes to achieve, but in many cases it conflicts with his basic

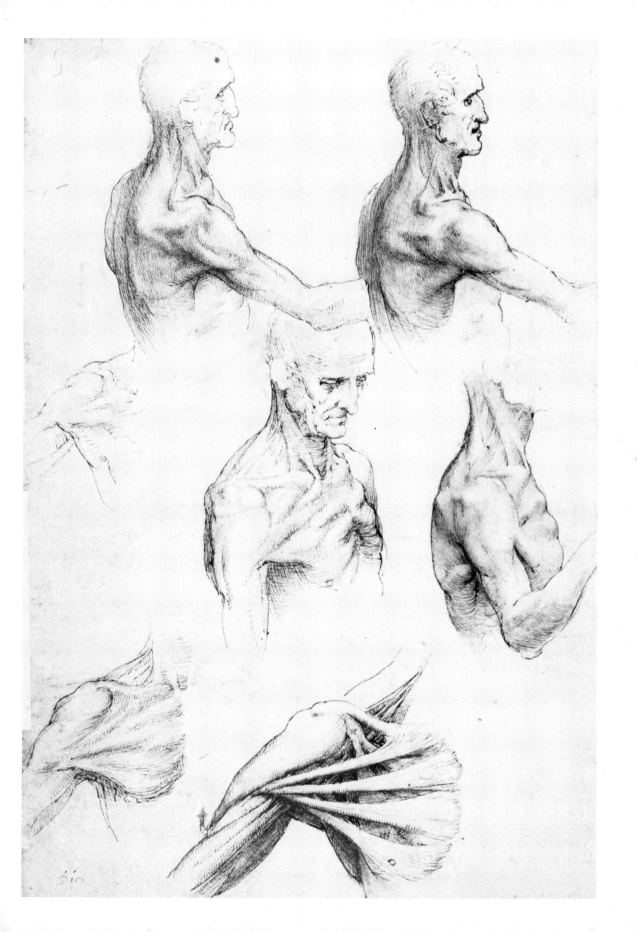

ANATOMY

Auguste Rodin: *Negro girl against a green background* Pencil and water colour, 32.4 cm × 24.1 cm
Rodin Museum, Paris

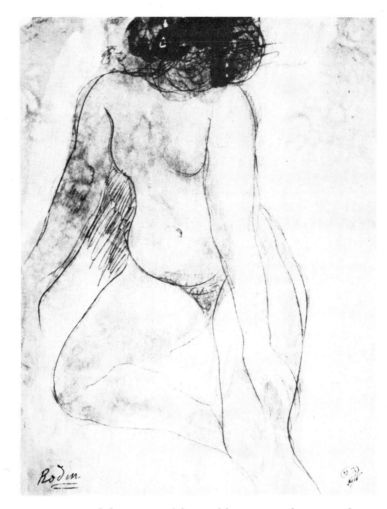

intention, and the cause of the problem is not always evident.

The anatomical knowledge which might be of value is a broad knowledge of the disposition of bone, muscle and fat, as this will help the observant draughtsman to understand the behaviour of the figure in certain positions. In a female life model lying on one side, for example, the rigid bone structure of the body, principally the pelvis and the rib cage, will tend to hold up like a framework, while the softer parts of the body, such as the belly and the breasts, will tend to hang slightly to one side under the force of gravity. This will displace the conventional symmetry of the body, so that the navel and the nipples will no longer be symmetrically disposed.

When drawing a standing figure or one which is on the move it is essential to identify how the weight of the body is being supported and distributed, how limbs are used as

checks and counterbalances, and how movement itself is used in order to keep the body upright and stable. Rodin's drawings of moving models provide us with little in terms of scientific information, but they capture and record all he needed to know, and re-create for us the full impact of his observations at that point in time.

ARCHITECTURAL DRAWING, ENGINEERING DRAWING

Architectural and engineering drawing are specialised fields of activity with their own history and conventions. However, they have sufficient in common to justify treating them together in the present work. Architects and engineers often employ drawing in a way comparable with the drawing of the fine artist or illustrator. For example, they may sketch freehand the intended visual effect of a project prior to the preparation of working drawings. Alternatively, they may undertake a descriptive drawing of an existing piece of architecture or engineering which is intended as a visual record.

Both these drawing activities should be distinguished from architectural and engineering drawing proper, in which the primary intention is not to create a visual impression, but to record and communicate through drawing and associated graphics the precise and literal form of an existing or intended artefact, whether it is a bridge, a private house, a power station or an electric pump. The primary purpose of architectural and engineering drawing is not to transmit

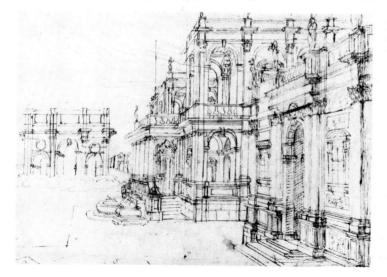

Andrea Palladio: Sketch design for a palace and a triumphal arch
Pen and ink, 19.1 cm × 26.7 cm
Victoria and Albert Museum, London

25

subjective visual impressions, but to communicate forms and materials in a way which will permit the physical realization of the thing depicted by someone capable of reading the drawing. Architectural and engineering drawings often have qualities which would justify regarding them as art works in their own right, with imagery full of power, refinement and beauty; however, this is never the primary purpose for their creation, which is simply to communicate accurate information in the most convenient way possible.

Examples of architectural and engineering drawing have been recorded as early as ancient Babylon, and there are many examples known from the middle ages, such as Villard de Honnecourt's famous sketchbook (c 1225–50), which included drawings of churches, furniture and similar subjects. The history of modern engineering drawing begins with the French military strategist Gaspard Monge (1746–1818), who was on the staff of the military school at Mézières. During the 1790s Monge developed a system of what is known as descriptive geometry, a method of drawing which permitted him to plan and record with unprecedented accuracy the structure of military fortifications and equipment. Monge's method of drawing was regarded as so important strategically that it was kept secret for some time

Newcomen engine, 1717
Engraved by Beighton
Science Museum, London

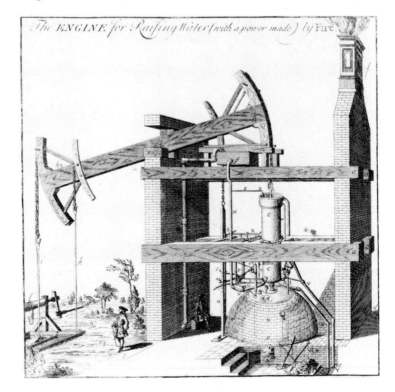

26

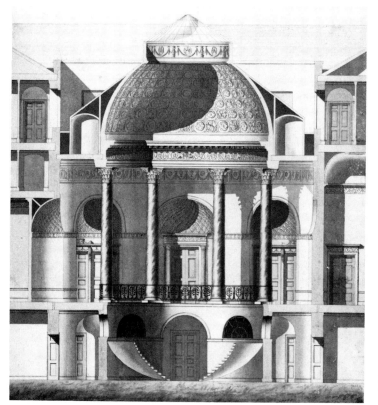

James Paine: *Wardour Castle, Wiltshire*. Section. About 1768 Pen and ink and water colour, 59.7 cm × 47.9 cm
Victoria and Albert Museum, London

Friderico Henr: Chapman: Royal Caroline Yacht, State Barge, Dutch Yacht and Dutch 'Scout' of 'Boyert', Plate 49 of *Architectura Navalis Mercatoria*, Holmae 1768 Engraving, 53 cm × 81 cm
Science Museum, London

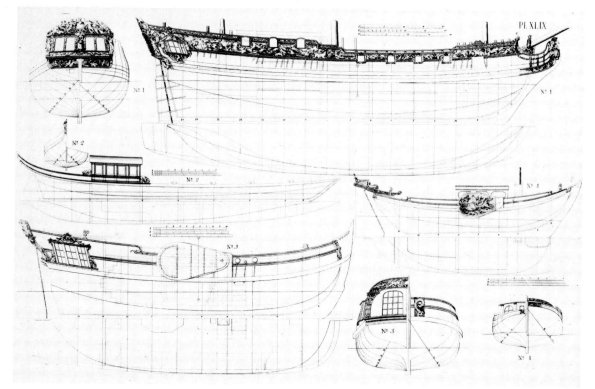

27

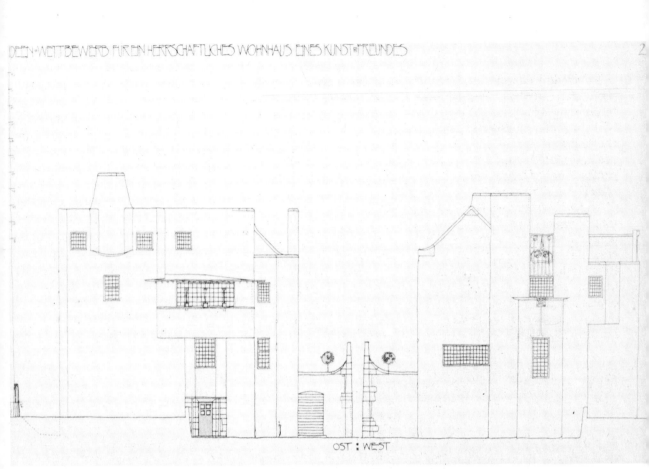
OST : WEST

Charles Rennie Mackintosh: *House of an art lover, Darmstadt.* 1902 Photo litho reproduction from pen and ink, 45.7 cm × 50.8 cm *Victoria and Albert Museum, London*

after its development and did not become more widely known until the early years of the nineteenth century. Many of the concepts and practices still current in modern architectural and engineering drawing had their origin in Monge's pioneer work, although they have of course been refined upon since his day.

The *orthographic projection* drawing is the most fundamental type of drawing for the architect and the engineer. In this projection, the object is represented as viewed from a position perpendicular to one of its principal planes or axes. All the dimensions on the plane facing the picture plane are shown true to scale, and no perspectival effect is assumed or depicted. Consequently, dimensions which are not perpendicular to the line of sight will appear foreshortened. In more mundane terms, when a roughly box-shaped house is represented by orthographic projection, the wall facing the spectator will be represented in its true dimensions (to scale) and with its true shape. The walls at right angles to the facing wall will be foreshortened so that they disappear. Other surfaces which are neither perpendicular to the line of sight nor parallel with it will be foreshortened accordingly.

28

Information about an object represented in orthographic projection may be expanded by including several views, the main views being taken perpendicular to the principal axes of the object in question. Hence, in an architectural drawing the main views will include the elevations and plan. These are normally displayed in a way which conforms to professional practice, enabling someone skilled in the art to read the drawing quickly and fluently.

The *main views* may be supplemented by so-called *auxiliary views*, which are taken from positions other than perpendicular to the principal planes or axes. These may be essential in complex pieces of engineering. Additional information can be conveyed by means of sections, in which internal detail is revealed by imagining a slice through the object along a stated plane. These are often essential in architectural drawings, where a great deal of internal detail must be recorded.

C. R. Cockerell: Design for a branch of the Bank of England, Liverpool. About 1842 Pen and ink. 35 cm × 50.8 cm
Victoria and Albert Museum, London

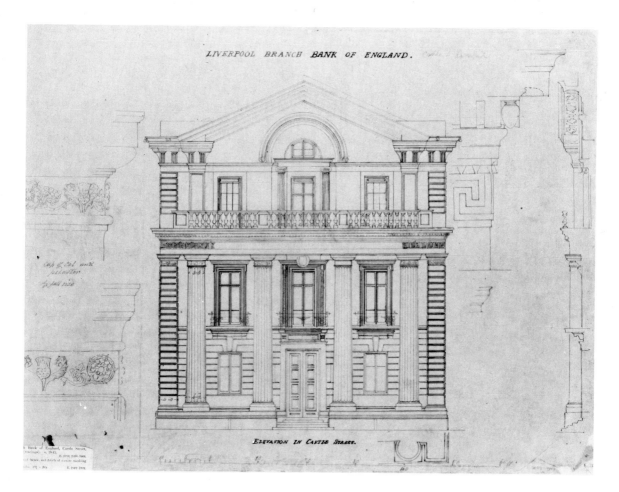

29

In addition to straightforward orthographic drawing, the architect and the engineer often employ what may be described as pictorial methods of representation. However, it should be emphasised in this context that the word pictorial is used relative to orthographic, and is not intended to indicate a departure from the central intention of recording and communicating precise information about objects. The three main categories of pictorial drawing are axonometric projections, oblique projections and perspectival drawings.

In an *axonometric projection*, the line of sight is inclined to the principal faces (or axes) of the object being depicted. Consequently all the dimensions along the principal axes are shown as foreshortened. When an axonometric projection is represented so that all the principal axes are foreshortened to the same degree, the result is what is known as an *isometric projection*. In an *oblique projection*, the picture plane is established at an angle other than 90° to the visual rays. The picture plane is usually parallel to one of the main planes of the object represented, and this plane is depicted as true in shape and size (to scale). Other planes of the object are depicted along a receding axis at an angle other than horizontal or vertical. The effect of the oblique projection can be rather ungainly, but it is very useful in communicating information not easily available in other projections.

Perspective drawings approximate most closely to visual experience, but they are less effective than axonometric and oblique projections in communicating literal information about dimensions, forms and relationships. There are in fact several types of perspectival projection, but what they all have in common is that, unlike other forms of architectural and engineering drawing, lines which are parallel in the object depicted are normally represented in the drawing as converging. It is possible to represent the axes and planes of a rectangular object in such a way that parallels on one, two or all three of the main axes converge, the last resulting in so-called three-point perspective.

Within a limited space it is not possible to provide more than a brief review of the many and complex drawing methods available to the architect and the engineer. In conclusion it is worth remarking that the various systems of projection are complemented by standardised ways of using line, tone and colour. Visible lines, such as the meeting of planes, are normally represented in continuous thick lines. Secondary detail within the main planes may be drawn in a light weight line. Hidden outlines are shown in a light line of short dashes, and centre lines as a 'chain' of alternate short and long dashes. Further information can be found in the

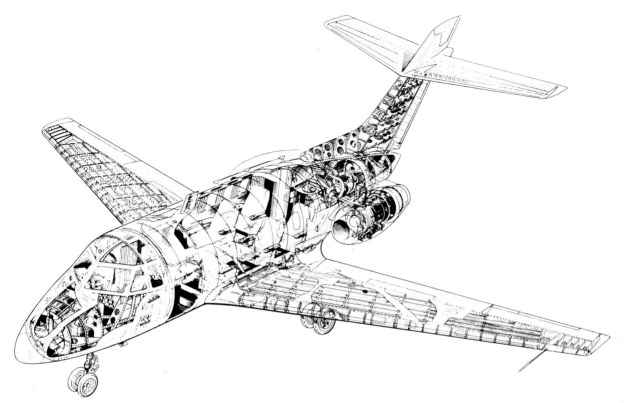

pamphlet published by the British Standards Institution entitled *Engineering drawing and practice* BS 308: 1972.

Considering their immense cultural and historical importance, the traditions of architectural and engineering drawing have been unjustifiably neglected. Peter Booker *A History of Engineering Drawing* (1963) is one of the few useful studies of the subject. Ken Baynes and Francis Pugh *The Art of the Engineer* (1981) contains a fine collection of drawings, mainly of nineteenth-century transport.

Cecil Misstear: D. H. 125, general arrangement drawing. 1960
Line, ink, 34 cm × 40 cm
Courtesy of the artist

ATMOSPHERIC PERSPECTIVE

See **Perspective**.

AUTOMATISM

The principle of automatism is that the artist should attempt to work spontaneously and intuitively, without the intervention of conscious thought processes. The origins of the theory of automatism as applied to artistic creativity can be traced to the psychoanalytic theories of Sigmund Freud, who

31

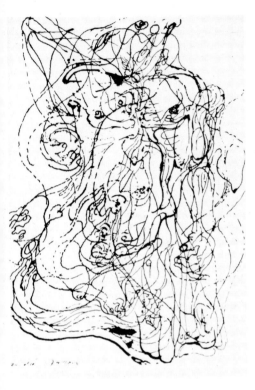

André Masson: Automatic drawing.
1924 *Location unknown*
Copyright ADAGP, Paris, 1982

See colour plate
A man helping a seated woman to rise from the ground by Watteau between pages 96 and 97

argued that in art, as in other fields of human activity, we are never in full control of our actions, but are driven and guided by impulses emanating from the unconscious.

The technique of automatic drawing, like automatic writing and musical composition, was developed by the Surrealists of the 1920s, who wished to exploit the deeper levels of the personality not normally accessible to rational thought. In the visual arts at least this ideal was very difficult to realize, because the physical mechanics of handling materials demands a modicum of conscious organization, if no more than to ensure that one's pencil has a point, and that the pointed end is directed at the paper. The result is that purely automatic drawings are really rather rare, and the Surrealists themselves soon attempted to find other ways of tapping the unconscious.

Nevertheless, automatism had a special significance for drawing, which can permit a more rapid and spontaneous mode of creation than either painting or sculpture. In its most extreme form, artists used drugs, hypnosis and other self-induced means in order to suspend the conscious and rational functioning of the mind and its control over the hand. Elements of automatism continued to be evident in the art of the period of the 1940s and 1950s, especially in Canada and the USA, and it provides an important ingredient of Abstract Expressionism.

Although the more extreme forms of automatism have been more or less abandoned, the technique prompts us to ask how far the act of drawing is or should be under the conscious control of the mind, and to what extent it is an instinctive and irrational activity.

AUX DEUX CRAYONS/AUX TROIS CRAYONS

The techniques of drawing with two colours of chalk (French: *aux deux crayons*), usually black and red upon toned paper, or with three colours of chalk (French: *aux trois crayons*), usually black, red and white upon toned paper, reached a high level of popularity during the eighteenth century, and is particularly associated with the drawings of the great Rococo draughtsmen such as Watteau and Boucher. Normally black was used to construct the form of the image, white provided it with highlights, and red was used economically to suggest the blush of flesh and details such as lips and the tear glands of the eyes. Drawing with two or three colours of chalks or pencils considerably increases the potential for textural effects, permitting the draughtsman

to suggest the surface qualities of substances such as different cloths, flesh, hair and stone.

Draughtsmen with a dominant preoccupation with form tend to avoid the use of more than one colour, regarding it as a distraction from the structural qualities of the drawing. In recent years there has been a widespread revival of interest in drawing with more than one colour and it has become a feature of the work of modern artists and illustrators such as David Hockney and Adrian George.

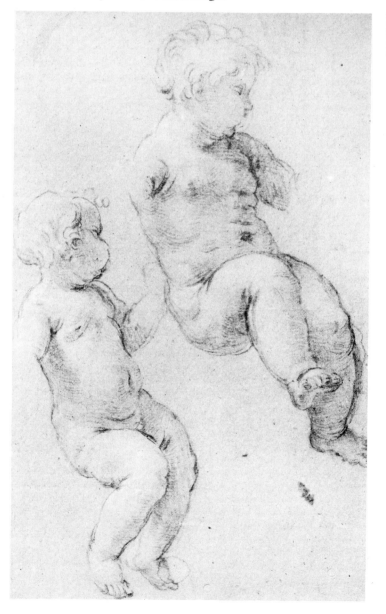

François Boucher: Studies of children Red chalk heightened with white, 33.3 cm × 21.6 cm *Victoria and Albert Museum, London*

33

BACKGROUND

A well-known feature of the psychology of human perception is the tendency to distinguish between what are known as 'figure' and 'ground'. Presented with any visual phenomenon, we attempt to interpret it in terms of one or more 'things' of varying importance, which are known as 'figures', set against a 'ground' of relatively less psychological importance. Hence, the figure/ground relationship might take the form of a head against a wall, or a tree against the sky. It has been demonstrated that when the eye cannot distinguish figure from ground, in nature or in art, the result can be disturbing and disorientating for the spectator.

Phil Amy: *Still life* Pencil, 41.9 cm × 58.4 cm The drawing has been developed in terms of robust combinations of figure and ground *Courtesy of the artist*

34

The tendency in real life to distinguish between important material 'things' and their 'surroundings' or 'background' is both natural and necessary; but when carried over into art it can have damaging consequences, resulting in an exaggerated preoccupation with the internal form and detail of the subject matter and a neglect of the total design and structure of the drawing as a graphic image. Many draughtsmen have recognised that in drawing, if not in life, the background surrounding a subject may be as important as the subject itself, and should be conceived and constructed as a meaningful part of the design of the image.

Not so long ago there was a vogue amongst drawing teachers for getting students to draw everything in terms of 'the spaces between'. This degenerated to something of a fetish, and the result was a large number of drawings which neglected the internal structure of forms as seriously as the surrounding forms had been previously neglected. Clearly, there is a need for balance and discretion, but it is advisable to cultivate the habit of constantly checking the conception and development of one's drawings in terms of positive and negative interlocking forms—in terms of both figure and ground. Exactly the same is true of the draughtsman dealing with abstract forms, who must constantly evaluate the character of the marks being created by the positive application of the drawing tool to the support, in relation to the forms which result from the changing boundaries of the unworked areas of the drawing.

In addition to these psychological and abstract considerations, it should also be remembered that background may serve many other functions in the context of drawing. Beginning from the concept of background as blank space, or a kind of inert void surrounding the motif, the draughtsman may introduce tonal variations as a way of emphasising parts of his subject. In portrait drawing the illuminated part of a brow or profile may be thrown forward by bringing down the tone of the adjacent area of paper; in a similar fashion the attached shadows on the dark side of a head may be given relief by lightening the adjacent area of a toned support, or by leaving white paper.

Moving forward from simple tonal variations of the background, directional movement may be introduced by picking up lines in the context surrounding the model or subject, and using them as a foil to the subject's internal directions and structure. For example, the fluid, organic lines of the human figure and its clothing may be contrasted with the more geometric character of background furniture and architecture. Directional contrast can also be created by

BACKGROUND

Eizan: The courtesan Egawa of the Matsuba. From the set Kuruwa no Bi Meikun Zoroi. 1855 Woodcut, 36.5 cm × 24 cm The fluid lines of the figure and draperies are brilliantly contrasted with the rectilinear architectural detail *Private collection*

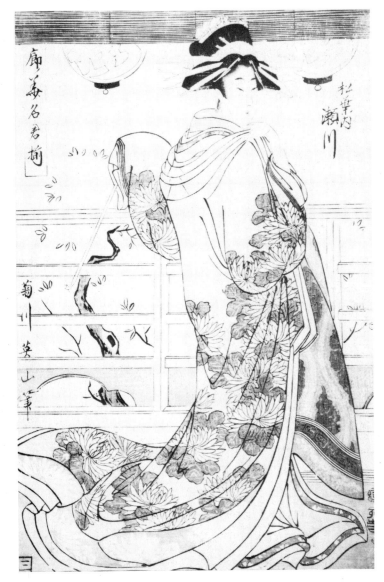

background hatching. The elaboration of background may involve the creation of textures which, combined with directional elements and tonal variation, can be used to provide contrast and animation.

Finally, many draughtsmen provide a great deal of detail about the actual objects which occupy the background of the principal motif. Preoccupation with the representation of objects in the background can be attributed to at least two artistic motives which are worth mentioning. The artists of the Pre-Raphaelite Brotherhood (founded 1848) believed

36

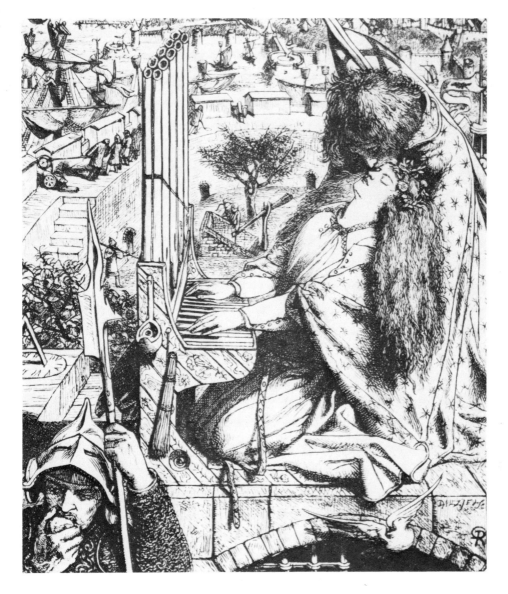

that the artist had a moral responsibility faithfully to represent everything which nature presented to the eye in relation to a chosen subject. This principle, which was closely followed by many Victorian artists, led to the attempt to capture every detail of background right down to the inclusion of each leaf on a tree. Although the practice is not necessarily to be recommended, at its best it did lead to the creation of some drawings of breathtaking intensity and conviction.

The second tendency which has led to increased interest in

Dante Gabriel Rossetti: Illustration to 'The Palace of Art', in *Poems of Alfred Tennyson*. 1864 Wood engraving by Dalziel Brothers after Rossetti's drawing, 9.2 cm × 7.9 cm
Rossetti's meticulous attention to background detail is patiently rendered by the wood engraver, creating an image of almost hallucinatory intensity

37

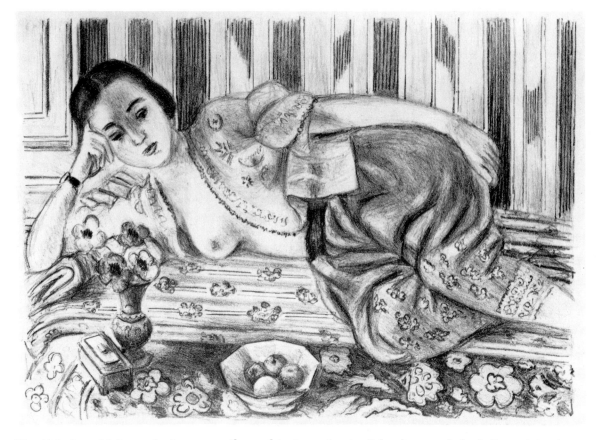

Henri Matisse: *Odalisque, Coulotte, satin rouge.* 1925
Lithograph, 19 cm × 26.7 cm
Victoria and Albert Museum, London
Copyright SPADEM, Paris, 1981

the subject content of background had its origin in a completely different kind of motive. This was the view, held by many artists of the twentieth century, that the neglect of background led to an unbalanced treatment of the picture surface. In order to counteract this tendency some artists have made a practice of introducing not only objects, but often richly decorated surfaces such as textiles, tiles and wall coverings, as a background to their subjects. Good examples of this approach may be found in the work of Vuillard, Bonnard and Matisse.

BODY COLOUR

See **Gouache**.

BRUSH

The brush was used as a drawing tool in ancient times, and although its popularity has fluctuated from time to time and

from place to place it has never been neglected for very long. The structural principle of the modern brush is that a tuft of animal hairs is bound to a wooden handle by means of a ferrule of metal. An enormous variety of hair has been used, including that of the camel, squirrel, ox, sheep, deer, fox and wolf. The most highly prized brushes are those known as sables, which are made from the hair of the Siberian mink. The quality most desired in a brush is its ability to pick up and hold a large quantity of medium, such as ink or water colour, and to deposit it easily and fluently in response to the movements of the artist's hand. Brushes are manufactured in a large range of sizes and with a wide variety in the length and shape of the hair. Some come to a fine point, others fan out at the end; some are circular in section, others wedge-shaped.

Rembrandt van Rijn: *A girl sleeping.* Study of Hendrickje Brush and bistre, wash, 24.5 cm × 20.3 cm *British Museum, London*

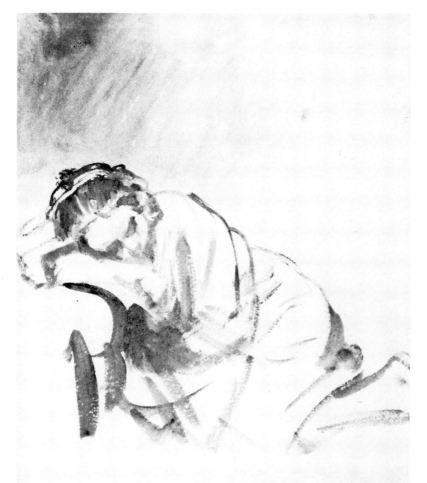

OPPOSITE **Tosa Kenji:** *Otsu-e of a samurai* Ink and colours on paper, 22.9 cm × 33 cm
British Museum, London

Hiroshige: Geishas and an artist, from *National Types in Comic Verse*, *c* 1850. (Detail) Woodcut, 23.4 cm × 16.6 cm
British Museum, London

In mediaeval times a fine brush was often used as a substitute for the quill pen in drawing and painting miniatures and in manuscript illumination, and in some cases only an expert eye can distinguish the difference. Brush drawing came to a position of unprecedented importance during the late sixteenth and seventeenth centuries, when the Renaissance preference for pure line was overtaken by the baroque enthusiasm for broad tonal effects and painterly handling. The master of seventeenth century brush drawing is Rembrandt, who used it in skilful combination with reed pen. As a drawing implement the brush experienced a period of great popularity during the nineteenth century, when it was used with effect by artists as varied as Turner, Delacroix, Daumier and Manet.

The great strength of the brush in comparison with most dry drawing media is the enormous variety of effects of which it is capable, ranging from fine, delicate lines drawn with a sable, to broad, shaggy areas of tone drawn with a large hog-hair. The marks of the brush can be varied in terms of the amount of medium which it carries and by means of

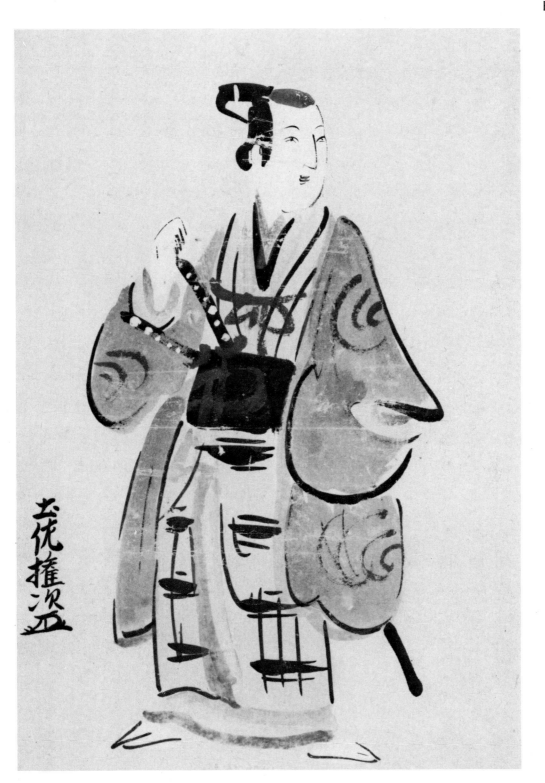

the speed and pressure of the artist's hand. A 'loaded' brush moved slowly across the surface of the drawing leaves a rich, fluid track of medium. A drier brush with stiff bristles moved fairly quickly leaves a completely different mark: since it does not cover the paper completely but leaves a tiny pattern of untouched areas the effect is a lively textural surface. The character of the brush stroke often changes between its beginning and its ends, when it has deposited most of its load of medium; hence a stroke which begins in a full, saturated blob may be made to drag out to a dryish end in which the traces of the individual hairs of the brush are visible.

The brush has enjoyed a higher continuing status in the Oriental tradition of drawing than in the West. In China and Japan it has strong links with the tradition of brush calligraphy both technically and expressively. The European artist has tended to hold the brush in a manner similar to that of dry drawing media, that is gripping the handle at the top of the ferrule between the thumb and the first and second fingers, with the handle resting on the web of skin between the thumb and the first knuckle of the index finger. Oriental draughtsmen use a completely different hold. The drawing surface is placed horizontally, and the brush held more or less vertically above it. The handle of the brush is held higher up than in the West, gripped on one side by the thumb and on the other by the flat of the inside of the four fingers. The vertical position of the brush allows the medium to flow easily on to the paper, and the hand is held well clear of the body, permitting great fluency of movement in the wrist and arm.

CARICATURE

The term 'caricature' is derived from an Italian word *caricare* meaning 'to load'; and that expresses as clearly as anything the essence of a caricature, which is a drawing in which certain features are exaggerated or 'loaded' in order to make a point. It is worth reflecting that caricature in one form or another, in children's comics, in newspaper and periodical cartoons and in animated films, probably reaches a larger public than any other form of drawing and therefore its

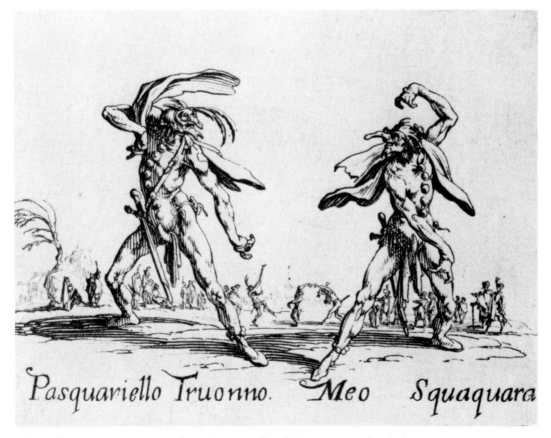

Pasquariello Truonno. Meo S'quaquara

cultural importance must be recognised. The essence of caricature is and always has been the use of two principles, one negative, that is the elimination of all superfluous content, and one positive, that is the identification and exaggeration of key features.

It is a characteristic of caricature that it has the potential to make people laugh. Why human beings feel the need to laugh at all is a profound riddle beyond the competence of this book, but it should be pointed out that caricatures vary in the kind of laughter they evoke, ranging from the outer physical laughter of sympathy, contempt or derision, to the more subtle inner laughter of the mind which may produce no more than a momentary twitch of the lips. Caricature tends to produce imagery we associate with the ludicrous or the grotesque, qualities we think of in connection with what is popularly known as the **cartoon**. But not all cartoons can correctly be described as caricatures, as a minority strive for what one might call idealisation of characters and situations, an emphasis upon virtue and the heroic rather than the bizarre or the comic, which is the essence of caricature.

Jacques Callot: Pasquariello Truonno. Meo Squaquara. Scene from *Balli di Sfessania.* 1621 Etching, 6.7 cm × 8.8 cm Callot is generally regarded as one of the fathers of the art of caricature, illustrated in this scene from the Commedia dell'Arte

CARICATURE

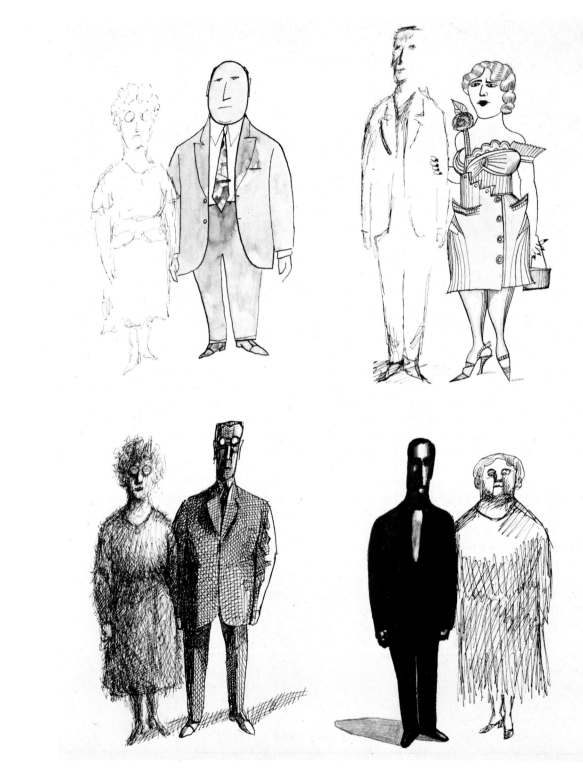

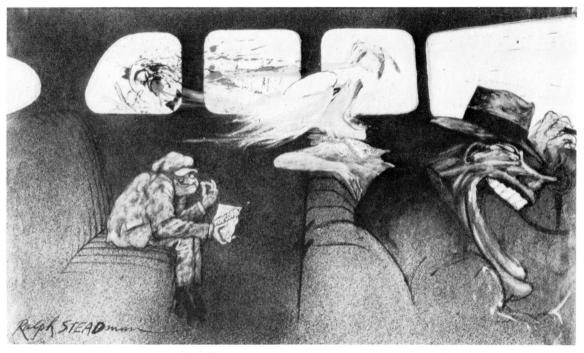

A study of the work of successful caricaturists suggests that they tend to specialise to a very high degree in regard to both the kinds of topics which they tackle and the way in which they draw, in the formulation of what one might call their 'style'. In some cases one finds, as in many nineteenth-century cartoons, a high degree of interaction between the drawn image and the verbal caption; in others, the verbal caption contributes little to the meaning of the drawing or is altogether absent. In some cases the caricaturist aims for the creation of one precise moment in time; in others he implies a strong sense of narrative, or story-telling, or even extends the drawings into a narrative series such as we find in the strip cartoon. Most caricaturists establish their personal identity by the repeated use of a combination of certain characteristics of drawing, such as a distorted head-to-body relationship, the exaggeration of noses, a formula eye, or the use of broad areas of tone. In the drawings of Steinberg it is not so much the use of one predictable graphic style which establishes his personal stylistic identity, as the ability to leap with brilliant virtuosity from one kind of graphic effect to another, in the same way a mimic can assume one identity after another in rapid succession whilst retaining the constant foundation of his own personality.

Good observational drawing is the basis of most good caricature, so the first requirement for the aspiring

Ralph Steadman: *Bonnie and Clyde*. 1977 Drawing for Radio Times feature *Courtesy of the artist*

OPPOSITE **Saul Steinberg:** Four couples from *The Passport*. 1979 Pen and ink reproduced in line. 30.5 cm × 22.5 cm

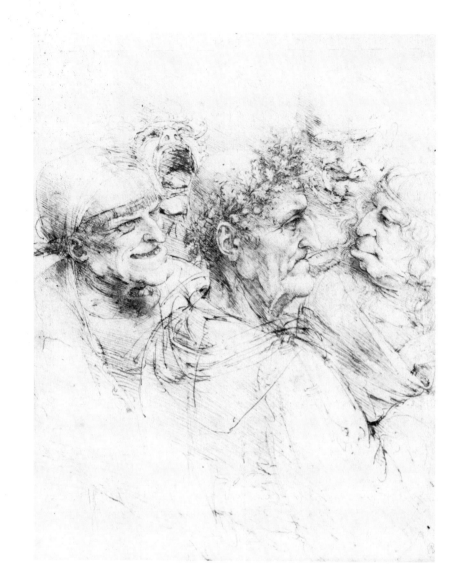

Leonardo da Vinci: *A group of five grotesque heads*
Pen and ink, 26 cm × 20.5 cm
Royal Library, Windsor
Reproduced by gracious permission of Her Majesty the Queen

caricaturist is a sharp eye for nature combined with the ability to record transitory impressions with speed and accuracy. The caricaturist needs to build up a large reservoir of forms and ideas through rapid sketching and through more sustained observational drawing. Notes, drawings and sketchbooks should be supplemented by a personal reference collection of cuttings, photographs and reproductions, and these should be indexed for speed of reference. This kind of reference collection will grow much faster than one may at first imagine, so one should begin with an expandable storage system such as alphabetically arranged wallet files, box files or suspension files kept in a second-hand filing cabinet.

An invaluable source of reference is the drawings of other caricaturists and cartoonists. However, it is most important to recognise from the outset that the value of studying the drawings of other draughtsmen is not merely to impersonate their style, but to analyse and understand how their drawings 'work'. Good caricature represents the conclusion of many stages of selection, alteration and refinement upon an original idea, and simply trying to imitate the physical marks of a fine caricaturist without grasping the underlying structure of the drawing will lead nowhere.

The caricaturist must identify his own strengths and cultivate them assiduously. For example, does he relish words for their own sake and find it easy to invent original and apt captions? Or does he depend heavily upon the graphic content of the drawing? Does he draw naturally in fine unmodulated line with little or no use of light and shade? Or does he like to use a shaggy textural line combined with broad sweeps of shadow? Does he pull features out of scale to quite horrific proportions? Or does he maintain a drawing style close to naturalism in which the humour consists of slight nuances of gesture, expression and word? Even after answering these questions to his own satisfaction and after having established his personal identity over a period of time, many caricaturists find each drawing demands a long series of drafts involving selection, rejection, alteration and steady refinement upon the original idea.

As regards materials, at one time all illustrators in line used to be firmly instructed to drawn only in the blackest ink upon the whitest paper available, since nothing in between would survive the reproduction process. This is no longer the case, and with modern methods of reproduction almost any kind of clearly visible mark will appear in the published drawing, which may be executed in soft pencil, pen and ink, wash and mechanical tints. The success and effectiveness of these and other media depends to a great extent upon the quality of the paper and printing of the publication in question, and a professional caricaturist will always bear these factors clearly in mind when drawing for a periodical or newspaper.

CARTOON

A cartoon was originally a full-size drawing made for the purpose of transferring an image on to a wall, panel, tapestry or piece of glass. In medieval and renaissance practice cartoons were drawn on stout paper, sometimes taking in

47

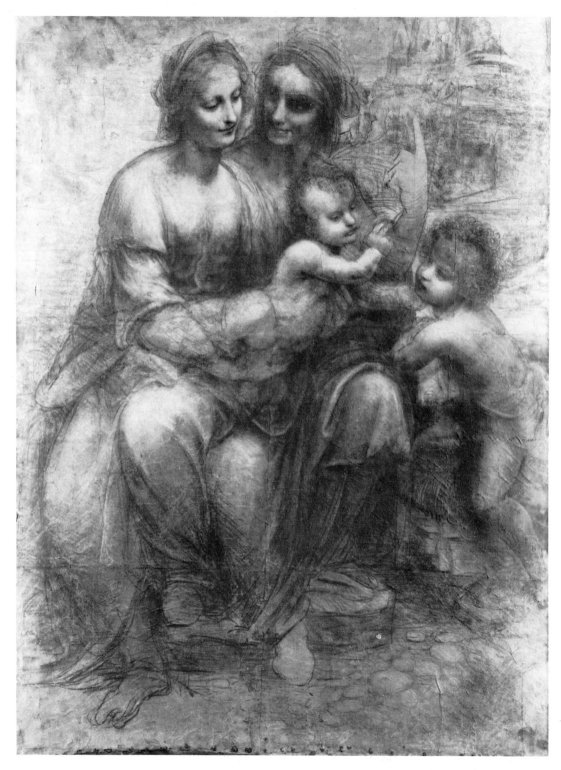

the whole of a composition, sometimes only a part or an individual figure. The lines of the drawing were punctured with holes, and when the drawing was fixed to the wall or other surface the design was transferred by 'pouncing' the drawing by beating it with a bag full of charcoal dust. This produced a pattern of dots which provided the painter or craftsman with a guide for the execution of the final work. Cartoons tended to be regarded as purely instrumental, and of no intrinsic artistic value; consequently they were often thrown away after the completion of the transfer and very few have survived. During the nineteenth century a number of cartoons were produced in response to a competition for the decoration of the newly rebuilt Houses of Parliament in London. These were the subject of a parody in the humorous journal *Punch*, with the result that the word 'cartoon' acquired its modern popular meaning of a humorous drawing or caricature.

The original function of the cartoon has to some extent been superseded by the use of projection. In this process the

OPPOSITE **Leonardo da Vinci:** *Cartoon for The Virgin and Child with St Anne and St John the Baptist*
Black chalk heightened with white on paper, not pricked for transfer, 141.5 cm \times 104.6 cm
National Gallery, London

Marco D'Oggiono: *Head of the Virgin*
Black chalk on laid paper, pricked for transfer, 16.8 cm \times 13.9 cm
Victoria and Albert Museum, London

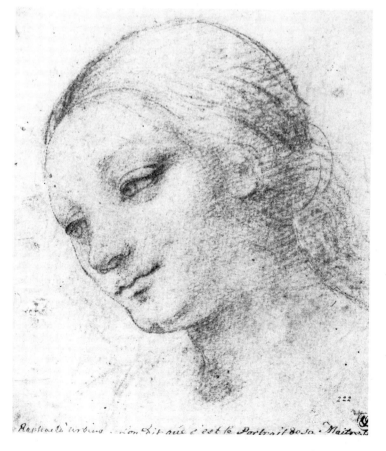

49

drawing can be placed in an epidiascope and projected on to the working surface in the required position and at the desired scale, permitting the artist to draw around the projected image whilst standing slightly to one side of the beam of the lamp.

See also **Caricature**.

CHALKS

Natural chalks are made from clay-like deposits which, because of their chemical composition, have a strong mark-making potential. Historically, the principal colours used are black, red and white. Their colour is never pure, and varies considerably according to ingredients such as iron oxide which produces red, carbon which produces black, and calcite which produces white. Natural chalks were mined straight out of the ground and then cut or sawn into

Michelangelo: Study for Adam Red chalk, 19.3 cm × 25.9 cm
British Museum, London

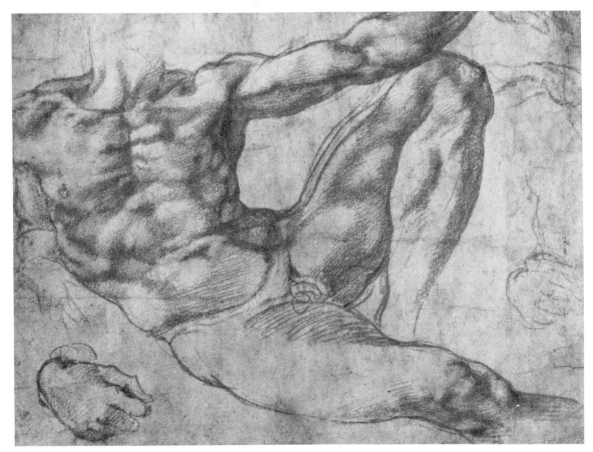

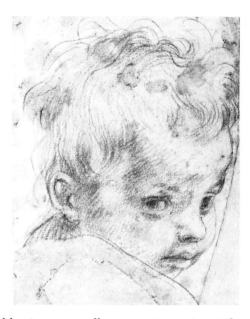

Andrea del Sarto: Study for head of Jesus Red chalk on laid paper, 14.5 cm × 11.7 cm
Victoria and Albert Museum

manageable pieces, usually square in section. Like charcoal, these could be brought to a point by sharpening with a blade or by abrasion.

In order to be really useful as a drawing medium natural chalks had to be soft enough to draw easily without a great deal of pressure, but hard enough not to break repeatedly whilst being used. They had also to be consistent in tone and texture, so that the draughtsman could predict the kind of mark they would make. Understandably, these conditions were fulfilled by only a small minority of natural chalks, and most of the deposits have in the course of time been either mined out, or abandoned and forgotten as a result of the later competition of artificial chalks.

Black chalk was with charcoal one of the broad line media which rose to great popularity around 1500, as it satisfied the growing interest in textural effects and atmospheric values. It was used with great effect by the Venetian artists, such as Titian and Tintoretto. Red chalk became established if anything slightly earlier. It had been known in ancient times, but it was revived and used with brilliance by the artists of the High Renaissance, including Leonardo da Vinci, Andrea del Sarto and Correggio. Often referred to as 'sanguine' (blood-like), red chalks made available a range of warm colours which were ideal for suggesting the subject of most interest to the artists of the High Renaissance, namely the form, life and movement of the human figure. Because of its tendency to suggest animal warmth and life, red chalk has been ill-adapted to use in landscape, where its redness tends

51

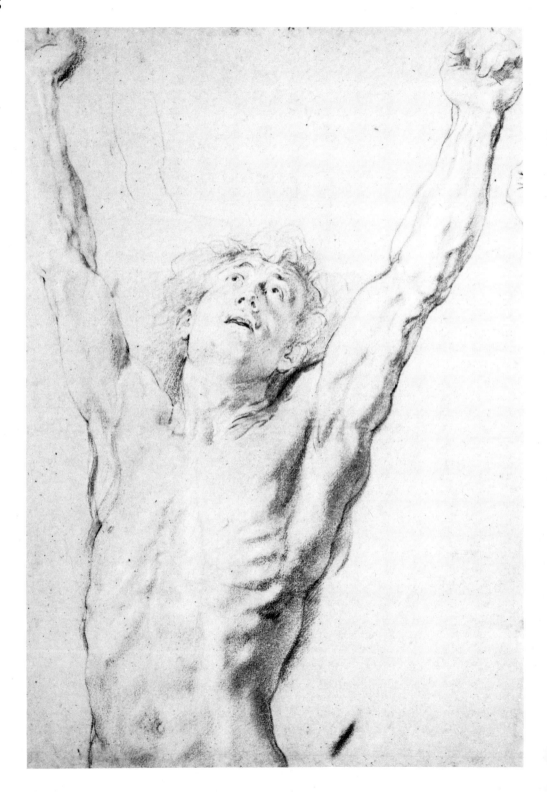

to produce an unpleasant gingery effect which is quite out of keeping with the cool harmonies of greens, blues and greys which we associate with foliage, sky and water.

White chalk, like charcoal, has a long history of use as a preliminary drawing medium, possessing the advantage of being easy to erase and correct. It is of course necessary to prime surfaces with a colour or tone in order to render white chalk drawing visible, and this was common in the historical tradition of oil painting.

During the sixteenth century a number of artists experimented with combinations of chalks, either by adding white highlights to drawings done in black on toned or tinted paper, or by adding small touches of red to lips, cheeks, the tear gland of the eye, etc. This latter technique was known in Italian as *tocchi di rosso* (touches of red) and opened the way to a whole tradition of working in more than one chalk.

Drawings which were fully developed in two chalks were known in French as **aux deux crayons** (with two chalks), and drawings which combined three chalks, usually black, red and white, were known as **aux trois crayons** (with three chalks). The technique of working with two or three chalks on toned paper reached its peak in the French art of the eighteenth century, of which the drawings of Watteau and Boucher are excellent examples. It is significant that this technique corresponded to an unprecedented interest in the depiction of textural varieties of fabric, flesh, hair, foliage and other substances. The development of chalk drawing in the direction of an extended colour range and a full tonal range naturally led to the disapproval of those who believed that drawing should be concerned with form and line rather than with colour, texture and tone.

Because of the scarcity of really satisfactory natural chalks, techniques for the manufacture of artificial chalks were already known in the sixteenth century. Artificial chalks were produced by mixing colouring substances such as lamp black and soot with clay and a binding agent, rolling the resulting paste into a cylindrical form, and letting it dry. Because almost any pigment whatever could be added to the clay and binder, artificial chalks could in time be produced in almost any colour. By varying the amount of white added to the paste, a full tonal range could also be obtained.

It is difficult to draw a firm distinction between coloured chalk and pastel, since both may be manufactured from a paste, which gives us the word 'pastel'. In practice, the term 'chalk' is used for media which because of their constituents are dry to the touch, rather dusty in use and have poor adhesion, whereas 'pastel' is used for artificial media which

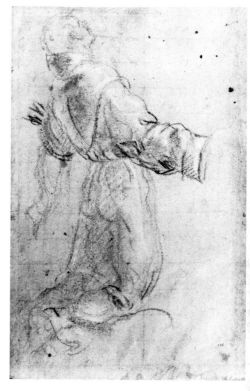

Tintoretto: *A kneeling monk*
Black chalk heightened with white,
37.4 cm × 23.4 cm
Victoria and Albert Museum, London

OPPOSITE **Peter Paul Rubens:** Study for the figure of Christ on the cross
Black chalk heightened with white, with some brown wash,
52.8 cm × 37 cm
British Museum, London

53

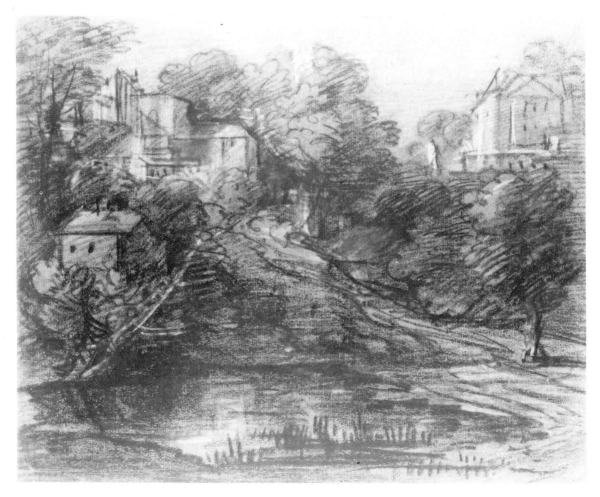

Thomas Gainsborough: *Wooded landscape with buildings on a hillside.* About 1775–80 Black chalk and stump and white chalk on blue paper, 25.1 cm × 31.7 cm *Tate Gallery, London*

OPPOSITE **Gustav Klimt:** Study for *Hope I.* 1903–4 Chalk, 44.5 cm × 30.5 cm *Fischer Fine Art Ltd, London*

have a close texture, are slightly oily to the touch, and have a rather better adhesion.

Since chalks and pastels are very similar in handling characteristics, the techniques of using both will be dealt with together under **Pastels**.

CHARCOAL

Charcoal is one of the commonest of what are known as the broad-line drawing media, and is probably the most ancient of drawing media which is still in regular use. Its employment in drawing goes back to antiquity and it was in use in palaeolithic times. The physical constitution of charcoal is quite simple. When wood is burned it eventually disintegrates into a fine greyish powder. However, if it is

54

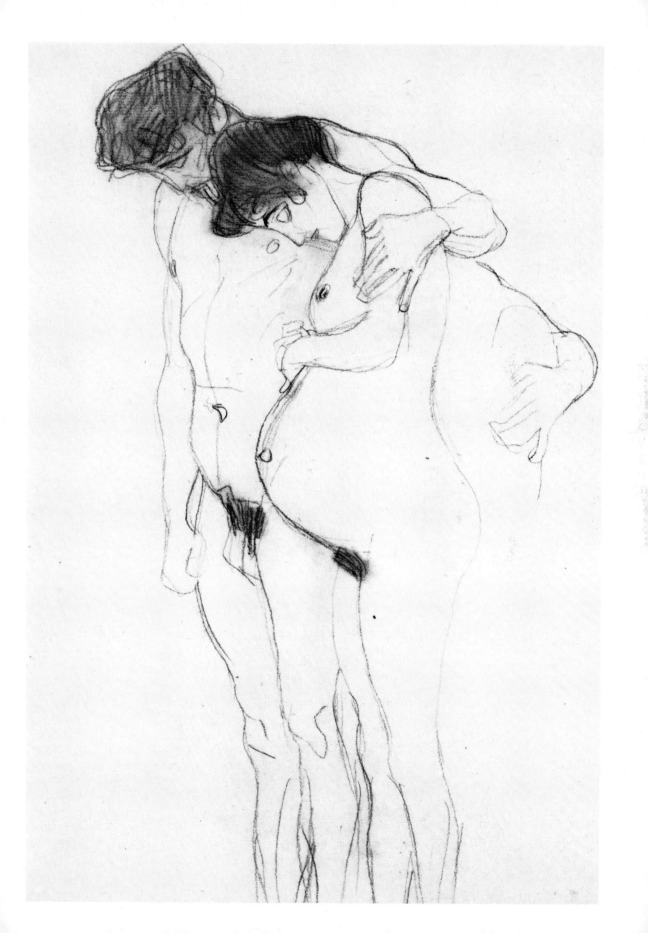

Henri Gaudier-Brzeska:
Study of a nude female figure
Charcoal, 50.8 cm × 38.1 cm
Victoria and Albert Museum, London

baked for a long period without being exposed to air it chars throughout without disintegrating. In the historic past this was achieved by sealing bundles of suitable twigs, such as willow, vine and plum, into an earthenware jar and subjecting it to prolonged and intense heat. Alternatively, the twigs could be sealed into a lump of clay and then baked in the same way. When broken out of their clay container, the charred twigs could be used as they were, or sharpened to a point with a blade or by abrasion. A good quality piece of charcoal will emit a faint tinkling sound when dropped on to a hard surface.

Although more scientific methods are now used to produce charcoal, the principle remains the same, and it is perhaps the only material available to the contemporary artist which is identical in character and handling to its equivalent as used by the masters of the fifteenth and sixteenth centuries.

In addition to the traditional form of charcoal, often referred to as stick charcoal, it is also possible to obtain compressed charcoal which is made by grinding stick charcoal to a dust and then re-constituting it by the use of a binding agent and compression. Compressed charcoal does not break so easily as stick charcoal, it has better adhesion and it produces less dust. Charcoal has also been produced in a form similar to that of the graphite pencil, by enclosing sticks of compressed charcoal in a wooden or paper sleeve. These so-called 'charcoal pencils' are obtainable in a variety of grades.

There are numerous minor variations in the preparation and use of charcoal, many of which will no doubt be discovered by the reader with a little intelligent experiment. One which can be detected in some old master drawings is so-called 'oiled charcoal'. In this process, charcoal is soaked in linseed oil. Charcoal which has absorbed a certain amount of oil tends to be less friable and brittle than normal, producing a more velvety mark and less dust than untreated charcoal. A serious disadvantage of oiled charcoal which is not evident at the time of using it is that in time the oil tends to spread around the mark, producing an unpleasant brown stain. (This stain, which spreads through to the back of the paper, is a sure way of telling that the drawing has been done with oiled charcoal.) As with all 'accidents' in art, it is always possible that someone should turn this problem to good advantage and exploit the spreading of the oil for a special artistic effect.

Charcoal has many advantages which make it attractive as a drawing medium. Only a little pressure is needed to

produce a strong, rich black mark. It can be used as a line medium, and the character of the line can be varied by using different thicknesses of charcoal, by changing the angle of the stick, and by varying the pressure of the hand. Unlike most other line media, it can be used to produce largish areas of tone without a great deal of scribbling or hatching. Unlike the pen, it never needs re-charging, it can move with great speed and fluency, and it is 'omnidirectional' in that the hand can move in any direction whatever whilst at the same time producing a mark of quality.

One of the most striking characteristics of charcoal is that it can be easily erased and altered by dusting or rubbing with a soft cloth and re-drawing. Considered as an advantage, this was one of the reasons why it achieved widespread use as a preparatory drawing medium on all kinds of surface, including canvas, plaster and wood. However, this lack of adhesion was also a serious disadvantage and meant that it could not be considered as a suitable medium for finished drawings. This problem was overcome by the development of effective **fixatives**.

But it was not only a technical development which transformed charcoal from a humble preparatory medium into a fully-fledged medium for the execution of finished

Tom Barrett: *Positive-negative revolution* Charcoal on paper, 53.3 cm × 63.5 cm
Courtesy of the artist

57

drawings. The rough textural qualities of charcoal were of no interest to the artists of the early Renaissance, who preferred the precise, delicate line produced by media like the quill and **metalpoint**. About 1500 there was a gradual change in taste, which led to more interest in atmospheric effect, texture and chiaroscuro, such as we find in the work of the Venetian masters. Charcoal was ideally suited to rendering these effects, especially when used on textured or toned paper.

Charcoal is most effective when used in a way which suits its nature, that is in broad, vigorous sweeps without fiddly detail. In order not to erase previous marks, it is necessary to hold the hand clear of the paper, which makes fine or precise drawing difficult. This can be partly overcome by resting the hand on a sheet of clean paper laid over the drawing, although this will tend to lift off the drawing under the paper. On a lengthy drawing it is feasible to fix one layer of drawing before proceeding with the next.

Charcoal handles best on a paper with a marked tooth or texture, and it can also be used with effect on toned or tinted papers.

CHIAROSCURO

The term 'chiaroscuro' (Italian: bright-dark) came into regular use at the end of the seventeenth century and was intended to denote striking contrasts of tone in pictorial works. It has, however, carried several different shades of meaning. Although the chiaroscuro of a drawing may be

John Constable: Study for The Leaping Horse Indian ink, wash and black chalk, 20.3 cm × 30.4 cm
British Museum, London

58

largely determined by the fall of light and shadow, it is not possible to distinguish this completely from tonal variations caused by the local tone and colour of objects, and also the reflective quality of surfaces such as stone, metal and water. When Constable used the expression 'chiaroscuro', he meant not merely the tonal variations which result from the fall of light and the casting of shadow, but the peculiar effects of scintillation and vibration which result from the fall of light across the components of landscape such as leaves, water and clouds.

The expression of chiaroscuro favours the use of a broad medium such as chalk, charcoal or brush, and is obviously most suited to subjects which contain strong contrasts of tone resulting, for example, from acute angles of lighting and boldly modelled forms.

See also **Tone** and **Shading**.

CHILDREN'S DRAWINGS

It has long been recognised that the drawings of children differ in significant respects from the drawings of adults. Until the last quarter of the nineteenth century it was widely assumed that the child should be encouraged to abandon its own way of drawing as soon as possible and adopt the more sophisticated imagery used by adults. The methods used up until this period to teach children to draw were all based on the principle that the child's own drawings were comparable with the babbling which precedes comprehensible speech— a kind of harmless nonsense which communicated little or nothing. This was to be eradicated and replaced by a more 'correct' or objectively accurate method of drawing, and the child was made to practice drawing straight lines and curves, to observe nature closely, and to attempt to draw in a way which communicated material facts about the character of the world about it.

From about 1880 an increasing number of educationists changed their approach to the teaching of drawing, claiming that the child should be encouraged to develop and enjoy its own way of drawing and should not be bothered by notions of objective accuracy or artistic taste. Its innate creativity should not be stifled and replaced by a premature attempt to imitate the drawings of adults, but should be permitted to evolve naturally until it felt the need to convert to a more objective and mature style of drawing. This gave rise to a new and at first revolutionary concept, that of 'child art'.

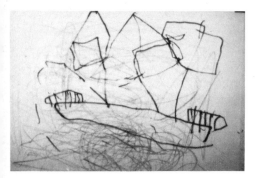

Trevor (aged 4)
Galleon in a Storm Felt tip pen,
21 cm × 28 cm

See colour plate
They're biting by
Paul Klee between
pages 96 and 97

This reform of educational thought was not absolute: many teachers continued to use the old methods of instruction, and still today there are teachers who appear to have been left untouched by the revolution of the last century. Nor was it an isolated phenomenon: the same period of the late 1880s witnessed a remarkable expansion of interest in many hitherto neglected areas of artistic expression, such as so-called 'primitive' art, prehistoric art, African tribal art, and the art of the Far East. The thing which child art appeared to have in common with many of these newly-discovered areas of interest was its vigorous spontaneity and its freedom from the sometimes inhibiting restrictions of the conventions of Western art, such as perspective, correct anatomy and orderly scale relations. Many distinguished artists of the twentieth century have, like Paul Klee, so admired the drawings of children that even after a thorough traditional training they deliberately attempted to revert to a more child-like or 'naive' style of drawing. In addition to those artists who tried to learn from the drawings of children, artists who for one reason or another completely escaped the usual system of art training have been highly prized for the naivety of their vision and imagery.

The child's first attempts to draw take the form of scribbling. It has been noted that small children often go on scribbling while engaged in conversation and looking away from the drawing, or even when the drawing tool is blunt or needs re-charging and is in fact making no mark. This suggests that the child is not completely preoccupied with the image being created, but is simply enjoying the kinetic performance—the vigorous exercise of fingers, hand, arm and body. Another interesting point in relation to these early drawings is that they are rarely made with the deliberate intention of representing something specific in the child's environment, and it seems likely that the child's first stimulus for drawing at all is not to represent but to imitate the behaviour of older children and adults as they write or draw.

The child's first drawings normally take the form of free and uncoordinated dashing strokes and crosses. In time it learns how to bring a stroke right round to form a more or less circular or oval enclosure, and this primitive enclosure provides the basis for many represented forms, including the sun, the human face, a tree, and so on. The child responds to encouragement from adults, and often asks for help in interpreting its own drawings by the provision of titles. Having hit upon a graphic form which 'works' in the sense of

being capable of interpretation as a representation of something, the child tends to repeat it and perfect it, producing what is known as a **schema** (plural: schemata). Schemata do not change significantly from one drawing to the next, but are a kind of formula image to denote a thing or an idea, rather like the simplified figures used to indicate the doors of public facilities or road signs. The drawings of a very young child can often be analysed in terms of the repetition of a limited number of schemata in various combinations.

As the child's graphic repertoire grows and it increases the number of schematic forms over which it has control, it becomes more interested in the nature of the image and its possible relation to reality. However, the child's view of reality is profoundly different from that of the adult, and its drawings reflect this difference. Whereas the adult, at least in modern Western culture, tends to be preoccupied with the appearance of material reality as it is perceived, the child is more concerned with what it knows or thinks about what it is drawing regardless of its visual appearance. For example, if something important is happening inside a house in one of its drawings, it will provide an X-ray view through a wall.

Karl Ludwig Francke: Plate IV from *Methodische Anleitung für den Unterricht im Zeichnen*, 1833
In the early 19th century children were drilled by copying geometric forms which were subsequently combined to make decorative and other subjects

61

When drawing the side view of a horseman, the child may well draw the 'hidden' leg on the other side of the horse, as it is more important to show clearly that the rider has two legs than to show that the horse's body is opaque. This characteristic of children's drawings has been dubbed 'transparency'.

Another feature of a child's drawings is that it tends to maintain a preferred schema for a subject even when the schema does not relate in perceptual terms to the other part of the drawing. For example, a plan view of a road with parallel sides may be combined with frontal views of

Mexican school-child: Figures in an avenue Coloured crayons, 19 cm × 28 cm In this drawing by a child in a Mexican primary school trees have been represented by a formula image or schema. The plan view of the roads has been combined with the laying-over of trees and figures *The Author*

Hobbema: *The avenue, Middelharnis.* 1689 Oil on canvas, 103.5 cm × 141 cm Hobbema's picture presents what is generally accepted by Western culture as a naturalistic account of the subject, employing as it does linear and atmospheric perspective combined with naturalistic colouring
The National Gallery, London

62

pedestrians walking along the road (who therefore appear to be lying down in the road), and side views of trees along the edge of the road. This common feature of children's drawings is known as 'laying-over'.

As a broad generalisation, it could be claimed that when it draws the child is as much or more concerned with what it knows about its subject as with what it sees. Although much of the Western tradition in art takes the form of various kinds of perceptual realism, child art is guided by the principles of logical realism.

In conclusion it might be worth observing that one of the problems of modern art education is that it has so far failed to find an effective way of helping the child to convert from its instinctive way of drawing to that of the adult. Many observers have noted that at about the age of puberty the majority of children become dissatisfied and impatient with their drawings because they feel they cannot use them to communicate their developing view of the world, with the result that many of them abandon drawing completely as a means of communication and self-expression. A possible solution to this problem is that the child should be encouraged to realise at a much earlier stage than is customary that in addition to expressing the spontaneous outpourings of the mind, drawing, like language and numbers, can be used to communicate objectively verifiable facts about the material world and our relation to it; that drawing can be used to record the truth and, indeed, to tell lies.

COLLAGE

The term 'collage' is derived from the French verb *coller*, meaning 'to stick', and it refers to pictorial works, including drawings, which are produced by cutting pieces of material from different sources and sticking them down together. The technique was first developed by the Cubists about 1912, and a feature of collage has been the use of readymade imagery and textural effects derived from sources such as newspapers, sheet music and printed wall papers.

Collage is capable of a certain amount of visual shock from the fact that the different sources often continue to declare their origin as well as serving as components in the artist's composition. This sets up a level of visual tension, and the art of collage is the art of permitting the maximum diversity of source material whilst at the same time producing a coherent artistic synthesis.

Dick Whall: *Idea-forming child, global embrasure,* 5.6.1970 Photographic materials and drawn imagery on graph paper, 38.5 cm × 53 cm
Courtesy of the artist
Photo Eric Webster

Kurt Schwitters: *Opened by customs.*
About 1937–9
Mixed media, 32.5 cm × 25.4 cm
Tate Gallery, London
Copyright ADAGP, Paris, 1982

64

The opportunity to use in collage materials which would otherwise be classified as rubbish, such as discarded bus tickets, old newspapers and sweet wrappers, gave it the character of a challenge to many of the established modes of fine art activity. This is particularly evident in the work of the Dada artists such as Kurt Schwitters, who coined the term 'Merz' to denote his works in collage.

COLOUR

Drawing is traditionally regarded as a tonal means of expression, not concerned with the use of colour except in an incidental sense. This is a rather unrealistic view, since most drawing media may be said to possess some colour, albeit of a subdued kind, and the colour characteristics of a medium can have important consequences for the resulting image. Some drawing media have been particularly favoured for their colour, which can be used to reinforce the nature of the image. For example, red chalk, often used in conjunction with black, imparts a sense of animation to drawings of the human figure, and represents the first step in the direction of fully coloured pastel paintings, in which the drawing medium is used to simulate the effects of fluid colour. Bistre, a brown pigment produced by boiling soot, enjoyed a considerable and prolonged popularity as a drawing medium for use with pen and wash.

The term 'colour' is also used to refer to the notion that it is possible to create a sense of hue in a drawing executed in black and white by means of the creation of subtle effects of texture. Some have claimed, for example, to see colour in the black-and-white work of Aubrey Beardsley. This use of the word may be accepted in a metaphorical sense to denote the idea of rich surface variety, but it is unlikely to have any objective basis in scientific fact and probably depends upon the subjective associations of the spectator for its effect.

For further material on colour, see **Chalk, Crayon, Gouache, Ink, Pastel, Pencil** and **Water colour**.

COMIC

The modern comic, in the sense of a humorous magazine of picture stories with verbal captions or speech bubbles, took its present shape during the last quarter of the nineteenth century. The comic has, however, important antecedents which provide a line of development going back to antiquity,

and many graphic devices which we associate with the comic can be found in ancient Egyptian inscriptions, in Aztec manuscripts, in the Bayeux tapestry and in seventeenth-century political cartoons. The convention of including speech in a pictorial image was common in medieval painting, which often depicted a scroll emerging from the character's mouth. This combination of word and image was incompatible with the renaissance desire for pictorial naturalism, but it has continued unabated in political and satirical cartoons right down to the present day.

The most prevalent characteristic of comic drawings is a sense of **caricature**, in which personal appearance is selectively generalised and the salient features exaggerated. This can be used to identify public figures or to create a fictitious personality whose exploits are traced in the successive images of the narrative.

The Funny Wonder, 5 February 1916

66

The physical character of comic drawings is a predominent dependence upon simple line combined with patch-like areas of tone. This style was partly forced upon comic artists by the means of reproduction. In the early days they were cut in wood (hence the expression 'comic cuts'), and later printed by poor quality photomechanical line block on to cheap paper. When, about the period of the Second World War, colour became a regular feature of comic papers, it consisted of the application of one, two or three rather crude colours to the black and white key block. These colours were often printed as a mechanical tint, an effect which in time took on a nostalgic attraction of its own. At the same time as diversifying its technical means, the tradition of the comic paper extended itself culturally, catering for adults as well as children, and treating content of a serious or even a philosophical nature.

The tradition of comic drawing is so extensive, complex and sophisticated that no attempt can be made here to provide a systematic review. All one can do is to indicate some of the most significant ways in which comic draughtsmen have created their unique graphic style. The first is the degree to which the artist departs from objective naturalism and introduces stylisation and exaggeration, tending, that is, towards caricature. A second point of distinction is the number and shape of the pictorial units or 'frames'. In some classic cartoons the page was divided into a regular grid of identical frames, each one containing a clear step in the development of the narrative. In more complex strips the size and format of frames varies and different methods of enclosure are used to indicate different kinds of event—for example a frame with a bubble edge being used to suggest a dream or memory sequence. Finally, comic strips vary widely in relation to the implied **station point** of the artist and the spectator. In the classic cartoon strip, the figures held a consistent and unvarying scale relation to the box frame. With increasing sophistication, the scale of the characters changed, sometimes dramatically, from one frame to the next. The effect was to suggest sudden changes in the position from which the narrative is viewed. In a continuous dialogue, a frame of two characters in conversation might be followed by one showing the face of one character in close-up. This might in turn be followed by a long shot of the house in which the dialogue is taking place, with a lighted window from which a speech bubble emerges. This style of drawing comic strips has without doubt grown out of the cinematic technique of animating narrative by constant changes of viewpoint.

COMMERCIAL ART

The expression 'commercial art' was at one time used to denote graphic imagery including drawings which was produced for the purposes of use in commercial contexts such as advertising, book illustration and package design. 'Commercial art' was distinguished from 'fine art', such as independent paintings or drawings which had no immediate commercial application. In the course of the last two decades the expression 'commercial art' has been generally abandoned and has been replaced by terms like 'graphic design', 'illustration' and 'advertising design'. None of these expressions has a stable or permanent meaning and can only be understood in terms of the context in which they are used. The expression 'commercial art' is now rarely used in professional or educational circles and is generally regarded as outmoded and imprecise.

COMPOSITION

The word 'composition' is derived from the Latin *compositio*, meaning the arrangement of parts to make a whole. Used in relation to drawing, composition can have two quite separate meanings. On the one hand, a 'composition drawing' is taken to mean a drawing produced as a proposal or draft for a more ambitious work, such as a large painting or sculptural group. Composition drawings are often intended to enable a patron to envisage the finished work, as well as to help the artist to resolve questions of structure and disposition. On the other hand, the term composition can be used to refer to all questions of disposition and arrangement within a drawing, whether or not it is to be used as a design for a subsequent work. It is dangerous to assume that any drawing, however simple, can be produced without taking account of compositional issues: even the slightest sketch might stand or fall according to its composition rather than the skill with which its individual parts are rendered.

It used to be the practice in academies and art schools to teach students strict rules of composition, which were learned by heart and practised assiduously. Picture surfaces were divided up according to prescribed mathematical proportions and figures were marshalled into preconceived forms such as the triangle. Nowadays it has been recognised that such formula compositions have no absolute validity, and that, used in the right way, almost any compositional

technique will succeed. Nevertheless, it is possible to draw some tentative conclusions from an analysis of master drawings, and to avoid some obvious pitfalls.

In drawing from observation, the first thing to remember is that the process of composing begins before the first mark is made. It begins when we take up a **station point**, decide on an angle of vision, and determine how the reality which confronts us is to be related to the surface on which we intend to work. This most fundamental point is often overlooked by amateurs, who seize their materials and begin working in haste without giving a thought to the future development of the drawing. A classic consequence of this situation is the figure whose legs have to be compressed into an insufficient area of paper.

What considerations should be borne in mind when setting up a composition? The first is that like a musical composition a drawing should possess some basic, simple overall structure into which its details, however numerous, fit. This structure may take the form of some broad subdivisions of the surface, one or two simple directions in space, or two or three contrasted forms. Exactly what approach is used depends upon the personality and intentions of the artist. For example, many of Seurat's mature drawings are built up around some simple subdivisions of the surface. The drawings of Daumier frequently feature two strongly modelled forms in a dynamic relationship.

The same differences of approach can be even more clearly seen in abstract works. The mature drawings of Mondrian consist entirely of subtle divisions of the surface by straight, intersecting lines. Kandinsky on the other hand tended to compose with discrete units of form which he disposed about the picture area.

An issue which must be borne in mind when determining a composition is that certain parts of the blank drawing surface have a greater psychological weighting than others. For example, we tend to think of the centre of a form as more important than its edges. Similarly, in a collection of forms some will strike us as more important than others. Presented with a line of blank pear shapes together with one which contains a caricature face, our eyes will repeatedly return to the face and ignore the blanks. Applying this observation to composition, it would be possible to draw the attention to low priority sectors of the picture surface by placing within them some eye-catching motif. Dull composition frequently results from placing the drawing's most important content in positions of obvious psychological importance, especially at

Edward Hopper: *Night on the El train* Etching, 18.5 cm × 20 cm Off-centre composition and the furtive postures of the figures is used to generate a sense of psychological tension
British Museum, London

or near the centre. The composition tends to stagnate, and we are left with the boring and inept composition one finds in so many holiday snapshots, where symmetrically placed figures stand rigidly to attention in the centre.

Small displacements of form may be introduced in order to counteract this tendency for centrally or symmetrically placed content to lose all sense of life. Ingres' portrait drawings, which are often centrally placed, show how careful posing of the model and discriminating disposition of the head and limbs can off-set the tendency of a centralised image to stagnate.

An even more exciting solution to the problems of

composition is to be found in the drawings of Degas. Following the lead provided by the composition of Japanese prints and by early snapshots, Degas abandoned conventional methods of composition and tried to capture the dynamic equilibrium of events as they are actually seen. We do not see life in a 'composed' way: forms are constantly in a state of flux, moving in and out of our field of vision, and often taking on the most surprising aspect. Degas used composition to obtain the same sense of visual shock which we derive from real life, often placing his most important forms at or near the edge of the paper or high up in one corner. The result is a delicious sense of tension, in which a large space appears to draw the main motif towards it, while the motif resists.

There are always many exceptions to prove the rule. The drawings of Malevich were explicit attempts to disprove most of what I have described above, consisting as they often do of bald geometric forms plonked unceremoniously in the middle of the paper. Paul Klee's drawings seem to break every rule in the book, but still remain masterpieces of design. Perhaps the only sound rule of composition is that it deserves as much attention as any other aspect of drawing technique.

See colour plate *Woman at her toilet* by Degas between pages 96 and 97

Robert Mason: Illustration for *The Sunday Times* on the theme of the changing roles in the family Water colour and coloured pencils, 15.5 cm × 27.5 cm The displacement of the subject matter to the edges of the composition invites the spectator to supplement the image from his own imagination *Courtesy of the artist*

COMPUTER GRAPHICS

The first attempts to utilise the computer as a source of graphic imagery date from the late 1950s. The Boeing aircraft company wished to calculate the pilot's posture in relation to the flight deck of an aircraft during take-off and landing. To do this by hand would have required innumerable calculations and drawings; and no matter how numerous the drawings were, they could never include phases of the operation which fell between one drawing and the next. The solution to this problem was to design a graphic 'pilot' and to feed into a computer all the statistics regarding the form and layout of the flight deck. Eventually the computer could be instructed to produce a drawing showing the posture of the pilot at any point in the take-off and landing procedures.

The same principle is now being widely applied to every field of construction, manufacture and operation. An architect can provide a computer with all the dimensions of a room or a building, and can then instruct the computer to provide a drawing of the proposed structure viewed from any position, inside or outside. The technique has been extensively applied in the field of transport design, where variables such as size, performance and posture are so crucial and complex.

Early computer graphics were produced by a rather primitive arrangement in which the computer drove a plotter working on a rotating drum, rather similar in principle to the devices which record changes in barometric pressure. Later this was replaced by a cathode ray tube linked to a visual display unit (VDU) capable of rapid response to the operator's instructions. This has since been combined with the use of the light pen, which permits the operator to revise the image rapidly and with ease.

J. A. Vince: Isometric view of a surface generated by an equation employed in control system design. 1981 Plotted on a CALCOMP digital plotter using the PICASO graphic system, 25.5 cm × 13 cm *Courtesy of the artist*

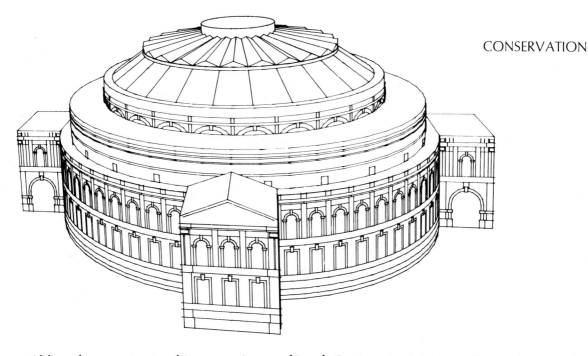

Although computer graphics were pioneered in relation to design and technology, the potential for imagery of unique subtlety and power has been recognised by artists in other fields, and a growing number of graphic artists, painters and sculptors have employed the computer in various ways as an accessory to the creative process.

Paul Ashdown: Perspective view of the Royal Albert Hall used in an animated sequence for television. 1981 Plotted on a cell via a CALCOMP digital plotter using the PICASO graphic system, 12 cm × 18 cm *Courtesy of the artist*

CONSERVATION

The care and conservation of drawings has in recent years become a scientific specialism in its own right. There are however a few simple rules which should be observed by anyone concerned with the preservation or exhibition of drawings. For questions beyond the scope of these simple rules, expert advice should be taken from qualified gallery staff.

Almost all drawing media tend to fade with excessive exposure to light. This is particularly true of inks and water colours. Consequently, drawings should never be hung in bright light or in direct sunlight, but in relatively subdued light, away from windows and sources of intense artificial light. The human eye adapts rapidly to quite low levels of illumination, permitting easy and complete examination and enjoyment of the work. When not on exhibition, drawings should be kept in relative darkness. In the past, portfolios for unframed drawings and racks for framed drawings have been used, but more recently solander boxes have become the preferred alternative.

Drawings deteriorate if exposed to extremes of temperature or humidity. Consequently they should not be exhibited or stored near radiators or in excessively damp or dry rooms. The conditions generally recommended are a temperature of 65°F (18°C) and a relative humidity of 45–60 per cent.

Any kind of direct pressure or abrasion on the surface of the drawing should be avoided. Drawings should not, for example, be stacked unmounted or carried in a portfolio without proper window mounts or at least some kind of interleaving with soft paper. Some media, even when fixed, are easily damaged by abrasion and should be placed in a suitable window mount at the earliest opportunity. A window mount consists of a backing board, to which the drawing is attached, hinged to another piece of card of the same size containing an aperture through which the drawing can be viewed. The minimum of means should be used to keep the drawing in position in the window mount, preferably light paper hinges attached by paste which is soluble in water. Do not stick the drawing down all over, and never use adhesive tape. A light mounting similar in form to stamp hinges will permit the drawing to 'breathe', expanding and contracting marginally in response to slight variations in conditions. Some curatorial staff prefer a single hinge attached to the top edge of the drawing.

One should avoid the use of mounting card made from wood pulp, since it has an acidic content which can in time migrate into the paper of the drawing causing staining and decay. Few picture framers are aware of this problem, although its results are all too evident in many drawings which have been kept in conventional mounts for a number of years. It may be that this issue will be regarded as too remote to interest most working artists or amateurs, but for those who are concerned with the long-term conservation of drawings it is possible to obtain a conservation board which has been specially manufactured for use in mounts.

Glass should never come into direct contact with the surface of a drawing, but should be held clear by the thickness of the window mount. Even when it is not in direct contact, it is possible for glass to generate an electrostatic charge which can lift particles of a powdery medium such as charcoal or pastel. Consequently drawings done in a powdery medium should be provided with a relatively thick window so that they are held well clear of the glass.

In recent years there has been widespread use of mounts consisting of a sandwich of glass, card and wood held together by Swiss clips or L-shaped brackets. These are

inferior to conventional frames since they are open at the edges and permit the penetration of particles of dust.

Drawings which have been damaged by incorrect conservation may show signs of deterioration such as cockling, fading or the stains known as 'foxing'. Some of these problems can be reversed by expert treatment, but this should only be undertaken on the advice of qualified gallery or museum staff.

CONTÉ CRAYON

Up until the late eighteenth century England was the principal supplier of high quality graphite for the manufacture of pencils in Europe. With the outbreak of hostilities between England and France in 1793 this supply was interrupted, and the French government offered encouragement for the invention of an effective substitute. In 1795 Nicolas-Jacques Conté patented a process for making pencils from inferior graphite, which was still available on the Continent, by grinding it down to a powder and mixing it with additives which included fine clay.

This mixture was compressed into cylindrical rods and then enclosed in a wooden sleeve in order to make it portable and to reduce the risk of breakage. Conté's invention represented an advance on earlier methods of making pencils, since it permitted a high degree of control over the hardness, quality and colour of the medium. Modern Conté crayon has a waxy feel in comparison with conventional graphite pencils. It draws easily and produces a rich, even and dark line.

CONTOUR

Most laymen associate the word 'contour' with the drawing of maps. Used in relation to the drawing of artists, the contour of a form is the point at which, when viewed from a stated position, it appears to terminate. One must say 'appears', since most contours are produced when the visible planes of an object turn away from the spectator's eye but continue beyond his vision on the hidden side of the form. When we draw a line to represent the contour of a solid body we are indicating the transition from what is visible to what is invisible, or what is popularly referred to as its outline. William Blake spoke very appropriately of 'the bounding line', which conveys the quality of the contour in the sense of

75

William Blake: The soul hovering over the body reluctantly parting with life. Sketch for Plate VI in Robert Blair's *The Grave.* 1804–6
Pencil, 27.2 cm × 45.5 cm
Tate Gallery, London

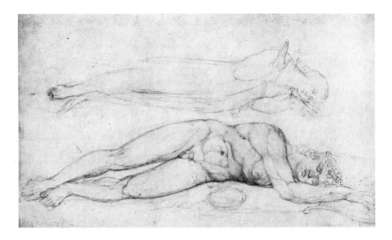

providing a boundary to forms as well as suggesting the dance-like animation of his own drawings.

Fine draughtsmen can adjust the quality and intensity of the contour to suggest the angle at which the boundary plane is turning away from the eye of the spectator; lesser draughtsmen are often left with something which resembles a piece of bent wire. This is the most common meaning of the term, but it can also be used to denote the boundary of any surface division in nature or in art, including tonal subdivisions of a flat surface.

The way a draughtsman draws a contour constitutes one of the most noticeable elements of his style. The contours of some draughtsmen, such as Rubens and Legros, tend to be highly inflected in direction and weight, producing a strongly calligraphic effect. Others, like Cézanne, break the direction of a contour down into a number of subsidiary directions which are more or less straight.

See also **Line.**

CONTRE JOUR

The term *contre jour* (French: against the light) denotes a drawing or painting in which the principal light source is behind the subject. The result is normally that the subject takes on a silhouette quality with little internal detail, and often casts a shadow towards the station point of the spectator. *Contre jour* effects are relatively rare in drawing until the nineteenth century, when the heightened interest in optical truth led to a preoccupation with unusual effects of light and shade. In German it is known as *gegenlicht* (against-light).

OPPOSITE **Adolph Menzel:** *The artist's brother-in-law at the piano*
Black chalk, 36.5 cm × 29 cm
Oskar Reinhart Foundation, Winterthür See *Contre jour*

76

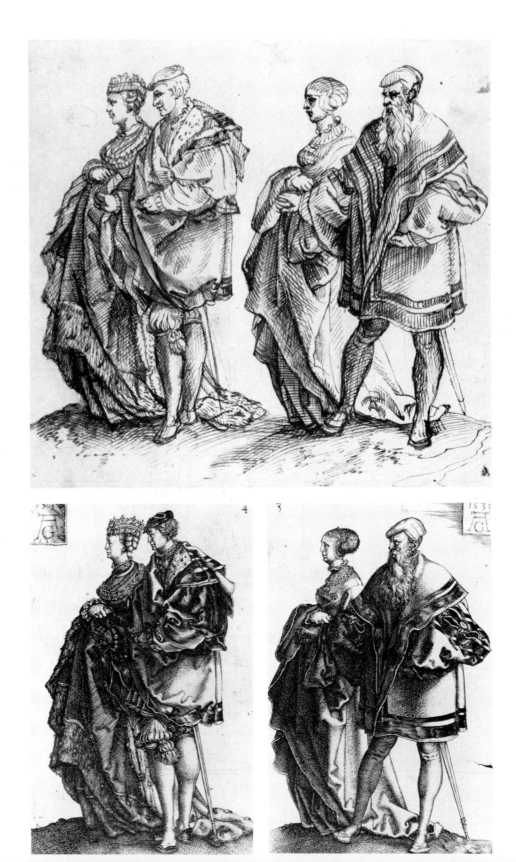

COPYING

One of the peculiarities of the modern practice and teaching of drawing is the degree to which copying has declined in esteem. Throughout most of historical time copying was regarded as a necessary or central part of learning to practice any artistic skill, and generations of students were presented either with drawings by their master or with engravings of the work of other artists and required to produce a reasonable imitation.

Nowadays copying is widely regarded as worse than useless, calculated not only to produce no benefit for the student, but actually to retard his progress through the exercise of the faculty of servile imitation. This is a pity, as there is no doubt in my own mind that intelligent copying has much to offer in relation to the understanding and command of drawing. The intention of producing a copy of a drawing should not be to deceive the eye with a facsimile which could pass as a forgery, but to use the process of copying as the opportunity for undertaking a thorough analysis of the structure, technique and style of the original. For this reason, the best copies are rarely to be confused with their originals, but represent a kind of interpretation and stand in much the same relation to the original as the original does to the motif from which it was taken.

CRAYON

The word 'crayon' has led to a large number of ambiguities and confusions, especially since it has been used in French to denote both chalk and pencil. In English, it is usually taken to mean a drawing medium with a high proportion of oily, waxy or fatty binder. The fatty quality of crayon is very evident when in use. It moves easily—one might almost say slithers—across the surface of the drawing with a feel which is quite unlike that of drier media such as chalk or pencil, which have a more granular, abrasive touch.

Oils or fatty substances have been employed in the manufacture of drawing media for several centuries. At first this tended to take the form of impregnating chalks by soaking them in an oily medium. In the true form of crayon, oil, wax or fat and pigment is mixed into the paste for the medium during the process of manufacture; the paste is then dried out to form cylindrical rods of drawing medium. Wax crayons are more viscous and far less brittle than graphite

OPPOSITE ABOVE **Peter Paul Rubens:**
Two pairs of wedding dancers,
after Heinrich Aldegrever
Pen and ink, touched with wash,
18.5 cm × 20.5 cm
Kupferstichkabinett, Berlin-Dahlem

OPPOSITE BELOW **Heinrich Aldegrever:**
Two pairs of wedding dancers. 1538
Engraving
Kupferstichkabinett, Berlin-Dahlem

pencils or chalks, consequently they do not need to be enclosed in wood for protection.

Crayons did not come into regular use until the last years of the 18th century, possibly stimulated by the problems of the supply of high quality graphite brought about by the wars following the French Revolution. The development of the wax crayon was accelerated by the invention of lithography in 1796, since the lithographic draughtsman needs a greasy drawing medium which will resist water when used upon the lithographic stone. Wax crayon was widely used by artists during the nineteenth century, especially by those who, like Toulouse Lautrec, favoured a fluid, linear style of drawing, often on a large scale.

The crayon leaves a thick, waxy deposit and is not well adapted to large areas or continuous gradations of tone or colour. Areas of a drawing which are drawn too heavily in crayon will acquire a greasy, congested appearance. One of the most interesting possibilities of crayon drawing is that its resistance to water and to water solutions of pigment creates the potential for 'grease-resist' techniques. A wash laid over a crayon drawing will be rejected by the drawn areas but absorbed by the untouched parts of the paper, creating visually exciting effects. By allowing successive layers of wash to dry before re-drawing it is possible to obtain glaze-like textures combined with stippling created by the formation of small blobs of colour.

OPPOSITE **Egon Schiele:** *Two sisters.*
1918 Black crayon,
46 cm × 29.5 cm
Fischer Fine Art Ltd, London

See colour plate
Seven ideas for sculpture
by Henry Moore between
pages 97 and 97

DOODLING

Doodling consists of more or less automatic drawing activity undertaken while the mind of the draughtsman is pre-occupied with some other matter. Typical occasions for doodling are during a long telephone conversation, or during public or committee meetings. The principal characteristic of doodling is that the hand moves about the paper quite spontaneously, creating forms, images and decorative designs which vary considerably in character from one person to another.

Since the advent of Freudian psychoanalytic theory (c 1900–) a great deal of interest has been shown in

81

doodles, since like slips of the tongue, jokes and personal mannerisms, they may be interpreted as symptoms of the operation of unconscious forces in the personality. The technique of **automatism**, practised by the Surrealists, was an attempt to develop the spontaneity of doodling into a fully-fledged mode of artistic activity.

DRAPERY

Drapery has held a place of special interest in the history of drawing. During the mediaeval and early Renaissance periods it was widely regarded as no more than a minor accessory to the depiction of human subjects and situations, of no particular significance in itself. With the increase of curiosity about all visual phenomena at the time of the High Renaissance, there was a corresponding arousal of interest

Anon: *St Mark.* About 800 Manuscript illumination, 27 cm × 19 cm *Trier Municipal Library*

RIGHT **Andrea Mantegna:** *Man lying on a stone slab* Pen and brown ink over traces of black chalk, 16.3 cm × 14 cm *British Museum, London*

FAR RIGHT **Raphael:** *The Phrygian Sybil.* Study for fresco in Sta Maria della Pace Red chalk over preliminary drawing with stylus, 26.2 cm × 16.7 cm *British Museum*

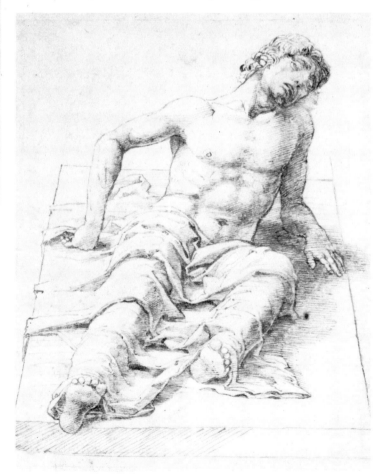

82

Jean-Antoine Watteau: *A woman in a striped dress seated on the ground* Red and black chalk, 14.6 cm × 15.9 cm *British Museum, London*

Eugène Delacroix: Studies of a seated arab Black and red chalk heightened with white, and water colour wash, 31 cm × 27.5 cm *British Museum, London*

84

in the peculiar nature of drapery, especially its capacity to behave in a manner which was highly reminiscent of, on the one hand, the flow patterns of water, and, on the other, the appearance of geological formations. The drawings of drapery by Leonardo and his contemporaries are far more intricate than would have been justified simply by their use as studies for subject pictures.

It is possible to distinguish two distinctly different approaches to the drawing of drapery. In the first, all emphasis is placed upon the forms produced by the fall of cloth, irrespective of the peculiar textural qualities of the cloth in question. Hence, many draughtsmen of the Renaissance strove to produce the impression of a rather anonymous drapery without strong textural implications. This approach to the drawing of drapery was maintained by artists of the Neoclassical movement, who generally despised textural and other sensory effects. According to its greatest spokesman, Reynolds, 'It is the inferior stile that marks the variety of stuffs.' For the painter of quality, 'the cloathing is neither woollen, nor linen, nor silk, sattin, or velvet: it is drapery; it is nothing more.'

In contrast with this starkly formal approach to the depiction of drapery, there is an alternative tradition in which great pains are taken to capture the precise qualities of particular materials. This tendency came to the fore in the art of Flanders in the seventeenth century, and was continued and brought to a peak by its greatest exponent, the French eighteenth-century artist Watteau.

The particular textural qualities of cloth are conveyed by a number of factors, notably the fold patterns which develop as it lies or is stretched across various underlying forms, or hangs loose. Heavy linen folds with some reluctance, and produces a series of angular changes of direction rather than smooth curves. At the other end of the spectrum, silk and velvet respond to every detail of the underlying structure, breaking into myriads of tiny folds as it is bunched into an angle in the underlying form, such as under an armpit or inside the bend of an elbow, and producing a fine sheen when it is pulled tight over a projecting plane such as a chest or thigh.

Draughtsmen often employ the printed or woven pattern in a piece of drapery as a way of describing the underlying form. A case in point here are drawings which represent a figure clothed in a material with a narrow stripe. The stripes of the garment flow over and around the form and bunch at the contour to convey a vivid impression of the enclosed figure.

Charles Keene: *Portrait of Madame Zambaco drawing*
Etching, 16.5 cm × 10.5 cm
Private collection

DRAWING BOARD

A drawing board is one of the most important pieces of the draughtsman's equipment. Drawing boards are available in a wide variety of sizes, ranging from double elephant ($26\frac{1}{4}$in. × 40in.) down to quarter imperial (15in. × 11in.). In selecting a drawing board, a number of factors should be taken into account. The board should be large enough to accommodate the size of paper normally used, with an additional margin large enough to permit the draughtsman to rest his hand while working on the lower edge of the drawing. If the board is to be used out of doors for landscape, the size—and consequently the weight—should be borne carefully in mind. When working out of doors many draughtsmen prefer to attach a strap to the two top corners of the board and pass it around the neck, enabling one to work while standing.

Drawing boards should be made of a fairly soft wood with an even grain—soft enough to accept drawing pins, but hard enough to resist scoring as a result of the pressure of drawing media. Although a good quality drawing board will be constructed to resist warping, it should be kept away from intense heat, dryness and humidity, which will tend to damage even the best quality of board.

EASEL

There are three varieties of drawing easel in common use. The first is the full-size studio easel, which permits the drawing board to be set at a wide variety of heights and angles. Secondly, there is the sketching easel, which is designed to fold into a small, compact and light portable unit suitable for working out of doors. The sketching easel normally has a more limited range of height and angle settings than the studio easel, and because of its light construction tends to be less stable. The third form of easel is the so-called donkey, which one still finds frequently in studios and art schools. This consists of a low, bench-like structure with a mounting for a drawing board at one end. The draughtsman sits at the end facing the drawing board,

86

Willibald Krain: *Zille at work*
Lithograph, 43 cm × 55 cm
Berlin Museum, West Berlin

either astride or 'side-saddle'. All three forms of easel have their strengths and weaknesses. It should be remarked that the donkey tends to restrict the position of the draughtsman and the angle of his hand to the drawing board, favouring an underhand or 'candle grip' on the drawing medium rather than a writing **grip**. Moreover, since the drawing board on the donkey cannot be raised to eye level the draughtman must normally swing his eye in a wide arc between the act of observing and drawing, whereas it is possible to adjust a studio easel so that this arc is reduced to a minimum.

ENGINEERING DRAWING

See **Architectural** and **Engineering drawing**.

ERASURE

Draughtsmen have practised forms of erasure since the earliest times. Metalpoint drawings often show evidence of erasure with a knife, which was also used to erase lines in ink drawings. It should be remembered that because of the relatively high cost of drawing supports such as paper and parchment in the historical past it was often necessary to reclaim used drawing surfaces by means of erasure. Preliminary drawing done in charcoal was often removed with a feather once the main lines of the composition had

been firmed up in ink. Mediaeval manuals recommend the use of an ink eraser made from a paste of alum powder, orange juice and sugar syrup. Crumbs of stale white bread have long been employed as an eraser and are still to be recommended today for use with certain media.

The history of the modern eraser begins in the last quarter of the 18th century, when the gum known as caoutchouc was imported and used as the raw material for what became known as 'gum rubbers' or simply 'rubbers'. Caoutchouc rubbers were at first extremely expensive, and also impure, and tended to damage the surface of the paper. In the course of the years rubbers have been very much improved in quality and have been complemented by a variety of synthetic materials designed to cater for every kind of medium and support.

Erasure has two completely different roles in the drawing process. First, it can be regarded as a way of correcting errors by removing sections of the drawing—or indeed the whole drawing—thereby reclaiming the support for a further attempt. Secondly, there is the practice of what is known as 'creative erasure', in which the process of erasure is consciously and deliberately used to develop the drawing by, for example, picking out highlights or by shaping the edges of areas of tone.

Many drawing teachers of the old school used to forbid the use of the eraser in their classes, on the principle that drawing should be an additive, organic process without reversals or changes of direction. There is some truth in this view in that it is often better to permit the first attempts at an image to stand and merge into subsequent over-drawing rather than attempt to eliminate preliminary thoughts at each stage of the drawing. The creative potential of the eraser as a drawing tool should, however, be recognised. The process of re-drawing a white area of paper enclosed between darks by means of erasure makes one think consciously of 'the spaces between' and can lead to improved structure in the drawing. Moreover, it is often desirable to soften under-drawing with the eraser without removing it completely, permitting one to work over it in stronger line.

The eraser should always be suited to the medium in use. A powdery medium like charcoal needs little pressure or grip in the eraser, and can be removed with a feather, bread crumbs or a putty rubber. More tenacious media like pencil require a tougher rubber which will grip and lift the marks. However, care should be taken when using the more powerful forms of eraser that the support is not damaged or thinned by abrasion.

OPPOSITE **Phil Amy:** *Figure in the garden* Pencil, 50.8 cm × 40.6 cm Erasure has been used extensively here as a method of developing the drawing
Courtesy of the artist

89

EXHIBITION

The practice of exhibiting drawings has been a subject of heated and long-standing argument, and one hesitates to prescribe any 'correct' method. Assuming that all points in relation to the safe conservation of the drawing have been attended to, such as protection from excessive light, heat and humidity, the intention in framing and exhibiting a drawing should be to enable it to assert its identity as an image and permit the spectator to contemplate and enjoy it without unnecessary distractions. Because many drawings are small in scale it is often necessary to isolate them by means of a window mount, and the width of the mount should be calculated so as to permit the drawing to 'survive' visually without dwarfing it by the size of the mount. There is no completely reliable formula for either the size or the proportions of mounts, but generally speaking it is advisable to make the lower margin of the mount slightly wider than the upper margin, and the two sides about the same width as the upper margin. This is because as form within a form the drawing set in a mount will have a tendency optically to sink, and needs to be adjusted upwards to compensate for this.

In regard to the choice of colour for mounts, something which lies in tone between the lightest and the darkest tones of the drawing is often most appropriate, such as cream, grey or buff. Drawings which are unusually large, dark or vigorous can benefit from a mount which is strong in tone or colour, and even black might be suitable in certain cases.

Frames for drawings should be relatively light and slender in construction, with a simple cross-section. Wooden frames can be left unpainted or given a faded gold finish which will signal the presence of the drawing from a distance without distracting the eye when attending to it close up. Many drawings look good in simple metal frames with a silver finish.

EXPRESSION/EXPRESSIONISM

Few artistic concepts are more problematic than that of expression. Renaissance artists and theorists tended to think of expression in terms of the moods and emotions represented in drawings and other art works, as, for example, conveyed in facial expression, gesture and the dramatic 'plot' of the scene being depicted. Hence tragic human situations combined with tragic facial expression and gesture were

intended to convey the notion of tragedy. The academic tradition of art training absorbed this approach to expression and many treatises were published to assist the student to attain mastery of the depiction of expression, the most famous being Charles Lebrun's work of 1698. This form of expression may be described as 'mimetic' expression, because it sets out to mime or imitate the physical consequences of emotion as we see them in human reactions to situations.

During the late eighteenth century and the nineteenth century, which corresponds approximately to what we know as the period of the Romantic Movement, a new concept of expression gained popularity. It was that the artist not only depicted manifestly expressive subject matter—scenes of joy, tragedy, melancholy, etc—but could at the same time express his personal psychological mood or condition. This evolved into the concept of 'self-expression', and very soon led to the view that it was possible to select a subject which had no obvious expressive meaning and to project into it emotions which originated in the artist's mind and personality. Landscape was the ideal subject area for such an approach to expression, since it excluded all the accepted sources of mimetic expression like facial expression, gesture and human incident.

It is not a very big step from this idea to the view that the expressive quality of an art work is more or less independent of the psychological implications of the subject matter, and that the artist need only choose expressive lines, forms, tones and colours in order to express the idea which he has in mind. Matisse summed this view up by saying: 'Expression to my way of thinking does not consist of the passion mirrored upon a human face or betrayed by a violent gesture. The whole arrangement of my picture is expressive. The place occupied by figures or objects, the empty spaces around them, the proportion, everything plays a part.' And the logic of Matisse's position applies equally well to figurative and abstract works of art.

The notion that what the artist is expressing in the art work is not some external idea or mood but his personal psychological or spiritual condition led to the use of the term Expressionism. Expressionist art is not so much concerned with the literal nature of the thing being depicted, but uses subject matter as an opportunity for the artist to communicate his personal mood or condition to the spectator via the art work. The development of the Expressionist approach to artistic creation can be traced through predominantly figurative artists like Matisse to predominantly abstract

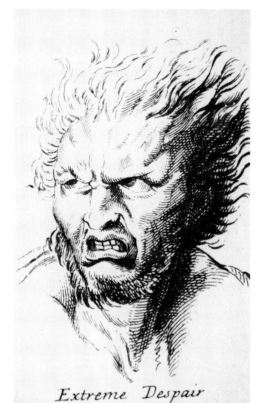

Charles Lebrun: 'Extreme Despair', illustration derived from Lebrun's treatise *Methode pour apprendre à dessiner les passions*, 1698

91

EXPRESSION/EXPRESSIONISM

RIGHT **Alan Davie:** *Head.* About 1955 Pen and ink and coloured chalks, 24.5 cm × 19 cm *Tate Gallery, London*

ABOVE **Henri Matisse:** *Visage de Ballerine Russe* Pen and ink, 46 cm × 31.4 cm *Waddington Galleries, London* Copyright SPADEM, Paris, 1981

Wassily Kandinsky: *Drypoint II.* 1913–14 Drypoint, 23.8 cm × 18 cm *Städtische Galerie, Munich* Copyright ADAGP, Paris, 1982

92

artists like Kandinsky, and reaches its ultimate point in the work of the so-called Abstract Expressionists, for whom the art work becomes the vehicle for the immediate and spontaneous outpourings of personal mood.

The principles of expression and Expressionism have a special relevance for the art of drawing since, perhaps more than any other artistic medium, it responds with immediacy to changes in the artist's personal mood and vision.

FASHION DRAWING

Although photography has taken over so many areas previously catered for by drawing it has so far made only limited progress in the field of fashion illustration. There is of course a developed and highly sophisticated tradition of fashion photography; but it is surprising just how extensive a role continues to be played by drawing. There is a simple explanation for this state of affairs, and it is that the world of fashion is concerned not so much with reality as it is or might be, but with the creation of images and a sense of style. In a nutshell, drawing provides a potential for idealisation which photography still finds it difficult to approach.

The successful fashion artist draws in a highly selective way. A feature of this style of drawing is the underplaying of facial detail, which is often omitted altogether, and frequent breaks in contour which provide a sense of lightness and movement. Normally only the salient features of a garment are recorded, pattern and texture being implied rather than depicted in a literal manner. This is after all how we perceive good stylish clothing; not as a mere assemblage of artefacts, but as an integrated ensemble animated by the wearer.

Fashion drawing requires acute powers of selection and a high degree of panache in the execution; any evidence of hesitation or uncertainty is incompatible with the fashion artist's profession, for the simple reason that hesitation and uncertainty are inimical to style itself. It is not a style of drawing which mixes easily with qualities such as painstaking observation or personal eccentricity. For this reason, fluency in fashion drawing might militate against other approaches to drawing by the same artist.

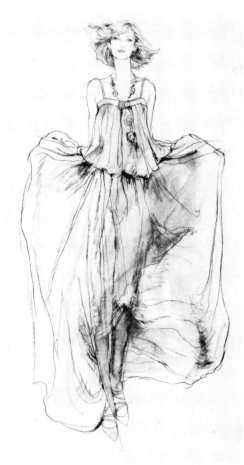

Jenny Powell: *Girl in a green dress.* 1980 Conté and gouache, 50.8 cm × 25.4 cm *Jenny Powell/Spectron Artists*

93

FIXATIVE

Many drawing media have a powdery consistency and a relatively poor purchase on the support, which means that they are easily damaged by vibration or abrasion which displaces particles, causing smudging or, in acute cases, removing sections of the drawing altogether. Charcoal and pastel are exceptionally vulnerable in this respect. The first records of attempts to fix drawings date from the seventeenth century, but there can be no doubt that draughtsmen were experimenting with methods of fixing drawings some time before that date. The essential requirement of a fixative is that it enables the medium to adhere to the surface of the support without substantially altering its appearance by creating changes in colour, tone or surface texture. Early recipes for fixative included gum arabic, gum tragacanth, skim milk, fig juice, fish glue, rice water, shellac and alcohol. Some of these early ingredients have caused subsequent problems; for example, fixatives which included skim milk have tended to grow fungi, a fact which has ruined many nineteenth century drawings. This point should always be borne in mind by the experimenter with fixatives: the long-term results are not always visible as soon as the fixative is dry.

It is still possible, and sometimes desirable, to mix one's own fixatives, but this is largely unnecessary since several good and safe branded varieties are on the market. These are applied either by means of an angled diffuser spray which is operated by air pressure from the mouth, or, as is increasingly the case, from an aerosol can. In the case of charcoal and pencil drawings, the drawing to be fixed should be mounted on a vertical or near-vertical board and the fixative should be sprayed from about 18 inches (45cm) in broad, slow sweeps of the paper. The distance and pressure should be calculated to give a fine spray or haze of fixative without large droplets or dribbles.

Pastel presents a special problem in relation to the use of fixative, since its use tends to change the tonal and colour values of the drawing. For this reason some pastel artists prefer not to fix their drawings, but simply to shake loose particles free by tapping the back of the board and then take scrupulous care that the surface of the drawing does not come into contact with any other surface which might cause abrasion and smudging. If a pastel drawing is to be fixed, a rapidly evaporating fixative is to be recommended, such as a solution of 2 per cent damar varnish dissolved in benzine.

If a pastel drawing has been heavily worked and consists of

several layers of medium, it is advisable to give each successive layer a light spray of fixative as and when it is completed—a practice used by Degas. The fixing of pastels can be improved by spraying the reverse side of the sheet so that the fixative penetrates the paper and helps the underside of the medium to adhere to its surface.

FOLIAGE

The depiction of foliage has played an important role in the history of drawing, especially in relation to landscape and topographical subjects, but also as an accessory to narrative and portrait drawings. The draughtsman's subjects may be classified into two broad categories, namely those in which it is possible to achieve some kind of literal correspondence between the subject and the image (for example, representing the exact number of eyes, fingers or windows visible in the subject); and those in which any attempt at literal correspondence has to be abandoned because of the number and complexity of the constituents of the subject. In this latter category we include hair and foliage. Although a few valiant souls have set themselves the task of drawing every hair on a human head or every leaf on a tree, the virtual

Samuel Palmer: *The harvest moon.* Drawing for 'A Pastoral Scene'. About 1831–2 Pen and ink heightened with white, 15 cm × 18.5 cm Palmer developed his own, highly idiosyncratic mode of depicting foliage *Tate Gallery, London*

John Singer Sargent: *Palmettos, Florida* Water colour on paper, 34.3 cm × 52.2 cm *Collection Metropolitan Museum of Art, New York*

impossibility of such an undertaking usually forces the draughtsman to aim for some kind of textural effect which does not pretend to have any kind of one-to-one correspondence to the subject comparable with the drawing of two eyes, five fingers or ten windows.

One of the most distinctive features of a draughtsman's style is the personal shorthand he devises in order to suggest the diffuse textural effects of foliage, and one test of a fine drawing is the degree to which successful schemata for the depiction of foliage are not permitted to degenerate into routine repetition of graphic formulae. Drawing manuals have often included a section on effects which could be used for the representation of the foliage of different varieties of tree, to be learned by heart by the student. However, it is unlikely that such a practice, unsupported by direct observation and experiment, would ever lead to the creation of anything other than mediocre, uninteresting drawings.

FORESHORTENING

The draughtsmen of antiquity and mediaevel times were inclined to depict their subject matter in terms of characteristic and familiar viewpoints. The human figure for example was normally represented either full-face or in profile, and in some cases, as in ancient Egyptian art, characteristic views such as a profile head and a frontal torso were often combined, even though such a combination produced its own sense of strain. With the growing influence of naturalism in Western art draughtsmen recognised that in

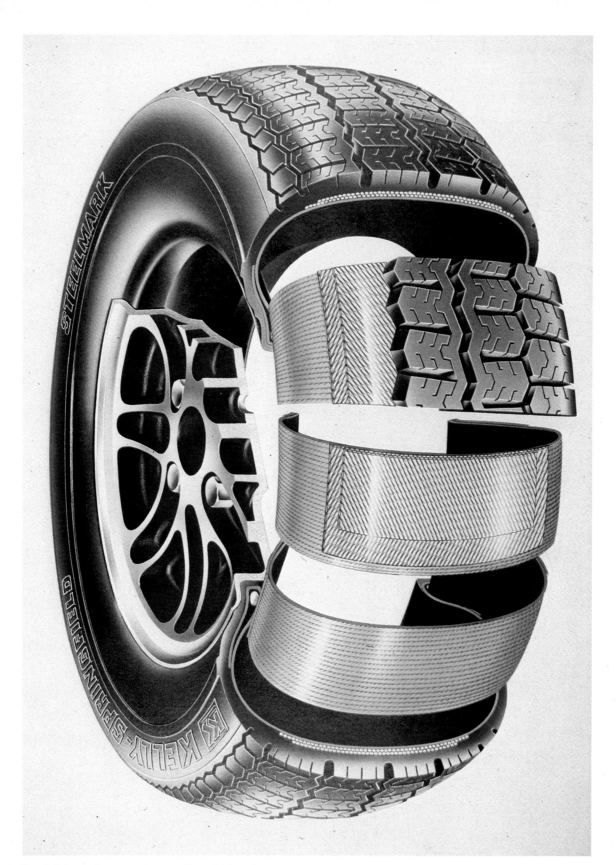

Hugh Dixon: *Cutaway tyre.* 1980 Airbrush, 41.9 cm × 30.5 cm
Hugh Dixon/Spectron Artists and Kelly-Springfield Tyre Co Ltd

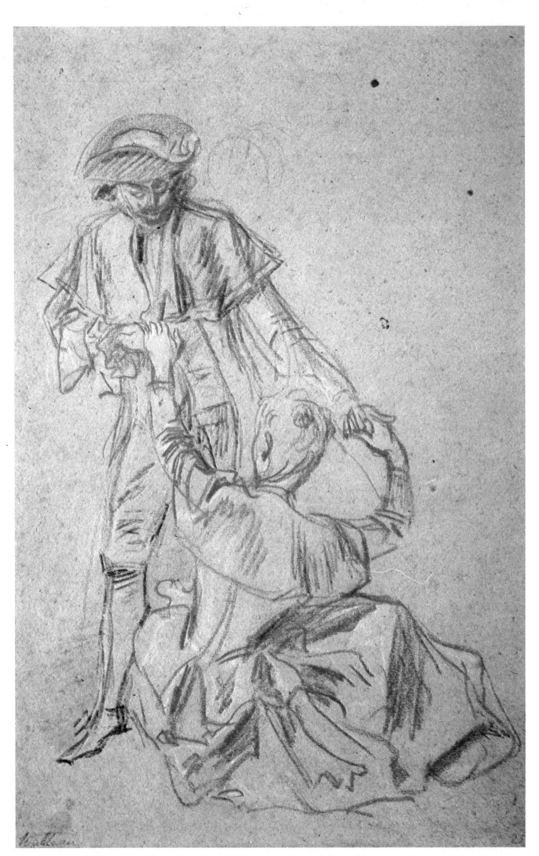

Jean-Antoine Watteau: *A man helping a seated woman to rise from the ground*
Red, black and white chalks on brownish paper, 33.6 cm × 22.6 cm
British Museum, London

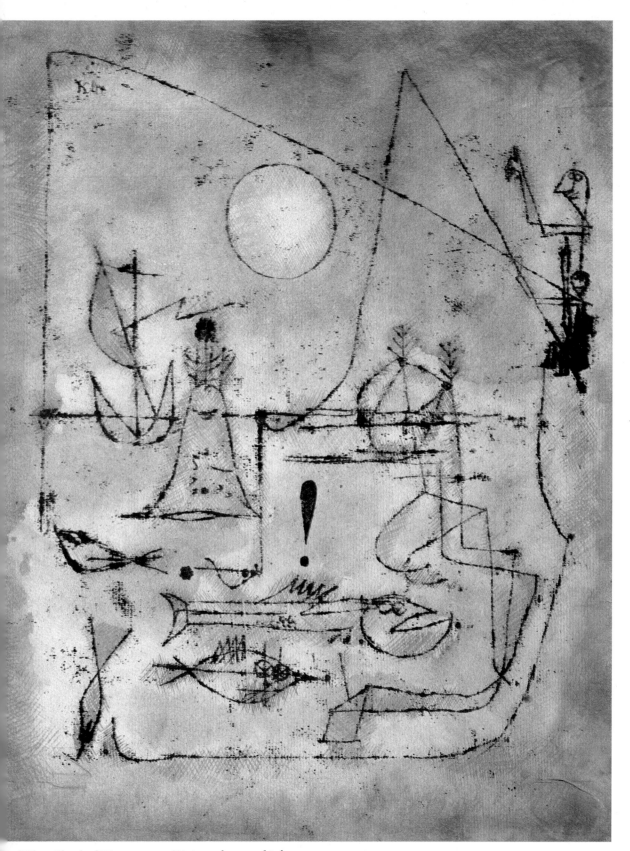

Paul Klee: *They're biting.* 1920 Water colour and ink, 31 cm × 23.5 cm
Tate Gallery, London Copyright ADAGP, Paris, 1982

Edgar Degas: *Woman at her toilet*. About 1894 Pastel, 95 cm × 110 cm
Tate Gallery, London

Henry Moore: Seven ideas for sculpture. 1980 Charcoal, white and yellow wax crayon, water colour wash, blue ball-point pen, pastel, chinagraph, 38.6 cm × 29 cm *Henry Moore Foundation*

Bikaner artist:
*A nobleman stading in a
field holding a straight
sword.* About 1760
Gouache and gilt,
18.7 cm × 10.5 cm
Private collection

Cornelius McCarthy: *Bathers in a wood* Gouache, 17 cm × 20 cm *Private collection*

Peter Paul Rubens: *Portrait of Isabella Brant* Black, red and white chalk with light washes, on light brown paper, eyes strengthened with pen and black ink, 38.1 cm × 29.5 cm *British Museum, London*

nature we rarely see objects from these 'typical' viewpoints, and that what we see is often optically distorted by the fact that we are viewing it from an end-on position. Drawing the human hand or arm as it is seen when pointed straight at the draughtsman is infinitely more difficult than drawing it from a side view, and the same may be said of most objects, organic and inorganic.

The optical shortening of forms when viewed end-on is known as 'foreshortening', and it became a prominent feature of drawings of the late Renaissance and the Baroque periods. Foreshortening produces exciting visual effects, but it can often introduce a jarring note of surprise into a drawing, and for this reason it has been used sparingly by artists of a 'classical' persuasion who, like Jacques-Louis David, attempted to maintain a level of calm and serenity in their work. Conversely, artists as different as Tiepolo and Degas thrived upon the element of visual shock which is produced by viewing forms from an unusual angle and made it a prominent feature of their work. Our ability to interpret and appreciate foreshortened drawings is to some extent dependent upon our conditioning to certain conventions in pictorial representation, and it has been shown that primitive peoples often find the conventions of fore-shortening disturbing and incomprehensible.

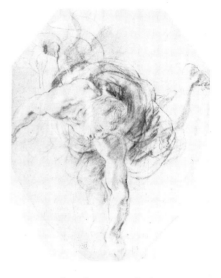

Peter Paul Rubens: Study for *Mercury Descending* Black chalk heightened with white on warm toned paper, 48 cm × 39.4 cm *Victoria and Albert Museum, London*

Corregio: *The Virgin in an Assumption*: study for the cupola of Parma Cathedral Red chalk with traces of heightening in white, 27.8 cm × 23.8 cm In designing for a ceiling or cupola, Correggio often conceived the figures as seen from below *British Museum, London*

97

FORM

In the study of drawing, or of art in general, few topics are more difficult to discuss than the question of form, and almost everything that has been written on the subject has been either philosophically very complex or downright banal. It is of course possible to ignore the subject altogether and continue to draw in a completely instinctive way, giving conscious thought only to such practical questions as the physical qualities of materials. Anyone who takes such a view should not bother to read this entry; but they should be aware that in doing so they are cutting themselves off from one of the most important issues in contemporary art, namely the theoretical basis of the relationship between what we call 'figurative' and 'abstract' art.

As far as the practice of drawing is concerned, form may be described as the physical realisation or embodiment of an idea independent of its connotations as a description of the real world beyond the confines of the drawing. Hence, the form of a drawn orange is not the real existence of an orange, but a simulation of qualities of a roughly circular contour, a spherical volume, and a dimpled surface. The form of an orange exists quite independently of all the numerous factors which we associate with the idea of an orange, such as its tangy taste, the fact that it grows on trees or that it is customary to put oranges in Christmas stockings.

In real life an orange has much in common with a banana: they are both fruits, they both grow in warm climates, they both have skins which can be removed by peeling. But regarded as a *form*, an orange has much more in common with a football, which is not a fruit, does not grow on trees, and cannot be peeled. This is because both the orange and the football have the same roughly circular contour and spherical volume. What both the orange and the football have in common we may describe as their *figurative form*, consisting of characteristics such as their circular profiles and their spherical surfaces, which tend to behave in similar ways under the action of light. These they have in common with all spherical objects, including the moon and marker buoys. Beyond these shared characteristics, one object differentiates itself from another in terms of its surface textures, its colour, and its scale relative to other objects in the same setting.

What I have described as figurative form works in two ways. First, the drawn form invites or stimulates certain analogies with forms which we have previously experienced, leading us to identify the form as indicating or symbolising a

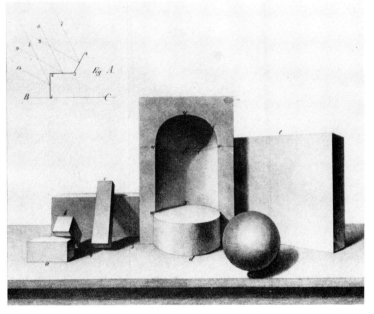

Peter Schmid: Plate XIII of *Das Naturzeichnen für den Schul- und Selbstunterricht.* Part Four, 1832 Engraving, 17 cm × 20 cm Schmid pioneered a method of teaching drawing from geometric wooden blocks

familiar object. We see the form on paper and attempt to match it with something from our store of remembered or imagined images. Secondly, in addition to assimilating the perceived form to some ready-made category by interpreting it as the representation of an object, we spontaneously begin a chain of associations and analogies which relates the form to a wider circle of forms with similar characteristics. So, for example, a football will lead us in the first instance to associations with other kinds of balls, such as golf balls and tennis balls, and then on to other spherical objects such as an orange or the moon, and then even further to objects which incorporate a spherical component in their form, such as a dome or a woman's breast.

An idea which we have inherited from the Classical world of ancient Greece is that all experience, including the experience of concrete reality, consists of encounters with individual and imperfect attempts to give material existence to an ideal form. According to this view, first proposed by the philosopher Plato, a real football is a more or less imperfect attempt to give physical expression to the idea 'football'; although the perfect football should be spherical in form, a real football is an imperfect sphere and can do no more than remind us, however vividly, of the ideal, which only exists as a mental concept. If we extend the principle to all experience, we see that according to this view all individual objects are imperfect attempts to simulate the ideal: real men are more or less unsuccessful attempts to give physical form to the idea

99

'man'; real oak trees unsuccessful attempts to realise the perfect oak tree. The principle even extends to geometric diagrams, because, in contrast with geometric ideals, one cannot draw a point without size, or a line which has length and direction but no width.

This all sounds rather abstruse and remote from the problems of putting pencil to paper in the act of drawing, but it is in fact one of the most potent ideas in our artistic tradition, and what has become known as Neo-Platonism (new or revived theory of Plato) had an immense influence during periods such as the High Renaissance c 1500–20 and in the age of Neoclassicism c 1750–1800. In artistic practice it led to the desire to create forms which resembled as closely as possible the ideal form, by refining upon nature and eliminating its local defects and peculiarities. Platonic idealism played a major role in the art theory of artists as diverse as Michelangelo and Sir Joshua Reynolds, and I can think of no better introduction to the subject than that contained in Reynolds' famous *Discourses* (1769–90) especially numbers IV and VII. The preoccupation with the quest for perfect forms had a number of consequences in drawing. Geometric proportion was seen as the key to harmonious pictorial composition; draughtsmen like Ingres constantly 'improved upon' nature by refining upon and selecting from what was seen; and generations of students were required to draw combinations of geometric forms made of wood, which were believed to represent the foundation of all visible objects no matter how complex or diverse.

This discussion of the theory of forms has led us quite naturally on to the notion that underlying the superficial complexities and peculiarities of the visible world there is a foundation of formal relations which can be expressed in terms of geometric relationships. Here we have the key to the theory of **abstraction**. If we turn to the explicit accounts of an early abstract artist like the Russian Malevich we see that his intention was to cut through the densely tangled vegetation of visual experience and reveal the perfect and fundamental forms which it obscured. This process of 'drawing-out' gives us the root meaning of the word 'abstraction', which derives from the Latin *abs-tracta* (drawn out). All figurative forms have some kind of abstract basis, however complex; conversely, purely abstract forms have no obvious figurative connotations, although it is always possible to insist on imposing some figurative interpretation upon them.

In talking of the form of a drawing, then, we may be intending to refer to several quite different things. These

Jean (Hans) Arp: Water colour
1924 *Location unknown*
Copyright ADAGP, Paris, 1982

include the figurative form or forms of identifiable objects, the abstract form of the same objects, abstract forms with no obvious figurative connotation, or the overall structure of the drawing together with its internal forms.

There is a dangerous temptation to think too exclusively of the positive forms which the drawing contains as objects disposed upon an inert **background**. This is a mistaken view, since so far as a drawing is concerned the shapes between things are just as important as the form of the things themselves. Hence, the areas of space between one object and the next in a still life should, as forms, be given the same priority as the objects which constitute the still life. This can be done by consciously drawing the shapes between, or what one may call the negative forms of the subject.

In his book entitled *Art* (1914), the art theorist Clive Bell coined the expression 'significant form' to denote the element which, in his opinion, gave quality to works of art of every kind and origin. Supporting the contemporary movement toward abstract art, Bell argued that ingredients such as naturalism and narrative played no part in

establishing the quality of a work of art, which depended entirely upon its formal content and structure.

See also **Abstraction**, **Background**, **Composition**, and **Subject**.

FREEHAND DRAWING

The expression 'freehand drawing' came into use as a way of distinguishing drawing without instruments from drawing with them. It has now tended to fall into disuse except in contexts such as engineering drawing where drawing with instruments is still the norm.

FROTTAGE

BELOW RIGHT **Max Ernst:** Untitled, 1932 Collage and frottage, 48.3 cm × 63.5 cm
The Mayor Gallery, London
Copyright SPADEM, Paris, 1981

BELOW **Mortimer Menpes:** *A Mexican woman.* 1896 Lithographic crayon on Japanese tissue laid over emery paper, 12.2 cm × 9.7 cm This drawing uses the principle of frottage to create half tones for line reproduction Published in *The Studio* Vol. VIII, 1896, p.243

The term 'frottage' is derived from the French *frotter*, meaning 'to rub', and was first used by the Surrealist artist Max Ernst to describe effects which can be achieved by placing a piece of paper over a suitably textured surface such as grainy wood and rubbing it with a pencil or crayon in such a way that the texture comes through. The attraction of the technique was that it enabled the draughtsman to produce a rich textural effect which reacted in exciting ways with superimposed imagery. The principle of frottage was certainly not discovered by Ernst, and there is evidence of its use at least as early as the 1890s.

There are three technical requirements for frottage: first, a

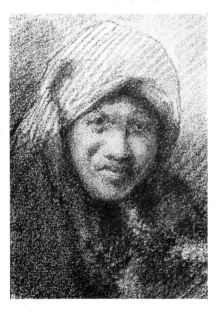

surface with a pronounced texture such as wood, canvas or glass paper, secondly, paper which is thin enough to permit this texture to come through, and thirdly, a drawing medium which is soft enough to pick up easily on the elevated parts of the grain of the surface under the paper. Frottage effects can be utilised by placing textural surfaces selectively under certain sections of the drawing, or by cutting up prepared pieces of paper and re-combining them by gluing them down to a new support.

GAMUT

In order to produce a line drawing the draughtsman must bring the drawing tool into contact with the support and move it in a determined direction. In theory at least it would be possible to create a drawing by moving the tool in only one direction—let us say vertically—by building up a pattern of vertical lines. In actual fact the draughtsman normally permits himself a variety of directions for the creation of the image, including verticals, horizontals, various diagonals and numerous combinations of straight and curved lines. The range and variety of directions used in a drawing is known as its gamut. Rather like the gamut of notes which the composer derives from a musical scale or key, the gamut of a drawing is the number of linear directions which the draughtsman has permitted himself for its creation.

Some drawings, such as those of the Cubists and Mondrian, are characterized by a very limited gamut, in the case of Mondrian often restricted to vertical and horizontal lines. Most draughtsmen employ a more extended gamut, but there is some truth in saying that when the linear gamut becomes too large the drawing loses character and strength. The reason for this is that by limiting the gamut of the drawing the draughtsman increases the possibility for the creation of numerous correspondences and visual echoes, as a direction in one part of the drawing is repeated by a direction in another, thereby generating a sense of economy, unity and cohesion.

Although it is normally used in relation to direction of line, the same concept of gamut can be applied to the variety of weight of line, and also to the tonal range of the drawing.

Piet Mondrian: *Church facade.* 1914 Dated on drawing 1912 Charcoal, 99 cm × 63.4 cm Mondrian progressively reduced the gamut of his drawings and paintings to almost complete dependence upon verticals and horizontals. *Collection, The Museum of Modern Art, New York The Joan and Lester Avnet Collection*

GEOMETRY

Because the art of drawing is concerned at least in part with the subdivision of surfaces there have been numerous attempts to relate it to the science of geometry. Perhaps the most famous example of a geometric rule which has found its way into art is the proportion known as the Golden Section. This proportion, which was given its name in the nineteenth century, was discovered by the ancient Greek geometer Euclid, and it may be expressed as follows: A line is divided according to the Golden section when the proportion of the lesser section to the greater is the same as that of the greater section to the whole. In other words, in the following line

$$\frac{a}{b} = \frac{b}{a+b}.$$

This relation can be deployed in various ways in the composition of a drawing, for example by placing the horizon line of a landscape so that it bisects the picture according to the Golden Section. It can also be applied to the construction of rectangles, the sides of which conform to the same ratio.

A great deal of evidence has been assembled to demonstrate that people express a spontaneous preference for forms which have been determined according to the Golden Section. It is also possible to find many examples of artists having used the proportions of the Golden section without having been aware of doing so.

Another source of geometric relationships which have been used by draughtsmen is the sequence of numbers discovered by the Italian theorist Fibonacci (1175–1230) and known as the Fibonacci series. In this series, each number is the sum of the preceding two, giving us the following sequence: 1 1 2 3 5 8 13 21 34 55 89 144, etc. The ratio between the adjacent numbers of the series comes progressively closer to that of the Golden Section, although it never actually reaches it. It has been demonstrated that the Fibonacci series underlies the structure of many natural organic forms such as leaves and flowers.

Geometric rules alone do not provide any simple formula for successful composition, in drawing or in any other art. However, since the Constructivist movement (1917–)

W. Jamnitzer: The cube and its derived solids. Plate BVI from *Perspectiva Corporum Regularium.* Nuremberg 1568 Engraving by J. Amman after a drawing by W. Jamnitzer Solid geometry has proved a source of fascination to artists and mathematicians alike *Science Museum, London*

RIGHT **Albrecht Dürer:** *Melancholy.* 1514 Engraving, 24.1 cm × 19 cm *Victoria and Albert Museum, London*

there has been a great deal of interest in the possibilities of geometric form as an element of creative activity and several artists of distinction have made it an important part of their work. Like most other sources of inspiration and subject matter, geometric forms only become of real value when they are studied in some depth.

In addition to the aspects of geometry already discussed, it is perhaps worth mentioning that the drawing of geometric forms has played an important role in relation to the creation of designs for all kinds of artefacts and architecture. Design students of the nineteenth century spent many hours laboriously copying and inventing repeating patterns and motifs with a view to their use as ornament. Although at its worst this kind of work deteriorated to mindless imitation and repetition, it should be noted that the history of drawing embraces a fine tradition of drawing decorative patterns for use as ornament and embellishment which dates back to the

stone age and continues today in many areas of manufacture. This deep-seated human need for decoration has recently attracted renewed attention from art historians and theorists, one of the most important contributions to the field of study being E. H. Gombrich *A Sense of Order* (1980).

Kenneth Martin: Study for a screw mobile. 1972 Pencil, 80 cm × 71 cm *Tate Gallery, London*

See colour plate
by Bikaner artist and *Bathers in a Wood*
by Cornelius McCarthy between pages
96 and 97

Western Australia: Baobab
nut with incised design of
a kangaroo Height 16.5 cm
Museum of Mankind, London

GOUACHE

Like conventional water colour, gouache paint uses gum arabic (or a synthetic equivalent) as a binder and water as a solvent. However, it differs from water colour in that its pigments are less finely ground and it contains a white ingredient to give it opacity and body. The result is that whereas water colour dries out to a transparent finish which permits the white of the ground to shine through, thereby giving the image luminosity, gouache completely obscures the ground and must generate its own luminosity. The principal advantage of the fact that gouache is opaque is that it permits the draughtsman to lay light colours over dark—a practice which is impossible with conventional water colours.

Gouache, which is also known as body colour, was employed in the art of ancient Egypt and has been in almost continuous use through the middle ages up until the present time. In addition to being used by many artists of distinction in the twentieth century, the forms of gouache known as 'poster colour' and 'designers' colour' have, as their names imply, found widespread use in the production of commercial imagery for advertising, illustration and packaging.

As in painting with oils, it is possible to apply gouache in a wide variety of consistencies ranging from thin dilutions to undiluted paint straight from the tube. Generally speaking it should not be diluted to much or it will acquire a thin, starved look. Gouache dries out lighter than it is in its wet consistency, and this makes it difficult to predict and control the tonal range of the image. It can also result in a dry, chalky texture which needs to be animated by vigorous tonal and colour contrasts. Gouache drawings which have been prepared for colour reproduction on art paper often acquire a luminosity when printed which is not evident in the original art work.

GRAFFITO/GRAFFITI

Graffito or sgraffito (Italian: scratched) is the name applied to the technique of scratching a design on to a ground. An image results from the fact that the layer exposed by the act of scratching is a different colour or tone from the surface of the ground, combined with the visible scoring as revealed by the fall of light across the surface. Drawings scratched into stone or brickwork are perhaps the most obvious and primitive examples of graffiti, but many other techniques are

108

based on the same principle. Metalpoint drawings, for example, are produced by scratching away a prepared ground to reveal the underlying support. The resulting line is reinforced by the fact that metals such as lead leave a noticeable trace.

Graffito effects are possible with a variety of grounds, such as chalk, pastel or gouache laid over paper or card, and can be obtained with a number of instruments, such as a needle, razor blade or pen knife. Many twentieth century artists have had a special predilection for effects which appear fortuitous or result from the random wear-and-tear on natural and manmade objects, and for this reason graffito has enjoyed something of a revival.

It should be remarked that technical advances combined with a higher material standard of living have provided the defacer of property with a more sophisticated range of materials. The sharp stone and the knife have been superseded by the felt-tipped pen and the aerosol can. Although it is not strictly correct to describe these as graffito techniques, nowadays the expression 'graffiti' has been broadened to include any kind of pictorial or literary defacement of property.

ABOVE **Jean Dubuffet:** *Joë Bousquet in bed.* 1947 Gouache and ink over gesso incised with pen on cardboard, 49.5 cm × 32.4 cm *Collection, The Museum of Modern Art, New York* Mrs Simon Guggenheim Fund Copyright ADAGP, Paris, 1981

ABOVE LEFT **Bill Sanderson:** *'The Lad Himself'*, illustration for *Radio Times* Scraper board, 20 cm × 14 cm In scraper board a fine surface of black is removed to reveal the underlying white *Courtesy of the artist*

109

GREASE RESIST

See **Crayon**.

GRIP

The way in which the draughtsman holds the drawing tool has an important bearing on the character of the drawing. Whilst there is no easy formula for improving one's drawing by changing one's grip on the drawing tool, it is important to recognise and take account of different techniques.

The child usually begins by using what is called a dagger grip, that is by folding the four fingers around the shaft of the drawing tool, held with its point downwards, and laying the thumb across the fingers. This grip permits the draughtsman to use the full force of the arm muscles, notably the biceps, but provides no flexibility or delicacy of movement in the wrist or fingers. Perhaps the next more sophisticated grip takes the form of holding a short drawing tool such as a stubby piece of crayon between the tips of the fingers and the thumb brought together in a cone formation, gripping the

Käthe Kollwitz: *Self portrait in profile from left.* 1933 Charcoal on ingres paper, 47.6 cm × 63.5 cm *National Gallery of Art, Washington*

110

tool near its point. For this grip the drawing tool must be fairly short in order to accommodate it within the palm of the hand. It allows the wrist to move freely, but tends to lock the fingers and hand into one fixed position.

A more advanced grip is the conventional writing hold. Here the tool may be rested on the last joint of the second finger, and gripped between the index finger and thumb acting in opposition. The remaining two fingers bunch up underneath the second finger, controlling the distance of the writing tip from the surface and serving as a kind of cushion. This assumes the use of a longish drawing implement, which rests across the web of flesh between the thumb and the first knuckle of the index finger. It has many variants, such as holding the hand completely clear of the paper with the fingers rather more to one side.

One other grip should be mentioned, since it is so often recommended in the teaching of drawing. Here the fingers are held side by side and more or less straight. The drawing tool lies at an angle across the inside of the fingers with the tip pointing upwards and is held in position by the thumb opposite the first or second finger. Let us call this, for want of a better term, 'candle grip'.

Johann Heinrich Fuseli: *Portrait of the sixteen-year-old Lavinia de Irujo drawing* Pencil, 27.9 cm × 22.2 cm *Oskar Reinhart Foundation, Winterthür*

111

These positions are immensely difficult to describe accurately and are also subject to an enormous number of variations: any notion that there is one universal 'writing grip' will soon be dispelled by watching half a dozen people write. There are however general consequences for each type of grip of which the draughtsman should be aware.

Dagger grip is of limited value because it permits so little flexibility of wrist and fingers. It also tends to obscure the drawing point, making it difficult to see and control the image as it appears. A criticism which has been made of writing grip is that it so resembles the act of writing that it is easy for calligraphic knacks and habits to slip unobtrusively into the act of drawing. This is a very real problem, and can lead to a situation in which the draughtsman appears to be drawing from observation, but is in fact producing a series of graphic (or calligraphic) clichés with little or no relation to the motif. In some cases, of courses, calligraphic qualities are both admired and desired, but the draughtsman should never be in any doubt as to whether what he is producing is a rigorous piece of observation or a decorative elaboration of forms.

Ferdinand Georg Waldmüller: *Young draughtsman at work.* Page from a sketchbook Pencil, 13 cm × 21.4 cm *Albertina, Vienna*

112

One of the arguments advanced in favour of what I have called candle grip is that it is remote from writing grip and prevents the hand from falling into calligraphic habits. A second is that it permits one to work at arm's length, standing back from the drawing and obtaining a better overall view of the image as it develops. In spite of these factors in favour of candle grip, it does present problems. It makes flexible use of the fingers difficult, as most of the movement must come from the arm and wrist. It also, to my way of thinking, encourages people to draw too large, especially if the drawing is to be completed in a fine point medium like pencil. Furthermore, it is only really practicable with dry media since wet media must be inclined at a downward angle.

On balance, a grip similar to the writing grip would seem to be most useful, provided that the hand is not allowed to fall into writing habits at the expense of real observation.

The Oriental tradition of brush drawing involves a completely different grip which is uncommon in the West and this is dealt with in the entry on **Brush**.

Bartolomeo Passarotti:
Five studies of nudes
Pen and ink, 41.9 cm × 26 cm
Victoria and Albert Museum, London

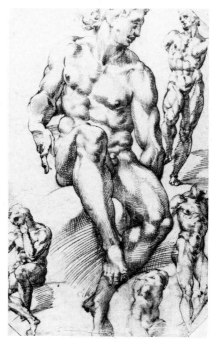

HATCHING

Hatching consists of laying an area of parallel lines on a selected part of the drawing. It can be used to create a local reduction in tone, suggesting for example a cast or attached shadow, and this is often combined with the use of directions in the hatching which suggest the volumetric form of objects on which the shadows fall. Right-handed draughtsmen tend to hatch from bottom left to top right, and left-handed draughtsmen vice-versa. In addition to its figurative function as a descriptor of shadow and volume, hatching is also used to create tonal masses in abstract works and to suggest a sense of dynamic momentum.

Cross-hatching consists of laying two or more layers of hatching travelling in different directions over one another.

113

ILLUSION/ILLUSIONISM

When we are confronted with an art work, whether it be in a gallery, cinema, theatre or other location, there is not in many cases any real risk of our taking the art work to be reality. More often than not, we have to put everyday habits of perception on one side and actively collaborate in re-creating the intention of the artist from the evidence before us. When an art work leads us to believe that we are witnessing not the representation of an event or object but the event or object itself, it may be described as illusionistic.

Illusionism has enjoyed periods of considerable popularity in the art of painting but has always been less feasible in drawing. This is because so much drawing depends upon outline, which declares itself immediately as an abstraction rather than as the thing-in-itself. Drawings are also generally more modest in scale and intimate in character, so that any attempt at illusionism can be broken down by changing one's viewpoint or by inspecting the surface of the drawing more closely. (Illusionistic painting thrived during the great period of Baroque ceiling decoration, when it was literally impossible to check visual illusions by touch.)

Nevertheless, illusionism has played a significant part in the development of modern drawing in relation to both Optical art, which generates illusionistic distortions of the drawing surface, and photo-realism.

ILLUSTRATION

An illustration is a graphic image devised to accompany and complement a verbal text. The word 'illustrate' means literally to light up—to illuminate and heighten a meaning which is apparent in the words to which it relates. Illustration is one of the oldest art forms, and although we tend to think of it in connection with the printed book and periodical it predates both printing and the book itself, being used in ancient Egypt for the elaboration of sacred texts and in ancient Chinese scrolls. It remains today not only the most widespread form of drawn imagery, but the most common source of income for the professional draughtsman.

M. C. Escher: *Three spheres.* 1945
Wood engraving, 27.9 cm × 16.8 cm

114

In reviewing the development of drawing for illustration we must bear in mind two very important historical turning points which had an immense impact on the nature of illustrative drawing. The first was the spread of printing in the fifteenth century. Previous to this period almost all illustration was produced by hand in the form of illuminated manuscripts, although more often than not each drawing was a copy of an earlier prototype. With the spread of printing, it became necessary to interpret an original drawing as a printing surface. At first this took the form of cutting the images on wood, later they were engraved on metal, and later still they were drawn with a greasy crayon on a lithographic stone. This interpretation of a drawing into a printing technique was almost always done, not by the draughtsman, but by a craftsman—a professional wood-cutter, engraver or lithographer. The tradition of *autographic* prints (prints in which the printing surface has been prepared by the draughtsman himself) was relatively rare until the late nineteenth century, notable exceptions being the prints of for example Rembrandt, Goya and Blake.

During the last quarter of the nineteenth century drawing for illustration was transformed by a second major technical innovation. This resulted from an invention (or series of inventions) by means of which an artist's drawing could be photographed and then engraved mechanically without the intervention of a craftsman engraver. The resulting illustration was much closer to the artist's original drawing than it had ever been possible to achieve under the old system, and from that time forth the vast majority of illustrative drawing has been processed photographically rather than being engraved by hand.

The history of illustration is vast and complex, with many varieties of national school, stylistic period and cultural context. (For an introduction to the subject, see David Bland

Anon: *'Impatience'* from *Ars Moriendi* (The Art of Dying), about 1450 Woodcut

115

A History of Book Illustration 1958.) There is considerable variation in the kind of relation which the drawn image might have with its associated text, in some cases playing a humble, supportive role; in others complementing it with new information or atmosphere; in yet others rivalling or completely submerging the text with its power and vitality, and becoming the book's principal *raison d'être*.

It is possible to identify two broad approaches to the task of drawing for illustration. In the first the content of the illustration is diffused and generalised, aiming to create a sense of mood or atmosphere rather than depicting a precise moment in time represented in the text. In its most generalised form, this kind of illustrative drawing shades off into decorative additions to the page such as ornamental borders and vignettes. This is not intended to denigrate this kind of illustration, which can be done superbly and may well be ideally suited to the needs of the text in hand.

In the second approach, the illustration is specific and focused, often portraying a precise moment in time together with a great deal of circumstantial detail. This approach to illustration reached a peak of popularity in the mid-nineteenth century, and is exemplified in Cruikshank's illustrations to Dickens' novels. A great deal of modern illustration falls within the same category. In addition to the contemporary vogue for photo-realism, the historic tradition of medical and scientific illustration is as alive and needed today as it ever was in spite of the availability of the camera.

A curiosity of the history of modern art is that although abstract idioms have played such an important role in the recent development of painting and sculpture, they seem to have made little or no impact on illustration, which remains for the most part as strongly figurative today as it was a hundred years ago. The experiments in abstract illustration undertaken by the Russian artist El Lissitzky during the 1920s remain little more than an historical oddity.

There has been a great deal of debate as to whether illustration demands a 'special kind' of drawing. On one side there are those who argue that illustration requires an approach to drawing which is highly specialised; on the other, those who claim that good illustration is synonymous with good drawing, the only difference being that in the case of illustration there is the additional requirement of the ability to use drawing in the right way—that is to be able to relate a drawing to an appropriate text. My own view is that good illustration can take the form of any style of drawing provided that it is used in the right way and is suitable for reproduction and printing. There is, I feel, a real danger in

George Cruikshank: 'Fagin in the condemned cell', illustration to Charles Dickens *Oliver Twist*, 1846

116

George Stubbs: *Anatomy of the horse* Indian ink, 34.3 cm × 45 cm *British Museum, London*

Andreas Vesalius: Plate 32 from *De Humani Corporis Fabrica*, 1543

117

trying to cultivate a special kind of 'illustrator's drawing'.

It is mistaken to assume that the art of the illustrator is confined to the imaginative realisation of fictional texts. One of the most important roles of illustration has been to present scientific, technical and other information in pictorial form. In some cases, illustrators have devoted their life's work to the study of a particular area of subject matter. One has only to think of the anatomical drawings of the Belgian physician Vesalius and his team of draughtsmen, the studies of horses by the English artist George Stubbs, and the birds of the American J. J. Audubon, to realise that illustration has been and remains one of the most significant and reliable ways of recording and communicating information.

This important function of illustration is as alive today as it ever was, and for a very simple reason: namely that even the best photography is incapable of capturing the information which an author often wishes to present. Medical and technical textbooks continue to depend heavily upon the illustrator's art to convey the precise information which is intended, and often there is no alternative, verbal or photographic.

Unlike the 'fine artist' draughtsman, who produces drawings speculatively in response to his personal interests and enthusiasms, the illustrative draughtsman normally has certain additional constraints and responsibilities. In most cases he will be working to a 'brief', that is a commission from a publisher or advertiser specifying the kind of drawing required. This brief may be very 'tight', giving a great deal of precise detail and even information on the style of the drawing. Interpreting a brief demands a sensitivity and response to words and ideas, whether they take the form of an advertiser's slogan, a poem, or a full length novel. The illustrator must be able to read perceptively, to listen closely to verbal instructions, and to generate a response which will enable him to make his personal contribution to what is provided by the client. This requires a sensitivity to both text, the verbal content of the brief, and context, the situation in which the drawing is to be used, whether it is a magazine, a book jacket or a poster. For a well-known practising illustrator the problem is partly solved by the fact that agencies tend to seek out illustrators whose work will, they feel, suit the task in hand, so the process of matching artist with brief has already begun.

An important part of the illustrator's response to texts will be a keen response to words, the ability to read a page or a chapter and conjure up a vivid mind picture which can be translated into a graphic image. Most illustrators produce a

Charles Pickard: Illustration of hip joint replacement
Acrylic, 21.5 cm × 15 cm
Courtesy of the artist

Robert Rauschenberg: Canto XXXI: Illustration for Dante's *Inferno* (1959–1960) Red pencil, gouache and pencil, 36.8 cm × 29.2 cm Rauschenberg's illustrations to Dante are free improvisations around the theme of the *Inferno* which make use of complex off-setting techniques from magazine imagery *Collection, The Museum of Modern Art, New York Given anonymously*

large number of roughs to help them to bridge the gap between the words and the completed image. These roughs constitute a kind of visual thinking in the process of which important ideas can be selected and emphasised and irrelevant detail cast aside. One aspect of this response to texts is a good eye and mind for detail, and the illustrator must be prepared to undertake research into details of dress, architecture, plot, character, etc, until these are fully understood. Few things are more irritating to a reader than obvious anachronisms of costume on the jacket of a period novel, or completely mistaken drawings of objects such as musical instruments or aircraft. The illustrator must remember that most of the people who will want to buy or read such material will already have some personal knowledge of the subject, and he must be prepared to satisfy the kind of scrutiny to which they are going to put his drawings. For this the illustrator will need not only his

119

I put out to sea
in a wooden row-boat
with a cheese and pickle sandwich
and a yellow hat and coat.

Down behind the dustbin
I met a dog called Jim.
He didn't know me
and I didn't know him.

Down behind the dustbin
I met a dog called Sid.
He could smell a bone inside
but couldn't lift the lid.

Quentin Blake: Double spread from *You Can't Catch Me* by Michael Rosen and Quentin Blake, published by André Deutsch, 1981 Fountain pen and ink with water colour, 25.5 cm × 38 cm
By kind permission of the artist

personal picture reference collection of costumes, architecture, machines, trees, character types, etc, but also the will and the ability to go out to libraries, museums, galleries and the streets in order to gather material for his drawings.

The illustrator must also remember that his work will be used for reproduction. It will probably be reduced in size and printed in a way which will entail changes in the quality of the image and character of the surface on which it is drawn. Effects which look so attractive in the original drawing may well disappear in the printed version, and problems not evident in the art work will become all too obvious when it is processed and printed. Consequently the illustrator must take an intelligent interest in the technical side of reproduction and printing, and must learn not only how to produce drawings which will survive these processes, but will if possible gain in strength as a result of being reproduced.

IMAGINATIVE DRAWING

A great deal of drawing is concerned with the making of some kind of record, however personal, of an object, situation or event which confronts the draughtsman, or which he has seen and experienced in the past. It is important to remember, however, that a great deal of drawing does not have its origin in either observation or memory, but is a record of a purely mental invention on the part of the artist. To imagine means literally to create a mental image; indeed, the expression 'to image' used to be employed as a verb meaning to conceive in the mind.

120

Taken to extreme ends, imagination is capable of supplying imagery which can only be described as fantastic, in the sense of being a record of a fantasy. A case in point are the drawings of Piranesi, whose architectural fantasies are awe-inspiring at the same time as being quite unrelated to the practical possibilities of architectural construction, past, present or future. William Blake found the world of concrete reality not only unattractive as a source of subject matter, but downright repugnant, and preferred what he called his 'visions'. In Blake's case, the intensity and frequency of his visions would probably, if he were alive today, lead to his being diagnosed as psychotic. It is fortunate for us that he was permitted to pour out his imaginative visions over such a long working life without being prevented by circumstances from doing so, even if he enjoyed negligible prestige and success in his own day.

Hieronymus Bosch: *The tree-man* Pen and bistre, 27.7 cm × 21.1 cm *Albertina, Vienna*

William Blake: The man who built the pyramids. Replica, perhaps by John Linnell Pencil, 28.7 cm × 19.7 cm Blake drew little from nature, preferring to cultivate and record his inner visions *Tate Gallery, London*

121

INK

Ink is one of the oldest drawing media, being used in ancient Egypt and China for both writing and drawing. In the long history of the development of ink four main varieties have been used, namely black carbon ink, iron-gall ink, bistre ink and sepia ink. Although workshop practices for manufacturing ink have been largely superseded by the availability of mass-produced inks, it might be worth describing these four varieties briefly, first because they help one to appreciate aspects of the techniques used in old-master drawings, and secondly because it is still possible and profitable to experiment with making one's own ink. For more information on the manufacture of inks, the reader should consult James Watrous *The Craft of Old-Master Drawings* Wisconsin 1957.

Black carbon ink is made from pigment obtained from the soot or organic matter produced by burning resinous oils, wood, bone, ivory, the stones of fruits and similar substances. This soot is ground to a fine powder and then mixed with a gum or glue which binds the particles together and provides adhesion to the paper. The standards of quality in European ink were set in the seventeenth century by the importation of excellent inks from China, and subsequently carbon ink became loosely referred to as 'Chinese ink' or 'Indian ink'. Most early carbon ink was made and transported in the form of small sticks, to be dissolved on a porcelain dish or shell with water or saliva as required. Although we tend to think of ink as an exclusively fluid medium, this is still practised today, especially in the Far East.

Cheng Hsieh: Chrysanthemums, bambo and epidendrum. Handscroll. Mid-eighteenth century (detail) Ink on paper, 33.7 cm × 240.5 cm *British Museum, London*

122

Good 'Indian ink', as it is known, is dense in tone, permanent, flows easily from the pen, and dilutes evenly with water to produce grey. Modern ink manufacturers add shellac or rosin to the ink, which gives it its 'waterproof' quality when dry; that is, it will not dissolve again when worked over in a water-bound medium such as water colour.

Iron-gall ink is produced from so-called gall-nuts, which grow on oak trees when punctured by the egg-laying gall wasps. The gall-nuts, which are harvested from oak trees in the Mediterranean region and the Near East, are collected, ground and boiled. The additions of ferrous sulphate produces a chemical reaction with the acids in the nuts, creating a strong pigment of a dark violet-grey colour. Iron-gall ink turns darker after use to a colour near black. However, in the course of several years it tends to fade to brown, which explains the colour of the ink in many old drawings and documents.

Bistre ink is made from soluble tars, produced mainly from wood soot which has been ground to a fine powder and then mixed with additives such as wine and child's urine. Gum arabic is added as a binder and the mixture is dried to a cake which, when dissolved, produces a rich and attractive brown ink.

Sepia ink is a dark brown ink verging on black in high concentration. Strictly speaking, sepia is manufactured from a fluid found in a sac carried by the cuttlefish and squid and discharged to produce a protective screen when threatened by predators. During the nineteenth century the term sepia was applied indiscriminately to almost any kind of brown ink or pigment, resulting in a great deal of confusion, and it has been estimated that only a small proportion of drawings described as executed in sepia are in fact in that medium.

Good inks should possess most of the following qualities. First, they should flow easily from the pen or brush without clogging or drying too rapidly. Secondly, they should have an attractive colour and tone, such as a dense, velvety black or a rich, luminous brown. Thirdly, they should be reasonably permanent in the sense of not fading after exposure to normal amounts of light over a long period. Fourthly, they should if possible dissolve easily in water, producing dilutions of even colour and tone. Finally—and this is normally required of modern drawing inks—they should be waterproof, not dissolving again when worked over with a dilution of ink or a wash of water colour. Modern manufactured drawing inks normally fulfil most of these requirements, but sometimes with a corresponding loss. For example, the addition of waterproofing ingredients can give

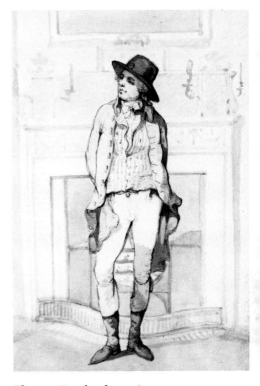

Thomas Rowlandson: *George Morland* Indian ink wash and pen, slightly tinted, 31.7 cm × 21.6 cm *British Museum, London*

123

the ink a rather hard, glassy surface when dry, and it is not surprising that some of the best draughtsmen in ink have, like Charles Keene, worked in weird concoctions of their own.

In addition to the colours of ink most common historically, namely black and brown, modern inks are produced in a wide variety of hues. These can be extremely useful in technical contexts, for example in distinguishing components of an engine or in medical illustration. Many coloured inks, however, have a rather garish quality which makes them unsatisfactory for the purpose of artistic expression, where watercolour would probably be preferable.

Techniques

The styles and techniques of drawing in ink have been almost as numerous as the many great draughtsmen who have favoured the medium. As a generalisation, one might say that during the medieval period and the early Renaissance ink drawings were predominantly executed with a quill pen and tended to be constructed of two kinds of mark, first a linear contour, and secondly hatching to create shadow and articulate internal modelling. This style of drawing is characteristic of the work of Pisanello. The predominantly linear style of drawing in ink continued into the High Renaissance, although in many of the ink drawings of Raphael we find a more rapid, sketchy technique which anticipates the great ink draughtsmen of the seventeenth century. Breugel developed this linear style of ink drawing, and in his more highly finished drawings we find complex patterns of hatching used to create areas of tone and texture.

The seventeenth century saw a revolution in the use of ink for drawing. The linear use of the medium became more spontaneous and gestural; the ink was often diluted and laid in washes to produce gradations and areas of tone and texture; and both the pen and the brush were used with unprecedented variety, often supported by unorthodox methods such as the dragging of a dryish brush and smudging with the thumb and fingers. These developments corresponded to the Baroque love of atmospheric effect, dramatic lighting and movement, whether used to depict some supernatural event drawn from religious literature or to represent the aerial perspective and movement of a landscape. The great seventeenth century masters of ink drawing include Rembrandt, Poussin and Claude, and their drawings repay careful study and analysis.

Ink drawing with a fine pen is capable of rendering details

Nicolas Poussin: *The Aventine* Black chalk and bistre wash, 13.4 cm × 31.2 cm
Uffizi Gallery, Florence
William Hogarth: *The industrious apprentice performing the duty of a Christian* Pen and indian ink wash,
27.3 cm × 35 cm *British Museum, London*

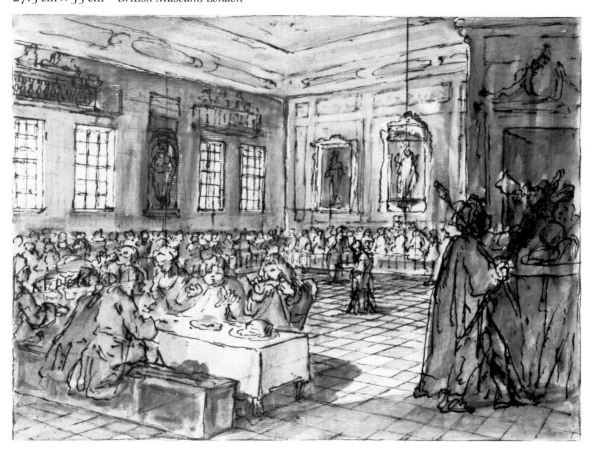

Walter Sickert: Study for *Ennui*
Sepia ink on brown paper, 42 cm ×
34 cm *Tate Gallery, London*

with extreme precision, and with the coming of the
Industrial Revolution in the late eighteenth century the
medium was increasingly used for the designing and
recording of machine parts and engineering detail. This
development was accelerated by the invention of the steel
nib, which made possible lines of unprecedented fineness.
The engineers and architects of the late eighteenth century
and the nineteenth century were often fluent and accom-
plished draughtsmen in ink, alternating with ease between
the written word and the illustrative image. The same
quality of precision made ink the medium ideal for the

topographical draughtsman, whose task it was to record landscape and architecture as faithfully as possible in the pre-photographic era.

During the last quarter of the nineteenth century pen and ink drawing was revolutionized by the invention of photo-mechanical methods of reproducing pictures. This meant that instead of each picture having to be laboriously engraved by hand from an artist's original drawing, it was possible to create printing blocks by photographing the drawing and then transferring it automatically on to a metal plate. The early methods were, however, rather insensitive, and demanded a high level of definition in the drawing. This led to a style of drawing which favoured very black ink, bright, white paper, steel nibs and fine brushes. These were used to create precise, clean lines and clearly defined areas of tone. The master of this style of drawing was Aubrey Beardsley, and it is significant that in most of his illustrations there is no dependence on the dilution of ink or on random effects: everything is worked out in meticulous detail and drawn with clean precision. Another peculiarity of the new

Aubrey Beardsley: *The Wagnerites* Pen, brush and ink on paper, 20.4 cm × 17.7 cm *Victoria and Albert Museum, London*

127

printing methods, and this is still true of graphic repro-
duction today, was that drawings could be enlarged, or, as
was more often the case, reduced in scale in the process of
being transferred on to the printing block. This permitted the
draughtsman to pack a great deal of detail into a drawing
which would subsequently be reduced to a finely-detailed
image.

Ink has continued to hold its own as a drawing medium in
the present century in every sphere of graphic art. Matisse
favoured a highly linear style of pen and ink drawing in
which a few economical lines scattered across an expanse of
paper evokes an image of compelling beauty and animation.
David Hockney, one of the most prolific draughtsmen in ink
of the present day, continues to favour this clean, linear style
of ink drawing, supported by only one or two tonal emphases
on, for example, hair or the details of a mouth. Ink has
remained the most popular medium for what are called line
illustrations, that is illustrations which contain no half tones
other than those which are simulated by the drawing of dots,
hatching, etc. A virtuoso of ink drawing for line reproduction
was John Minton, who combined conventional use of the

David Hockney: *Nick and Henry on
board, Nice to Calvi.* 1972
Pen and ink, 43 cm × 35.5 cm
British Museum, London

128

pen and the brush with effects achieved by scrubbing with a dry brush, smudging with the thumb and with pieces of fabric, and over-painting with opaque white body colour.

The Oriental tradition of ink drawing is, of course, much more ancient than that of Europe. It is also more complex, in that the great Chinese and Japanese calligraphers and draughtsmen have regarded ink not merely as a means of describing and recording forms and visual ideas, but as a symbol of life itself. In the Oriental tradition the visual density of ink is taken to symbolise the primal substance from which all things emerge, and the act of drawing in ink is regarded as analogous to the act of creation. The draughtsman prepares himself for drawing as for an act of worship, composing the body and the mind to a condition of harmony with the surrounding creation which will allow the life forces to flow vigorously and unimpeded down the arm, into the brush, and on to the paper. While the European eye tends to look *through* a drawing to see what it represents or means, to interpret the forms depicted, the Oriental eye tends also to look *at* the drawing, to interpret the marks as having some life of their own in addition to their purely descriptive function.

INSTRUMENTS

Although most of the drawing done in connection with the fine arts, illustration and graphic design is done **freehand**, there are still several areas of drawing activity in which the use of instruments is the norm, notably engineering drawing, technical drawing and architectural drawing. Instruments are necessary when a drawing is to be used as a working drawing; that is to say when dimensions, angles and forms in the drawing will be used as guides to the production of an object, whether it be a piece of engineering, a building or a bridge. The instruments employed are largely dictated by the conventions of drawing being used, but these normally include the T square, rule, set-squares, compasses, and more sophisticated instruments such as french curves.

Artists tend to eschew the use of instruments on the grounds that they produce a kind of mechanical quality in the drawing, or even that there is something immoral in 'cheating' by using an instrument rather than skill of the unaided hand. Although there is a degree of truth in these sentiments, there have been examples of artists who have made effective use of instruments; and in art there is, of course, no such thing as 'cheating'.

LANDSCAPE

Landscape has played a role of major importance as a source of subject matter in the artistic culture of many nations. One need only compare works as diverse as those of the medieval illuminators, the Dutch masters of the seventeenth century, Turner, the Impressionists, the Persian miniaturists and the classical painters of China to be convinced that landscape is, in its own way, as capable of expressive range and power as depictions of the huma figure. The history of landscape in pictorial art can be summarized in terms of three main phases, all of which are worth considering since they provide pointers for contemporary practice.

Landscape first began to play an important role in the history of Western art in the late medieval period, when it was used principally as a background and an accessory to subjects featuring the human figure. A curious characteristic of much early landscape is that the horizon line is often placed very high and the content of the landscape distributed

Huang Shen: *Kowloon beach.* Hanging scroll, mid-eighteenth century Ink and colours on paper, 89.5 cm × 117.5 cm *British Museum, London*

Pieter Bruegel the Elder: *Sea landscape with rocky island and the holy family* Pen and brown ink, 20.3 cm × 28.2 cm *Kupferstichkabinett, Berlin*

vertically up the paper in a way which suggests that vertical location is to be taken to mean distance from the spectator. This was often combined with little or no attempt to suggest depth by diminution of scale. The 'piling-up' technique of landscape composition reached its peak in the sixteenth century with the work of Dürer and Breughel, although in their cases it was combined with a surer grasp on the principles of scale recession. The general effect is that the spectator is viewing the scene from a high vantage point.

During the seventeenth century landscape began to acquire greater prestige as an autonomous subject with the result that the figures in subject pictures often shrank to tiny proportions against their landscape setting. In the idealised landscapes of Claude and Poussin, the landscape itself carries the greatest responsibility for conveying the mood or meaning of the picture, rather than the facial expressions and gestures of the figures, which are often too small to carry much weight. Out of this tradition of idealised landscape, which did not attempt to represent the real world but rather a landscape of the mind or imagination, evolved the idealized and often sentimentalized landscape of the eighteenth century, when the subject was regarded by many as little more than a pleasant source of decorative forms.

The third tradition of landscape is that of realism, which reached its first major expression in the art of the Netherlands in the seventeenth century. In this tradition, significant human subject matter tended to disappear or to take only a supportive role, and the landscape itself is treated as a poem in light and the evocation of a mood. An

Claude Lorraine: Landscape study.
Pen, pencil and brown tint,
25.4 cm × 34.3 cm
Victoria and Albert Museum, London

John Constable: *On the Stour, Dedham church in the distance.* About 1830
Sepia ink, 22 cm × 16.7 cm
Victoria and Albert Museum, London

interesting feature of the realist tradition is that the horizon line dropped very low in the composition, often as little as one seventh above the bottom edge. The effect is to increase the size and importance of the sky, which Constable was later to call 'the chief organ of sentiment' in the landscape. The result of this kind of composition is that the spectator feels that he is actually standing *in* the landscape, rather than, as in the medieval tradition, perched on some hypothetical hill top or tower.

Two concepts which became very important in relation to the landscapes of the late eighteenth and early nineteenth centuries were what was known as the picturesque and the sublime. Picturesque originally meant 'worthy of a picture' in the sense of having obvious pictorial qualities. However, it gradually took on a more confined meaning, being used to refer to landscape subjects which contained curious and intriguing features such as ruined buildings, waterfalls, and oddly shaped trees. The quest for the picturesque had the unfortunate effect of blinding the artist and the nature lover to the more obvious qualities of everyday landscape views, and it is understandable that the word has acquired a pejorative flavour akin to adjectives like 'quaint' or 'cute'.

The expression 'sublime' became very popular during the late eighteenth century as a way of describing landscape effects which were impressive not because of their conventional beauty but because they were awe-inspiring expressions of the forces of nature. Sublime subject matter, common in the work of Turner and his generation, included themes such as violent storms, avalanches, floods, deserts,

Thomas Rowlandson: *Dr Syntax sketching a waterfall* Pen and ink and water colour, $13\,cm \times 22\,cm$ Rowlandson parodies popular interest in the picturesque *Victoria and Albert Museum, London*

and other extreme manifestations of nature. Draughtsmen with a taste for the sublime often spiced their drawings with a high degree of imagination, increasing the height and barrenness of mountains and the violent destructive force of the storm in order to intensify the impact of their subject.

The realist landscape of the seventeenth century provided the principal impetus for the flowering of the subject area in the nineteenth century, through such great exponents as Crome, Cotman, Constable, Turner, and, later, the Impressionists. Towards the end of the century one finds evidence of a deliberate return to a sense of classical order and structure in the work of Cézanne and Seurat.

Because books and reproductions have widely disseminated the work of these early masters, anyone tackling landscape as a subject today must inevitably work in the consciousness of this tradition. In a sense, we have been taught to see the landscape as much by looking at images of it as by contemplating the landscape itself. Consequently, no apology is needed to cite the work of past masters in considering the problems of the present.

The contemplation of landscape is itself a source of comfort and pleasure to many people. As an increasing number of the population become urban dwellers, the pleasure of a weekend in the country or a holiday at the seaside provides us with visions which we feel the need to express on paper. One of the most difficult truths which has to be grasped as soon as possible is that landscapes which are a joy to behold are not necessarily good subjects for a drawing. Very often what moves or excites us in a landscape, such as brilliant

LANDSCAPE

David Cox: *A mountain landscape*
Water colour, 35.5 cm × 52.4 cm
Tate Gallery, London

contrasts of tone and colour or a sense of dramatic movement are almost impossible to render with graphic means. This might sound like a counsel of despair, but in fact it is the reverse. In looking for a subject, we must learn to identify what is capable of graphic treatment. When we have come to terms with this truth it is possible to enjoy the other splendours of nature without feeling an unsatisfied urge to do something about them.

For confirmation of this point, one need only compare the locations of many famous landscape artists with the drawings based upon them. At first sight the flat Dutch landscape has little that is obviously pictorial about it, but Rembrandt made it the theme of some of his greatest drawings. Admittedly, many draughtsmen have represented locations of great scenic beauty; but as often as not we find that they *discovered* this scenic beauty for the first time, and taught the public to look at it in a more appreciative light. In choosing a subject, therefore, one should not look so much for obvious scenic beauty, but for motifs and viewpoints which will provide the stimulus and the raw material for an exciting graphic image. This is as likely to be a field of allotments with ramshackle huts and fences as a cottage garden full of hollyhocks and roses.

The field of vision represented in many subjects is quite broad in comparison with its depth. When we draw a still life, or a figure posed against a wall, we may well find ourselves dealing with a represented depth of, say 6ft (1.8m), and a represented breadth of the same or slightly more. A striking difference in landscape is that the depth is invariably very much greater than the breadth. Our foreground might amount to no more than twenty yards across, while the most

134

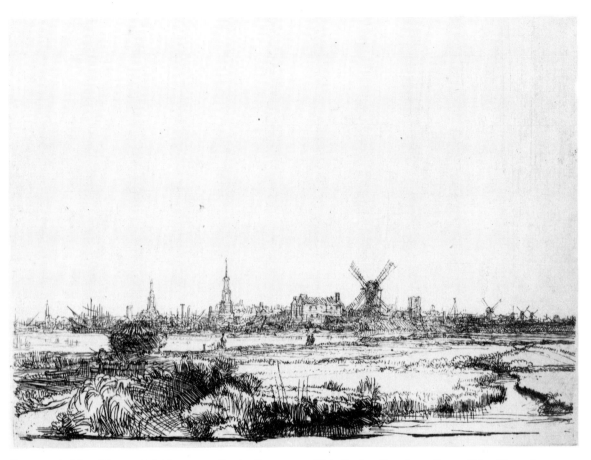

distant visible object might be some five miles away. This fact has important implications for every aspect of landscape, and explains why so many draughtsmen who have mastered other subjects find landscape an insuperable problem.

Depth in a landscape can be suggested by several means. The most obvious is contrast of scale, according to which objects of an identifiable size such as figures, roads, buildings, etc, diminish in perceived size as they recede from the eye. Objects which are not of a predictable size, such as trees, can also be used, since the scale contrasts may be so great that they are interpreted as depth rather than as local variations in the real size of the trees.

Closely linked to the question of the scale of objects in terms of their overall proportions, one must constantly bear in mind the scale of the marks used to depict them. Just as the perceived size of objects diminishes with distance from the eye, so too does the distinctness of their profiles and the clarity of their internal detail. This can be suggested by decreasing the weight of the marks used to depict them; in

Rembrandt van Rijn: *View of Amsterdam from the North.* About 1640 Etching, 11.5 cm × 15.5 cm Rembrandt's landscapes often lack any obvious topographical interest, depending upon quality of observation and expression
P. and D. Colnaghi & Co Ltd, London

135

fact, the marks which constitute a drawing have a scale of their own which is just as important as the question of proportion. The landscape drawings of Van Gogh admirably demonstrate the effect of recession achieved through variation of the scale of the marks. Following the same principle, depth can be suggested by reducing the tonal weight of distant objects.

These general suggestions must be treated with discretion, as it may be in the nature of the subject or part of the intention of the artist that the middle or far distance should carry more weight than the foreground, so that the eye is led quickly over the nearest part of the subject to some more distant point.

When choosing a subject and a **station point** one should try to identify visual clues which will assist the eye to move in depth. These may take the form of juxtaposition of sudden changes in scale, or objects such as a road, a fence or a plank which lead the eye into pictorial depth along a diagonal. What is known as *repoussoir* (pushing back) is achieved by placing a striking, large motif such as a building or a tree in the foreground in order to make the rest of the image recede.

John Minton: *Surrey Landscape.* 1944 Pen and ink and wash on paper, 54.5 cm × 74.8 cm *Arts Council of Great Britain*

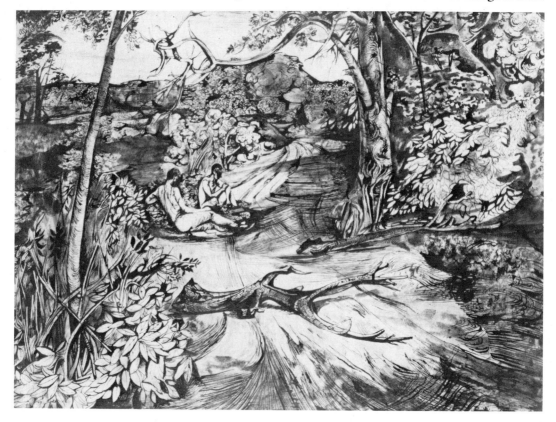

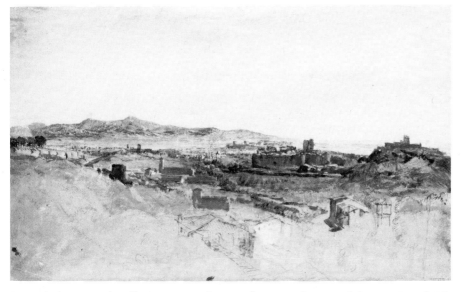

J. M. W. Turner: *The Alban Mount* Water colour, 22.6 cm × 36.8 cm *British Museum, London*
Alexander Cozens: *Landscape* Indian ink with wash, with some pen work, 22.1 cm × 35.6 cm
British Museum, London

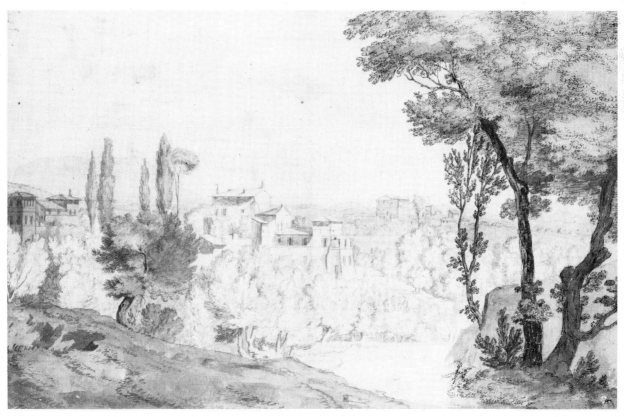

Charles Keene: *Coast scene,*
Devon Etching, 10 cm × 17.7 cm

The art of landscape is, to a great extent, the art of representing depth. But this should always be harmonized with a strong sense of pictorial composition in terms of the flat surface of the paper. In the drawings of Cézanne we see the attempt to relate the depiction of depth to sound design of the picture surface. The factors to be considered here are the location of the horizon line, the location and relationship between the main vertical and horizontal stresses, and the intervals between them. Generally speaking, the motif itself should suggest the design and the mood of the composition, but care should be taken to select a viewpoint which will provide enough interest and contrast for an exciting design.

A key question in landscape drawing is the selection of an appropriate medium. In some cases, artists have stuck to a preferred medium which they have used on every kind of subject, although there is usually a tendency to select subjects which suit the medium. A predominantly linear medium like the steel pen is not suited to broad areas of tone, and great dependence is placed upon subtlety of outline in order to suggest form. Charles Keene was a master of this medium applied to the drawing of landscape.

For scenes with large and strong contrasts of tone, a broad medium such as charcoal or brush and diluted ink is more suitable, as we see it used in the drawings of Claude. In subjects with little or no direct sunlight, tone is generally used to represent local tone, such as we find in a mass of dark trees silhouetted against the sky. In strong sunlight, tone can

138

be used to depict cast and attached shadows. Large tonal masses are particularly effective in subjects known as **contre jour** (against the light), in which the artist faces the light source and sees the components of the landscape from their shadowed side.

Pencil is especially suitable for landscapes which contain relatively intricate detail, such as machinery or buildings, and **watercolour** permits the landscape artist to move beyond purely tonal effects into the realm of painting.

LIFE DRAWING

Drawing from the nude, known as life drawing, has traditionally been regarded as the most demanding and the most fruitful of artistic disciplines, and it is only in recent years that the practice has tended to lose, at least temporarily, some of its prestige in the process of art training. In many art schools life drawing acquired a ritualistic element from the conventions of the timetable, the formal arrangement of easels, the fact that the model held an unnatural pose on a dais, and the air of hushed reverence in which it was conducted. Drawing produced in such forced

Rembrandt van Rijn: Study of a nude youth reclining Pen and ink and wash, touched with red chalk, 17.8 cm × 22.9 cm
Victoria and Albert Museum, London

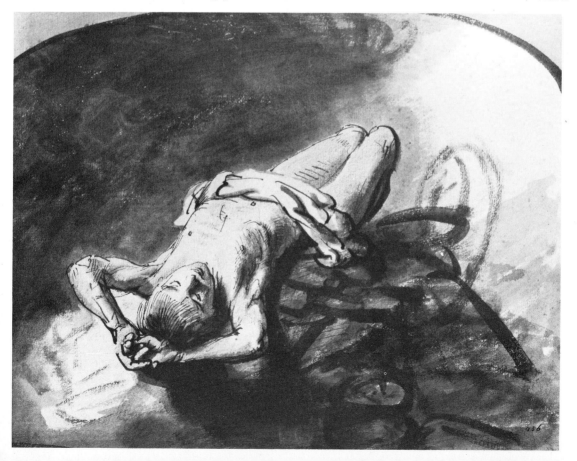

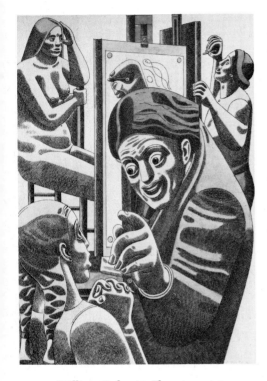

William Roberts: *The art master*
Pen and ink and wash.
34 cm × 24 cm
*Private collection, on loan to
Southampton Art Gallery*

See colour plate
Portrait of Isabella Brant
by Rubens facing page 97

and unnatural circumstances is bound to be influenced for the worse, and it is not surprising that so many life drawings were and continue to be of poor quality. Far from alerting the student's powers of perception to the variety and surprise of visual experience, the ritual surrounding life drawing tended to numb him to visual reality and led to the production of stereotyped 'life drawings' which had no meaningful relation to either life or drawing.

At its best, the life room can be regarded and conducted as a kind of visual laboratory, in which controlled experiments in perception and representation can take place. And like the experimental scientist in his laboratory, the draughtsman from life must constantly ask himself what the purpose of his exercise is, how reliable the data are, and what kind of conclusions can be drawn from them. The great enemy of life drawing is habit, and this must be counteracted by regular changes in the choice and distribution of furniture as well as variety of pose, lighting and period of drawing.

LINE

Line is in many ways the essence of drawing and as such justifies our special attention. It is possible to identify at least three distinct varieties of line as it is used in the art of drawing, which we may call *object line*, *contour* and *shading*. An *object line* is a line which may be interpreted as an object of an essentially linear nature. For example, lines in abstract art and in decorative motifs are often not intended to be read as descriptions of solid objects, forms, shadows, etc, but stand on their own as graphic motifs. The drawings of Paul Klee illustrate admirably this use of line. Also under the category of object line, one should include lines in figurative drawings which serve as a descriptor of a linear object, such as a line representing a hair or a telegraph wire. In these cases the line corresponds so very closely to the thing represented that it requires no very great leap of imagination on the part of the spectator to 'fill out' the marks in order to identify the object they represent.

A *contour line* is a line which represents a boundary or transition between one entity and an adjacent entity—or, in plainer language, the border between one thing and the next in space. Contour line emerges very early in human drawing activity, and small children soon learn how a circular line containing a few marks can suggest that the area of paper enclosed by the line is a head and the area outside the line the surrounding space or air. Contour line has strong as-

sociations with touch as well as vision, since often what it represents is the boundary at which solid matter terminates and the surrounding space begins rather than significant changes in the tone, colour or texture of what is seen. So, for example, a contour line enclosing a round form may signify points on the form where there is a strong tonal contrast between the enclosed area and its surrounding space; but it may also indicate the boundaries of the form where there is little perceived difference, such as the shadowed side of an apple which merges with its own cast shadow. When draughtsmen place a higher value on the tactile content of what they are drawing they tend to use the contour line to provide information about the motif as something which can be touched or felt; draughtsmen who attach greater importance to pure vision tend to use the contour line to capture visual information and hence lose the contour when there is no significant visual contrast such as a sudden transition of tone or colour. This is a complex point which, once grasped, helps us to understand the profound difference in intention and effect between the drawings of, on the one hand, an artist like Michelangelo and, on the other, someone like Whistler. The distinction between the contour as an expression of tactile form and visual form is perhaps related to the theory that we may be divided into haptic (ie tactile) and visual types according to our modes of perception and representation.

It would be mistaken to assume that contour line is exclusively concerned with the distinction between one solid form and another, or between solid forms and their surrounding space. Draughtsmen often use line to indicate transitions of tone or colour, even where there is no corresponding change in the nature of the physical matter. For example, a line may be used to indicate the boundary between the lit and the shadowed area of a cheek, or the points at which one colour in an evening sky grades off into another. Both these cases are examples of the use of line as contour, but in both cases the contour denotes a visual transition rather than a tactile one. It is also possible to use contour line in the manner in which we find it on maps, that is to indicate areas of elevation and depression within a form. For example, closely packed lines at the edge of a form tend to speed up the rate of the turn of the plane away from the spectator in the same way that closely packed lines on a map suggest a rapid gradient.

The third major area of the use of line is in **shading**. Here the line is used to build up an area of tone by means of repeated pulling of the drawing tool across a part of the

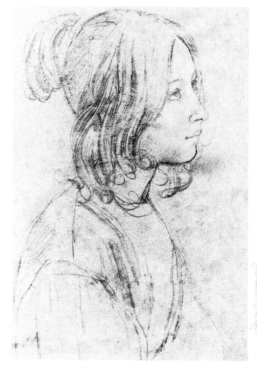

Rudolph Friedrich Wasmann: *Girl with curls, looking up* Pencil on toned paper, 21.5 cm × 16.7 cm *Oskar Reinhart Foundation, Winterthür*

141

surface of the drawing. In some cases, as in much Renaissance drawing, the lines take the form of parallel hatching of the shadowed area. Because most draughtsmen are right-handed, hatched lines tend to move diagonally from bottom left to top right on the paper, and at the time of the revival of interest in Renaissance drawing style at the end of the nineteenth century it was referred to as 'East wind style'. Alternatively, the lines indicating shadows may follow the form they are shading. Used to represent objects of a more or less cylindrical cross section such as an arm or a leg, this is known as 'bracelet shading'. Finally it is possible to use line as a shading medium without hatching or following the form, for example by using a variety of directions and lengths of line in a kind of scribble technique. These examples do not exhaust the possibilities of using line for shading, and they are often found in combination.

Having looked briefly at some of the roles which line might play in the creation of a drawing, it would be helpful to give some thought to the physical nature of line drawing and its

Nicholas Hilliard: *An Elizabethan lady in court costume* Pen and ink with pencil under-drawing, 13.7 cm × 11.6 cm In this drawing line is used to represent contour, as a visual equivalent for decorative motifs in the embroidery, and as hatching to suggest tone and volume
Victoria and Albert Museum, London

Clive Ashwin: *Reclining nude.* 1964
Pastel, 28 cm × 19.5 cm
Although essentially a broad linear
medium, pastel has been used with a
scribble technique to build up areas
of tone
Private collection

expressive implications. Most lines are created by bringing a
pointed marking tool into contact with the drawing surface
and pulling it in one direction or another. (One must say
'most lines', since it is possible to create lines by other means,
for example by pressing the long edge of a piece of crayon on
to the paper.) Depending upon the nature of the medium and
the ability and intention of the artist, the resulting line may
be broad or narrow, fine or coarse, heavy or light, short or
long, constant or variable. It is these variations and
fluctuations in the nature of the line which give most
drawing its distinctive character.

An important ingredient of line drawing is the 'speed' of
the line. A fast line moves incisively in one direction or
another, without appearing to hesitate or waver. A slow line

Augustus John: *Woman with the crazy eyes* Pencil *Isabella Stewart Gardner Museum, Boston*

may be full of small changes of direction, breaks, and variations in weight or density, suggesting that the artist has repeatedly checked and revised its development. Slow lines are often taken to indicate a close attention to nature rather than a spontaneous and perhaps inaccurate account of what is seen. John Ruskin, an advocate of slow line, advised his students: 'The pen should, as it were, walk slowly over the ground, and you should be able at any moment to stop it, or to turn it in any other direction, like a well-managed horse.' It should be observed that although fast lines are usually created by rapid drawing, and vice-versa, this is not necessarily the case, and it is possible to draw lines which look fast quite slowly and with deliberation.

Line represents the strongest link between drawing and writing, and it is not surprising that a distinct similarity can be seen between the writing and the drawing styles of individual artists. For drawing, this can be a dangerous influence, since the line plays very different roles in the two

Hokusai School: Sketch of tiger, with compositional lines Ink on paper, 23.3 cm × 31.2 cm *British Museum, London*

means of expression. In writing, the line is used to repeat and combine the relatively narrow range of graphic units which make up our alphabet and its punctuation. In drawing, the line has a much more extensive and complex role, and draughtsmen who attempt to reduce their lines to a repeatable range of motifs soon run the danger of slipping into cliché. For this reason calligraphic lines tend to vitiate a drawing done from observation. However, there are no absolute rules in art, and one must acknowledge the fact that several artists of distinction have been able to exploit calligraphic marks in their drawing.

Lines have an important role to play in the execution of a drawing as distinct from its final graphic character. For example, a drawing is often commenced with a number of what may be described as constructional lines which serve to map out the broad disposition of forms and masses. These preliminary lines do not fall easily into any of the categories given above and are in fact a bridge between the draughtsman's perceptual process and the final image. Constructional lines are often lost in the subsequent development of the drawing or may actually be erased. They can be left visible in the final drawing and often add to its graphic richness, but care must be taken that constructional lines are not used simply in order to give the drawing a 'busy' surface or as evidence of what a lot of hard work the draughtsman has done in preparing the groundwork of the drawing.

LINEAR PERSPECTIVE

See **Perspective**.

MARKS

Drawing consists of making marks on a surface. As Ruskin so delightfully put it: 'All good drawing consists merely in dirtying the paper delicately.' However, there is an important distinction to be made between the marks which constitute a drawing, and other kinds of marks, such as footprints in sand or food stains on a table napkin. This is that while the latter are merely by-products of a related process (namely walking or eating), the former is a deliberate attempt to use marks in order to convey observations, ideas and feelings.

The increasing interest in the role of the unconscious in artistic creativity during the early part of the twentieth century led to the view that perhaps the artist did not have so much conscious control over the creation of the work of art as had been previously assumed; that, for example, many of the marks which make up a drawing were the result of spontaneous impulses from the unconscious, over which the artist had relatively little control. This led to the popularisation of the concept of 'mark-making' as a way of describing drawing, and a tendency to blur the distinction between drawing and arbitrary kinds of marks such as footprints, stains, spills, etc. Many draughtsmen have, paradoxically, deliberately attempted to escape from the deliberate character of drawing, exploiting arbitrary-looking effects such as smudges, stains and dribbles; and there can be no doubt that these endeavours have enriched and expanded the range of the language of drawing. It seems unlikely, however, that they can ever constitute more than a part of the draughtsman's graphic resources.

MEASUREMENT

OPPOSITE **Jasper Johns:** *Jubilee.* 1960 Pencil and graphite wash, 71.7 cm × 53.3 cm Johns' drawing plays on the contrast between the arbitrary look of the mark-making technique and the sobre formality of the stencilled lettering *Collection, The Museum of Modern Art, New York* Mrs Simon Guggenheim Fund

For most draughtsmen measurement takes the form of a direct visual appraisal without the assistance of measuring instruments. These have, however, been employed extensively in the past and continue to be used by a significant number of contemporary draughtsmen. It should be made clear that when we talk of measuring in relation to the art of drawing we normally mean measurement of the visual ensemble as it is seen from the drawing position rather

146

MEASUREMENT

MENTAL EXCERCISE;
ESTIMATING THE CENTER
RED DOT: DRAWN FIRST, FREEHAND
GREY DOT: DRAWN LAST, MEASURED

MEL BOCHNER, NYC, 1972.

Mel Bochner: Mental exercise: estimating the centre. 1972 Coloured pencil, graphite pencil, pen and ink, eraser, 56.8 cm × 76.2 cm Bochner's drawing is a wry comment about the distinction between human estimation and precise measurement *Collection, The Museum of Modern Art, New York* Acquired with matching funds from Mr and Mrs Eugene V. Thaw and the National Endowment for the Arts

than direct measurement of the motif by placing a measuring instrument in contact with it. The latter technique has been used by a minority of artists, a case in point being the naive painter Henri Rousseau, who used to measure his subjects with a ruler. Generally speaking, lengths and directions are so transformed by being seen from a distance and a certain angle that there are major differences between the real form and size of the subject, and its visual appearance from the drawing position.

The draughtsman may attempt to assess two kinds of information by means of measurement with instruments: angle and length. The most common device for measuring angles is the plumb line. This consists of any substantial weight, such as a large nut, tied to the end of a piece of gut or thread and suspended from a rod mounted at the side of the draughtsman's drawing position. Angles may be assessed by aligning them with the plumb line. Using the same principle, a rod or rule may be mounted horizontally from the side of

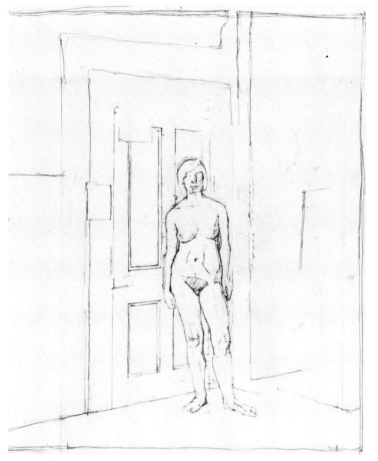

Euan Uglow: *Nude against door.* 1972
Pencil on paper, 59 cm × 51 cm
Arts Council of Great Britain

the drawing board to provide a guide to the horizontal. Measurements of length can be obtained by mounting a rule either vertically or horizontally and viewing it against the subject with one eye closed.

Draughtsmen often improvise a measuring instrument by holding a pencil at arm's length either vertically or horizontally and viewing it against the subject with one eye closed. Lengths are assessed by moving the thumb along the length of the pencil. The procedure has been criticised on the grounds of its inaccuracy: it is impossible to ensure that the pencil is being held vertically (or horizontally), and slight variations in the distance from the eye to the pencil produce major variations in the assessment of the sizes of forms. This criticism is justified, but I fancy that many draughtsmen who use the technique do not expect to get precise measurements from it, but regard it as a way of reminding themselves of the need to concentrate on the evaluation of angles and directions.

149

A note of caution to be entered here is that drawing which is too dependent upon measurement with instruments can become rather stereotyped. Extensive use of measuring instruments may produce a dry map-like appearance in the drawing, with angles and junctions cluttered with small ticks and crosses. Strangely enough, this kind of surface appearance has its own visual appeal; and it may also be taken as a token of the earnestness and hard work which has gone into its creation. But as Matisse put it: 'Exactitude is not truth.' Drawing is much more than merely mapping points, angles and directions in relation to the picture plane, and an excessive preoccupation with measuring can divert the draughtsman's attention from other equally important ingredients of a drawing, such as the linear flow and rhythms of contours and the movement of volumes and voids in depth.

MEDIUM

Strictly speaking a medium (plural: media) is the liquid with which pigment is mixed in order to produce a paint. It has a double purpose; first, to facilitate the spreading of the pigment, and secondly to bind the pigment to the ground or support when the paint is dry. Hence the medium of **water colour** may consist of water, which acts as the solvent, and gum arabic, which provides adhesion. The word medium can also be applied to materials which are named after the solvent used, such as is the case in 'oil painting' and 'water colours'.

However, in contemporary usage the word has acquired a much broader meaning, being used to refer to the whole constituents of both wet and dry materials; that is, not only the solvent and binder of a fluid material, but any form of pigment together with the drawing implements used and even the nature of the support or ground. So, for example, a drawing may be described as in the medium of pen and ink on toned paper. Although this usage may be regarded by some as incorrect it is now so widespread that it should be accepted as legitimate.

MEMORY

All drawing, it has been claimed, is memory drawing, since even when drawing from observation what is seen must be stored, albeit briefly, in the memory before being interpreted in the form of marks in the drawing. Furthermore, it is

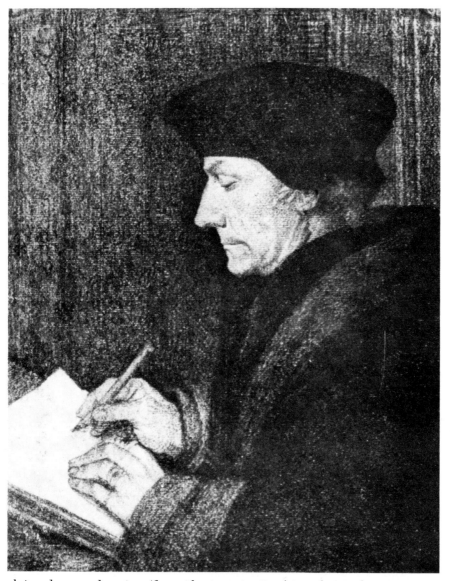

claimed, even drawing 'from the imagination' is a form of memory drawing, since we can do no more than call to mind images which have been stored up in the memory and present them in different combinations. There is a certain degree of truth in this view, but it tends to oversimplify the question. First, when we draw from observation we do not always look, perceive, remember and draw in that sequence: often the hand races ahead of the eye. Similarly, to claim that invention merely consists of new combinations of remembered forms rules out the possibility of the evolution of pictorial art, which is so manifestly evident.

Alphonse Legros: Memory drawing of Holbein's portrait of Erasmus. 1850s This drawing was done while the artist was a pupil of Horace Lecoq de Boisbaudran, the leading French exponent of memory drawing and teacher of Rodin, Fantin-Latour, Dalou and many other prominent French artists of the period *Location unknown*

The principal value of regularly drawing from memory is that it demonstrates just how feeble and fragmentary our perception of forms is. Immediately we attempt to draw the most familiar object from memory we discover that what we thought was quite simple and familiar is in fact remarkably confused and vague. The practice of close observation of an object or a situation followed by drawing it from memory cultivates the habit of directed looking as distinct from mere passive seeing.

Memory drawing enjoyed a period of considerable popularity in the mid-nineteenth century, when the French drawing teacher Lecoq de Boisbaudran made it the central principle of his teaching. He required his students to draw detailed studies of master works from memory, as well as getting them to observe the moving life model and then draw it from memory. The value of his teaching is reflected in the fact that many eminent artists went through his studio, including Rodin, Fantin Latour, Dalou and Legros.

There can be no doubt that exercise in drawing from memory which is intelligently conducted can provide a valuable part of the draughtsman's technique. However, one feels bound to express a note of caution about the practice. This is that when the mind is not supplied with information derived from observation it is very common for the hand to fall into the habit of producing the forms which come most easily to it, such as calligraphic scrolls and arabesques. An excessive dependence upon these forms is likely to produce elegant, but, in the final analysis, boring drawings. This problem is evident in some of the work of Legros, and it was a characteristic which he communicated to some of his students at the Slade School, of which he was principal 1876–1892.

METALPOINT

Previous to the development of graphite pencils during the late sixteenth century metalpoint was virtually the only drawing medium which was capable of producing a fine, even, and completely controlled line. The principle of metalpoint is that a metal stylus is used to make marks upon a prepared surface. The technique was employed by mediaeval merchants for making out accounts and records, and it rose to a level of considerable popularity as a drawing technique during the late mediaeval period and the early Renaissance. In addition to being used as an independent drawing medium, metalpoint was also used in the preparation of painting surfaces, for example for drawing in the

OPPOSITE **Leonardo da Vinci:** *Bust of a warrior in profile* Metalpoint on cream prepared surface, 28.5 cm × 20.8 cm *British Museum, London*

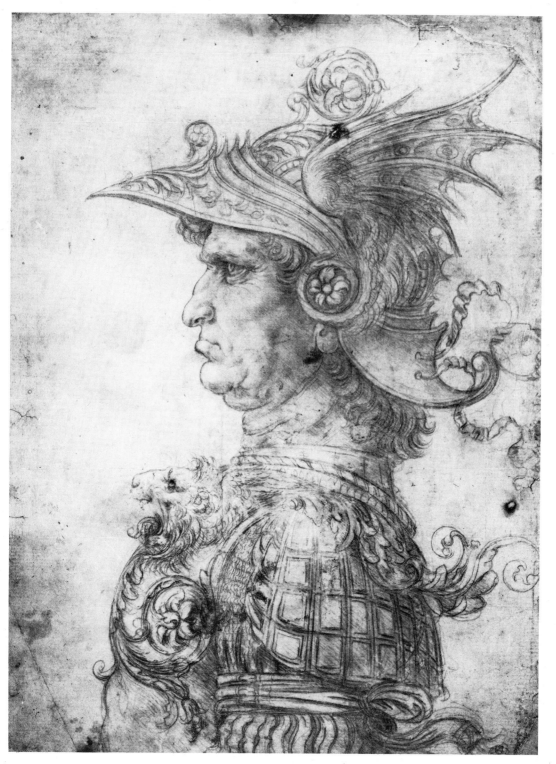

perspectival construction of a scene before the addition of figures. During the late sixteenth century the growing preference for atmospheric and textural effects combined with the availability of pencil led to a swing away from the use of metalpoint and it fell into disuse. It was revived again by a number of artists working during the late nineteenth century, notably Frederick Leighton and Alphonse Legros, and continues to be practised by a limited number of artists today. As there is no longer a commercially viable demand for metalpoint materials they are not now manufactured by suppliers of artists' materials; it is, however, relatively easy to produce one's own materials.

Metalpoint drawing requires two ingredients, a stylus and a prepared surface. The stylus can be made of a fine rod or wire of almost any metal, including silver, gold, copper, lead, tin, and alloys of these and other metals. Silver has traditionally been regarded as the most useful metalpoint, to such an extent that the term 'silverpoint' is probably more widely known than 'metalpoint'. The metal stylus is mounted in a shaft-like carrying handle made of wood, metal or synthetic material. Because the metal point wears very slowly the carrying handle used often to be decorative or ornate in design.

The drawing surface is prepared by painting a support with a solution and allowing it to dry. This solution can consist of white lead, or can be made by mixing powdered animal bones with water and linseed oil. It should be remembered that early papers were not normally white and were also fairly coarse in texture, so the addition of the ground provided a smoother and more even surface for the draughtsman to work upon. Colouring agents may be introduced into the ground in its fluid state, providing a wide range of tints.

Every metal makes its own distinctive colour and quality of mark, and this fact, combined with the variety of grounds which are obtainable, creates an enormous number of possibilities for the metalpoint draughtsman. It should also be noted that many metalpoint drawings change with age. (For a comprehensive account of preparation and working procedures, see James Watrous *The Craft of Old-Master Drawings*, Wisconsin 1957.)

The most attractive and distinctive quality of metalpoint drawing is its perfectly even, fine and delicate line. Unlike working with the pen or brush, metalpoint requires no periodic re-charging, so the line can be continuous in any direction. Its greatest limitation is that it cannot easily be varied in either thickness or intensity, and in this respect it

has a great deal in common with etching. Metalpoint is not capable of rich textural effects such as we find in broad point media like chalk or charcoal, or of the variations of the thickness of line of which the quill pen is capable. Because the scale of the mark is strictly limited by the thickness and character of the metal stylus, metalpoint is suited to a modest scale of working, and if used to exceed its natural limits can look pale and starved.

MINIATURE

The word miniature is derived from the Latin *minium*, the name for the red lead used to decorate initial letters in manuscripts, the artist being known as a *miniator*. Since the seventeenth century the meaning has been extended to include not only all kinds of manuscript decoration but, as a result of a confusion with the adjective 'minute', very small paintings in general.

The undisputed master of the portrait miniature is Nicholas Hilliard (c 1547–1619), who satisfied the Elizabethan taste for what were described as 'pictures in little'. Hilliard referred to his technique as 'limning', a word related to 'illumining' or 'illuminating', and it is clear from a study of his methods that the medium he used was similar to what we know today as water colour and gouache. An interesting modern commentary on his materials and methods is contained in the edition of his treatise *The Arte of Limning* (1981) edited by R. K. R. Thornton and T. G. S. Cain.

See colour plates
by Holbein and Hilliard
facing page 216

The production of portrait miniatures, usually intended for wearing in a brooch or locket, continued until the middle of the nineteenth century, when it was brought to an abrupt halt as a result of the availability of the cheaper and, to the popular mind, more faithful photograph.

It might sound rather quixotic to suggest that we have something to learn from the contemplation, and perhaps the creation, of miniatures. In an age of enormous colour field paintings and expansive, gestural abstract expressionism, the special virtues of the miniature have tended to be swept aside. The ambition of the miniature painter is to combine minuteness of scale with the greatest intensity of expression and content. In the art of the miniature, painting and drawing approach most closely the art of the jeweller. When we speak of the impact of scale, we usually intend to mean that of large scale; it should be remembered that small scale can have its own kind of impact, in its own way as intense as the other extreme.

See colour plate
by Deccan artist
between pages 216 and 217

NATURALISM

Naturalism is one of the most problematic terms in the vocabulary of art, and it has a crucial relevance to the art of drawing. I shall begin with a simple definition and then go on to more complex interpretations. Naturalism means 'like nature'. In relation to the art of drawing, it means creating imagery which reminds us vividly of the real world as it is, as it was, or as it might be. It is important to bear in mind that naturalism does not mean creating convincing images of things which necessarily have a real existence, or which had a real existence in the past. Nor do we need to have had direct experience of the thing represented. A drawing is said to be naturalistic when it conforms to our knowledge of the logical probabilities of nature; when objects, events and forms relate to one another in a way which accords to the real world as we experience it, or as we believe it to exist. The quality of naturalism is expressed through the combination of objects and figures in plausible relationships, the depiction of form and scale according to the laws of proportion and perspective, and so on. Consequently, a drawing can be a total invention, but at the same time be completely naturalistic.

Although it is impossible to give such terms a fixed and scientific meaning, naturalistic art is art which sets out to depict the material world as objectively as possible. Naturalistic art does not attempt to stylise forms according to some preconceived notion of artistic style; nor does it set out to improve on nature by the selection of certain features and suppression or omission of others, an approach which we may describe as 'idealisation'. It should also be distinguished from Realism (usually spelt with a capital 'R'), which also attempts to represent the unadorned material world but normally makes a feature of its grimness for the purpose of conveying some moral, social or political viewpoint.

As examples of stylisation in drawing one may cite the work of the Italian Mannerists of the sixteenth century. Idealisation is common in the drawings of the High Renaissance as well as in the academic work of the nineteenth century. Fine Realist drawings were produced by Millet and Daumier.

In theory at least, naturalism differs from all these tendencies in that it is the product of 'the innocent eye', refusing to select or omit, not subjecting what is seen to any preconceived stylistic formula, and not conveying any moral or social judgement. Naturalism should be distinguished from **illusionism**. All illusionistic art sets out to look like nature, but with the additional intention of deceiving the spectator into believing that it is in fact nature, and not a work of art, which he is witnessing. Naturalistic art rarely strives for illusionistic effects. The drawings of Constable may be cited as good examples of naturalism.

Modern theorists have called into question the whole concept of naturalism, arguing that there is no such thing as an 'innocent eye', since all art depends upon the selection

Gerardo Pita: *Natalia.* 1978 Pencil on paper, 42 cm × 40 cm
Fischer Fine Art Ltd, London

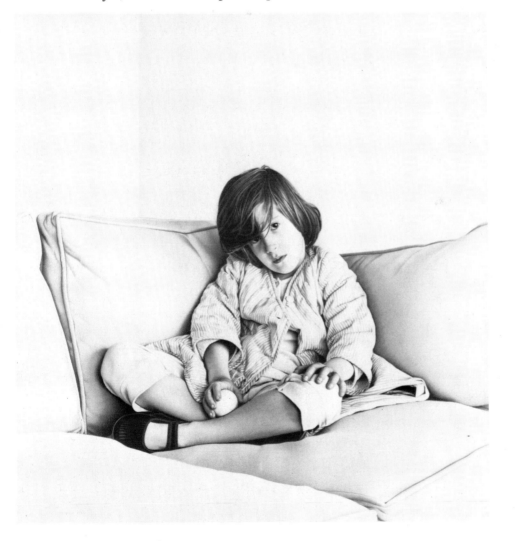

157

and representation of experience according to some agreed code, be it graphic, pictorial, literary, musical, or whatever. It has furthermore been claimed that all art reflects some identifiable social, cultural or political point of view, and that when this point of view is most difficult to detect it is in fact most pervasive and influential.

We might, for example, ask ourselves why Constable selected his subject matter from such a tiny area of England, and why, at the same time as presenting a heart-warming account of the English countryside he seemed to be totally blind to the dreadful hardship of the peasants who appear as details in his work. A cynical explanation is that Constable came from the class of land-owning English gentry, and his pictures were intended to celebrate, amongst other things, the possession of the most valuable form of property: land. The same class had a vested interest in ignoring or suppressing anything which might be calculated to disturb or challenge their dominant position in society, and the most serious threat to their position came from the poor, the dispossessed and the hungry. This might sound like a rather devious or bizarre reflection on what appears to be an innocent piece of naturalism, but it represents a challenge to the simple-minded view of naturalism which is still widely accepted.

Perhaps the most helpful approach to the idea of naturalism is not to regard it as a quality of art works, but as an intention in the artist's mind, however successfully that intention might be realized.

PAINTER'S DRAWING

With few exceptions, able painters have tended also to be capable and prolific draughtsmen. Although one cannot claim that there is such a thing as a single kind of 'painter's drawing', or an approach to drawing used by all painters, it is possible to point to a number of ways in which drawing has been used to serve the special needs of painting.

On the most basic level we have drawings produced by painters for the purposes of gathering information which is later to be used in a painting. The sort of information sought

in this kind of drawing depends entirely upon the character of the artist's painted work and his immediate interests at the time of doing the drawing. Drawing is a good way of noting and capturing information such as details of pose, dress, architecture and other accessories. Such drawings include notes of curious or unusual postures, distinctive character of form, scale and recession in a landscape, and written colour notes.

As time is often at a premium the painter should concentrate upon the use of portable, convenient and rapid media such as pencil, fountain pen and sketch pad. There is a distinct difference of attitude between those who carry drawing materials only on special occasions and those who are never without some kind of sketching medium, however rudimentary. In many cases the draughtsman outside the studio may be working in difficult, uncomfortable circumstances or against the clock, and the great test is the ability to direct his observation to capture the essential elements of a scene with the greatest economy of marks. Although relatively fine point media such as pencil are most manageable in such situations, in some cases a broad tonal medium like charcoal or ink wash might be of value in capturing broad dispositions of tone and form.

In addition to gathering information out-of-doors and away from the studio, the painter is often in the position of having to use drawing in the studio as a way of recording or manipulating source material. When the great portrait painter Hans Holbein found himself with the task of painting a whole series of dignitaries, right up to the king himself, he was confronted with the problem that none of his subjects would have the patience to sit for the duration of one of his meticulous paintings. His only solution was to draw in a way which was so precise and economical that he could reconstitute the likeness of his sitter from the drawing alone. Although this situation may be regarded as a nightmare by many lesser portrait painters (as it is by some very capable painters), it may well be that it inspired Holbein to use drawing with unprecedented precision and economy. What many artists regard as a problem, others turn to good account by treating as a challenge.

One of the traps in drawing for painting is to attempt to get the drawing to anticipate or emulate the qualities which one hopes to achieve in the painting. There is a temptation to begin to develop the drawing in the direction of full tonal range, textural variety and even to introduce real colour. This is a danger which must be watched and controlled. It should always be borne in mind that the drawing is

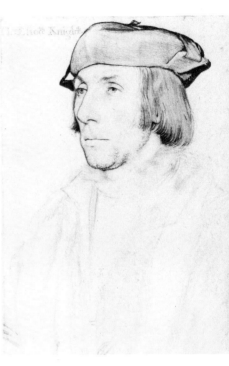

Hans Holbein: *Sir Thomas Elyot* Chalk and pen and ink, 28.5 cm × 20.3 cm *Windsor Castle. Reproduced by gracious permission of Her Majesty the Queen*

159

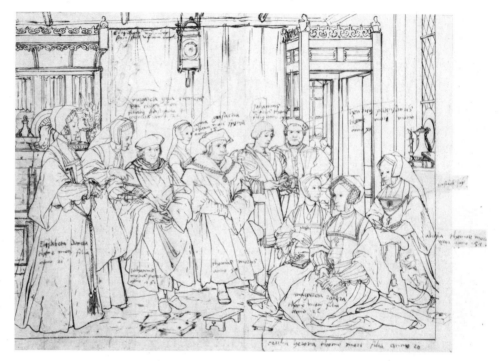

Hans Holbein: *The family of Sir Thomas More.* 1526 Pen and ink, 38.7 cm × 52.4 cm *Kupferstichkabinett, Basel*

Gentile Bellini: *A Turkish woman* Pen and ink on paper, 21.5 cm × 17.7 cm *British Museum, London*

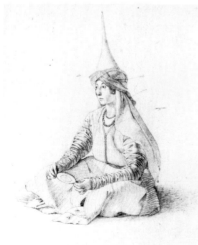

essentially a document or a set of notes in relation to painting, which may serve as an aid to the memory. By pushing the drawing too far in the direction of painting, one begins to undermine the drawing's identity as a drawing, in addition to defusing the sense of excitement which one derives from tackling the idea afresh with paint. Many painters have added written colour notes to their drawings, a procedure which with regular practice can be an effective method for recording colour observations.

In addition to the use of drawings as documents, as ways of capturing and recording information for painting, we have what might be called 'working drawings' in which ideas for paintings are turned over, developed, and clarified prior to beginning on the painting itself. There is, of course, no very hard and fast distinction between these two uses of drawing for painting; even when noting the most minor detail on a sketch pad the painter is often thinking about how it might possibly be used in a painting. At a later stage, however, the painter might be working more from his documents and studies and from his own invention, than from direct observation, and it is at this stage that the scheme for a painting often becomes resolved. Not all working drawings originate in observation, and many drawings consist of quite spontaneous expression of pictorial ideas with little or no dependence upon observation.

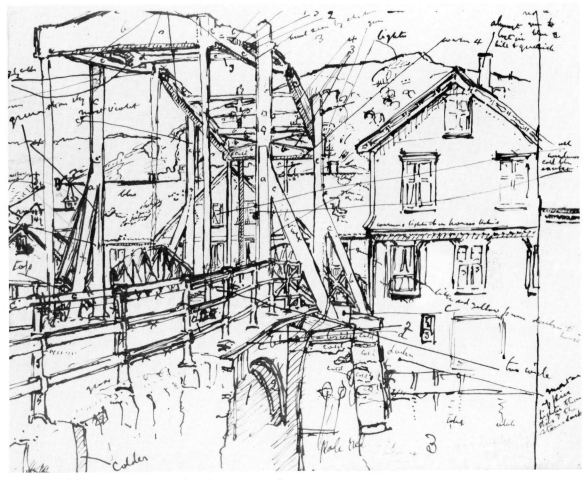

Harold Gilman: Study for *Canal Bridge at Flekkeford* Pen and ink, 23 cm × 29 cm
Tate Gallery, London

A frequently used way of converting drawings into paintings is to 'square up' the drawing by superimposing a grid of horizontal and vertical lines, replicating this grid at a different scale on the painting surface, and transferring the image square by square. Some painters even work on squared-up exercise paper, although most would find the printed grid of lines disturbing to draw on. The purpose of squaring-up is to convey the form of the drawing with some precision on to the painting surface. When one re-draws an image, especially on a larger scale, there is a tendency for the hand to slip into habitual movements and forms, resulting in a dull, predictable drawing. Consequently, if a drawing is to be transferred by squaring-up it should be done with some precision in order to maintain the full character of the original. If transfer by squaring-up is not done with a degree of precision, one might as well dispense with the squares all together and rough it in by eye.

161

Robert Bevan: *The feathered hat.*
Study for a portait of the artist's wife.
About 1915 Black chalk on wove
paper, 36 cm × 40.5 cm *Victoria
and Albert Museum*

Inexperienced painters may feel frustration as a result of the fact that their drawings do not contain enough information for the needs of their paintings. This is particularly true in relation to colour, where one is often thrown back upon the resources of a deficient memory or an equally undeveloped inventive power. The problem originates in a misconception about the relation of drawing to painting. It is wrongly assumed that when accomplished painters work from drawings, they derive all their information for a painting from the related drawing or drawings. This is rarely if ever the case. A drawing might provide a significant part of the content of a painting, but it is normally only a part, and it must be supplemented by a great deal more from the painter's total range of skills and

experience. The ability to use drawings effectively as documents for paintings is based upon a high level of command of directed observation, visual memory, and skilled manipulation of the medium.

In addition to the creation of drawings as an ancillary or parallel process to the act of painting, an important function of drawing for many painters consists of the laying out of a painting prior to its execution in colour. This class of drawing is often overlooked for the simple reason that it normally disappears in the course of developing and completing the picture. The fresco painters of the Renaissance used a red ochre medium called sinopia to draw their subjects, before commencing with the wet plaster, and many of these drawings have been revealed in the course of recent restoration projects. Another form of drawing, used in the preparation of panels, was to score the main lines of the composition with a sharp metal tool or stylus, and a close examination of panel paintings often reveals the indentations which result from the under-drawing showing through the paint.

It is common for painters in oil colour to use a dilution of some fairly neutral colour such as burnt sienna for under-drawing, gradually progressing by stages to monochrome blocking-in of the main forms and then on to full colour. One of the best sources for the study of under-drawing technique are unfinished or abandoned master paintings.

Thomas Lawrence: *William Wilberforce.* 1828 Oil on canvas *National Portrait Gallery, London*

163

PAPER

Paper derives its name from the Egyptian *papyrus* plant, which in ancient times provided the raw material for the manufacture of a support suitable for both writing and drawing. In the ancient papyrus process, strips of papyrus pith were first laid side by side. A second layer was laid at right angles to the first, a third at right angles to the second, and so on until a substantial thickness of papyrus was built up. This was treated with a glue additive, pressed flat and dried out. Papyrus has a distinct grain which results from the directions in which the strips have been laid, but it is also smooth and absorbent enough to make an admirable support for both drawing and writing.

Early papers were, like papyrus, made from vegetable fibres, distinguishing them from supports made from animal materials, such as vellum and parchment. The fibres were soaked in water and reduced to a pulp. After the introduction of certain additives to give the pulp cohesion and strength, it was lifted out of the vat on a wire grid and the surplus water was allowed to drain off. As the paper dried out, the wires of the grid left an imprint of parallel lines on the surface of the paper which was visible in the final product.

Paper was being made in the Far East as early as the second century AD. In the mid-eighth century the invention was carried to the Middle East by Turkish warriors and travellers, and from the twelfth century onwards it appeared all over Europe. These early papers were not white, but beige or grey, and were often treated with a whitening mixture which provided a surface suitable for working with a metal point. Bleaching of paper did not become common until the eighteenth century. Up until about 1800, paper was normally made of pulped rags. After this date it became common practice to control the quality of the paper by the use of additives such as china clay, size and starch. Wood pulp became regularly used for the manufacture of paper during the mid-nineteenth century, and this development combined with the introduction of improved machinery for mass production made it the cheapest convenient support for drawing and writing.

In addition to the techniques of manufacturing paper developed in the Western world, it is important to mention the rich variety of papers used in the Middle and Far East. These include papers made from bamboo, rice straw and mulberry bark. Oriental draughtsmen and calligraphers tend to prefer a paper which is thin and highly absorbent. This has the advantage that it drinks the ink from the brush

or pen immediately into the fibres of the paper, but the corresponding disadvantage that it is impossible to make corrections. The thinness of many Oriental papers also permits an image to show through on the reverse side of the sheet, which explains why Japanese books were traditionally designed on a concertina principle so that only one side of the paper was utilised.

Many terms have been used to describe different surface finishes of paper. Paper with a rough finish is known as 'antique'. The pattern of parallel furrows which resulted from the wire strainers used to dip the paper pulp from the vat is nowadays imposed mechanically on to the surface of the paper. Paper with a normal surface is referred to as 'machine-finished', and smooth paper as 'plate-pressed' or 'hot-pressed'. The introduction of highly detailed printing blocks at the end of the nineteenth century created a need for

Thomas Gainsborough: Studies of two goats. Late 1780s Black chalk heightened with white on buff laid paper, 17.5 cm × 21 cm The conspicuous texture of the laid paper makes a positive contribution to the quality of the image
Victoria and Albert Museum, London

165

Richard Parkes Bonington: *The Grand Canal* Pencil, with some touches of wash and heightened with white, 20.5 cm × 28.8 cm The tone of the paper has been fully utilised in the development of the composition *Tate Gallery, London*

paper with an extremely smooth surface, and this was achieved by coating with china clay, producing what is known as 'art paper'.

Paper is manufactured according to a range of accepted sizes, each with a special name. These include Demy (20 in. \times $15\frac{1}{2}$ in.), Medium (22 in. \times $17\frac{1}{2}$ in.), Royal (24 in. \times 19 in., or sometimes 20 in. \times 25 in.), Imperial (30 in. \times 20 in., or sometimes 22 in. \times 30 in.) and Double Elephant (40 in. \times $26\frac{3}{4}$ in.). These are now being widely replaced by the so-called A sizes, principally A4 (297 mm \times 210 mm), A3 (420 mm \times 297 mm), A2 (594 mm \times 420 mm), A1 (841 mm \times 594 mm) and A0 (1189 mm \times 841 mm).

As a support for drawing, paper has so many advantages that many draughtsmen would never think of using anything else. It is light and highly portable; it is easily stored; it can be manufactured in an infinite variety of surface qualities, colours and sizes; and it is cheaper than any other comparable support. Paper can be made to accept almost any conceivable marking medium, fluid or dry, and in

166

many cases correction by means of erasure or over-drawing are quite possible.

As with so many other technical questions, there is an unfortunate tendency to gravitate to the most obvious and most easily available type of drawing paper, namely white cartridge, although this is far from suited to all techniques and styles of drawing. Many drawings need more surface grain than is provided by cartridge, or perhaps a little colour to reduce the glare of the white. On the whole, paper is prized for its ability to accept and absorb the medium without permitting it to spread beyond the point of contact with the marking tool; but some drawing styles actually benefit from a slight tendency to spread, in which case a thin fibrous paper is preferable, giving an attractive smokey effect to edges similar to working on textiles with a fluid medium.

PASTEL

Pastel is a man-made broad-line medium similar in its manufacturing process to artificial chalks. In the case of pastel, pure ground pigment is mixed with gum, resin or other binding agents to make a paste (hence 'pastel'). The paste is rolled into a cylindrical form, cut into lengths, and then left to dry or lightly fired. The result is a soft, responsive medium. Records of the use of pastel date back to the sixteenth century, and in the early days of its manufacture numerous additives such as sugar candy, whey, beer, oatmeal and fish glue were tried. During the nineteenth century gum tragacanth was adopted as the principal binding agent. Pastels which consist of pure pigment and binder are extremely intense in hue. The colour can be lightened and made less intense by the addition of whiting, giving us the range of 'pastel shades' which used to be so popular with interior decorators. Alternatively, the tone can be deepened by adding lamp black.

At the time of its invention pastel was manufactured in a small range of colours and was used in the same way as coloured chalks in the technique known as **aux trois crayons**. During the seventeenth century the number of colours being manufactured steadily increased, and pastel found increasing use in the execution of small scale portraits. Because of the number of colours available, it became possible to 'paint' with pastels, and pastel painting became widely practised as a recognised medium. In pastel painting many graphic qualities, such as outline, were abandoned,

and the intention was to produce evenly gradated areas of colour resembling a painting in oil or water-colour.

The technique of pastel painting reached the peak of its popularity during the mid-seventeenth century, when its most famous exponent was the Italian artist Rosalba Carriera. She made a very successful living from travelling from one European capital to another, visiting the courts, and producing delicately idealised portraits of her aristocratic sitters. Her work is perhaps the perfect pictorial expression of the spirit of the Rococo, with its delicate colour combinations, its attention to texture, and its freedom from serious or depressing subject matter.

Pastel declined somewhat in popularity in the early nineteenth century, but revived again with the French Impressionists during the last quarter of the century, when it was used by artists of distinction such as Whistler, Degas and Lautrec.

Pastel painting has several advantages over conventional painting techniques. It requires no medium or vehicle, such as oil or water, but is applied directly to the support. It is capable of a greater intensity of hue than most painting media, and there is no change in hue or tone as a result of drying out; in other words, the pastellist knows exactly the final appearance of his work as soon as he sets the pastel to the paper. It has also been proven over the course of time that pastel fades less than any other painting medium, retaining its freshness of colour for years or even centuries. It is softer than any other broad-line medium, and deposits its colour

Rosalba Carriera: *Portrait of a man*
Pastel on paper, 57.8 cm × 47 cm
National Gallery, London

168

Edgar Degas: Mlle Malo Pastel, 52.2 cm × 41.1 cm *Barber Institute of Fine Arts, Birmingham*

easily and smoothly on the drawing surface. It is most successful on paper with a distinct grain or texture which will provide enough tooth to hold the deposits of colour. Toned or tinted papers are especially suitable.

One must set against these advantages of pastel certain disadvantages. The principal of these is that it is not possible to mix pastels before application as one can conventional fluid painting media. The pastellist is more or less confined to the number of colours available in his manufactured sticks. It is of course possible to have a very large number of colours, but this creates the secondary problem of continually having to change colours, selecting new ones and returning them to their correct position in the box. Nothing can be more frustrating than having to grope about in a muddled heap of pastels in a quest for the right colour.

Numerous methods have been devised to overcome the limitations of pastel. One of the most popular was the use of the 'stump', a tightly rolled cylinder of paper or leather

which was dabbed over areas of colour in order to mix one with another. The result was often an unpleasant muzzy effect and the stump, which was so popular in the art schools of the nineteenth century, is now mercifully forgotten. We find more acceptable techniques for combining pastel colours in the work of Degas and Lautrec, who tended to use stippling and hatching in order to lay one colour over another.

Another problem of pastel is that it is difficult to erase or correct. Rubbing-out tends to scuff up the surface of the paper, and overdrawing tends to clog its pores, producing an unpleasantly slippery surface. Finally, pastel is a dusty medium and has poor adhesion. Pastel drawings and paintings are easily damaged by inadvertent rubbing and can also transfer on to glass if not properly fixed or held clear by a suitable window mount.

Pastel techniques vary enormously in intention and effect, and any attempt to assess their value must depend to a certain extent upon one's personal preferences and tastes. Whilst admiring the brilliance and virtuosity of eighteenth-century pastels, many people find them rather sentimentalized and insipid. It may be that pastel's most attractive virtues, its seductive colour, softness, and ease of application, needs to be braced by a high degree of rigour in the drawing. A study of the pastels of the late nineteenth-century artists who favoured the medium, including Degas and Lautrec, will reveal that they always maintained a strong sense of linear profile rather than attempting to imitate the continuous gradations of tone and colour which we find in paintings done in a fluid medium. The pastel is often applied in firm, separate strokes, creating a sense of grain and avoiding the boneless insipidity of which pastel is all too easily capable.

The moral to be drawn from these observations is that pastel is, in the final analysis, a drawing medium rather than a painting medium, and it can only be used to simulate the effects of a fluid medium at the expense of its inherent nature. In a sense, pastel is too easy to apply, and the artist must be prepared to impose constraints upon his technique if the work is to acquire a degree of graphic rigour and constructive strength.

PEN

It has been estimated that the pen in its various forms has produced more old-master drawings than any other medium, and its history can be traced from its use in

See colour plate
Miss Lala at the Cirque Fernando
by Degas between
pages 216 and 217

beautifully wrought mediaeval manuscript illumination, through the vigorous drawings of the great seventeenth century draughtsmen like Rembrandt, to Van Gogh and the twentieth century Expressionists. Its use is still widespread in all kinds of drawing ranging from fine art to illustration and engineering design.

We can divide drawing pens into two broad groups, first so-called 'dip pens', in which the pen must be regularly re-charged by dipping into ink, and secondly fountain pens and reservoir pens which carry enough ink for the completion of one or several drawings and need only occasional re-charging. The business of having to dip or re-charge a pen should not be seen as merely an annoyance: the process of re-charging can permit the draughtsman to obtain varia-tions in the amount of ink on the nib which are not possible with fountain pens, so in spite of the interruptions occasioned by dipping, the draughtsman with the dip pen gains one advantage over those using other kinds of pen.

Dip pens are of three basic kinds, namely quills, reeds and those with metal nibs. For several centuries the quill pen held the field as the main instrument for both writing and drawing, and even today it is recognised as having qualities which we admire in old-master drawings and which are

Canaletto: *Bridge Across the Thames at Hampton Court*
Pen with wash, 23.2 cm × 38.9 cm
British Museum, London

171

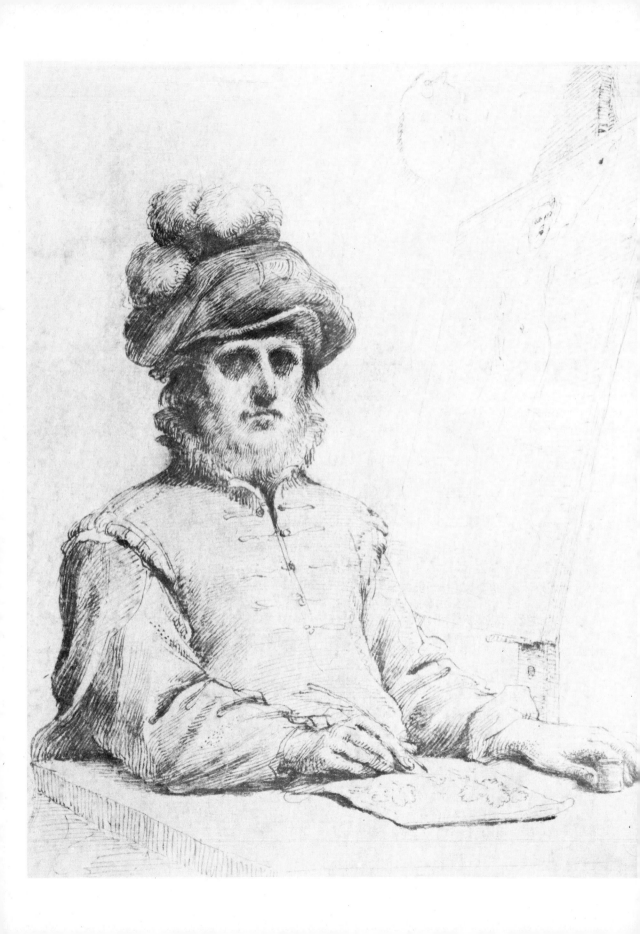

unobtainable with any other kind of drawing tool; so there is every reason to experiment with the quill as a drawing medium.

The best quills come from four species of bird, the goose, the swan, the raven and the crow. Of these, the goose is of course most accessible, and there should be no problem in locating a source of quills at a poultry slaughter house. The most suitable feathers are the long ones which grow near the leading edge of the wing. In its untreated state the quill is covered by a thin membrane which must first be scraped away with a small, sharp pen knife. In order to loosen the membrane and dry out the natural fats in the quill, it can be gently cooked in a saucepan of hot sand over a hotplate set at 'low'. The quills should be thrust into the sand at an angle so that the ends are fully covered, but not so deep that they touch the bottom of the saucepan as this will lead to scorching. After it has been dried out, the membrane can be removed, and the quill can be trimmed to length. The tip should be cut at an oblique angle and a fine slit introduced into the end, which will open in response to the pressure of the hand, thereby permitting ink to flow down the quill and on to the paper.

The chief advantage of the quill pen is its sensitive and immediate response to the pressure and direction of the draughtsman's hand. Variations of pressure on the point of the quill produce subtle and beautiful variations in the thickness and character of the drawn line. The tip of the quill can be cut and re-cut to produce a variety of lines to suit the needs of individual artists and individual subjects. Because of its physical constitution, the quill creates less friction with the paper than any other form of pen, and the general effect is one of fluency, freedom and expressiveness of line. It is most suited for use on handmade papers with a light texture. The sheer beauty of line produced by the quill can constitute something of a danger for the draughtsman, as it so easily leads to a preoccupation with calligraphic scrolls and gestural marks which can take on a life of their own and divert the attention from sound observation and structure.

The second class of dip pens is the reed pen, which has an even longer history of use than the quill. Suitable reeds are to be found in marsh and lake regions throughout the temperate climates of the world, and once a source is located the draughtsman can collect enough reeds in one visit to satisfy his needs for a period of months or even years. Different species of reed vary in width, the thickness of the walls, and the size of the internal cavity, and all these factors have an effect upon their use in drawing. When collecting

G. B. Tiepolo: *Two soldiers and an old man* Quill pen and ink, 20.6 cm × 9.1 cm The flexibility of the quill provides a rich variety of direction and weight
Victoria and Albert Museum, London

OPPOSITE **Guercino:** *Portrait of an artist* Quill pen and ink, 22.2 cm × 18.1 cm
Victoria and Albert Museum, London

173

reeds for drawing it is advisable to select reeds of different thickness and, if possible, different kinds, in order to provide a basis for experiment and choice. The reeds should be stored in a warm, dry place such as an airing-cupboard for at least two months before preparing them for drawing. When they are thoroughly dried out, they can be cut to length, ensuring that there is enough length to provide a counterbalance to the tip and to allow for shortening as a result of trimming. The drawing end should, as with the quill, be cut at an oblique angle, brought to a point, and a fine slit introduced into the tip. Perhaps the word 'point' is misleading in relation to the reed pen: if the tip is too fine it will become saturated with ink and crumble away into a fibrous mass.

In use, the reed pen is utterly different from both the quill and the metal pen. Compared with the quill it is rigid and inflexible, and it cannot be trimmed to a fine point. It responds very little to variations of pressure and produces a relatively thick, bold line with abrupt squared-off ends. To

Vincent Van Gogh: *Cornfield with cypresses* Reed pen and ink, 47 cm × 62.5 cm
Stedelijk Museum, Amsterdam

John Everett Millais: *Study for Christ in the House of his Parents.* About 1849 Pencil, pen and ink and grey wash, 19 cm × 33.7 cm
Tate Gallery, London

get the best out of the reed pen, the draughtsman must always bear in mind the fact that he is drawing with a modified stick, and must exploit its best qualities in bold, uncomplicated strokes. The reed pen tends to need recharging more frequently than other kinds of pen, so it is particularly suited to short, staccato marks with frequent dipping. A model of this kind of work are the reed pen drawings of Van Gogh.

Attempts to produce a cheap metal substitute for the quill date back at least to the late eighteenth century. The spread of literacy as a result of public education in the mid-nineteenth century created an enormous demand for cheap writing implements, which was satisfied by the mass production of steel nibs and wooden pen holders. The steel nib became increasingly popular as a drawing tool in the late 1880s when it was necessary for illustrators to produce very clear and precise drawings for reproduction by photomechanical means.

There are two basic forms of modern metal nib, the 'slip', which has an oval, open barrel rather like the old-fashioned school nib, and the 'mapping pen' or so-called 'crow quill', which have narrower, tubular bodies and a fine point. There are innumerable variations on these basic forms, all easily available for experiment and personal choice. Mapping pens

Robert Morris: Section of an enclosure. 1971 Pen and ink, and pencil, 107 cm × 185.8 cm The uninflected trace of Morris's pen line complements the machine-like elegance of the forms *Collection, The Museum of Modern Art, New York* Acquired with matching funds from the Walter Foundation Fund and the National Endowment for the Arts

and crow quills usually give a rather fine, precise line without much scope for variations in thickness or weight of line, and are most suited to fine, detailed line work or drawings with strict technical requirements. Slips permit a more relaxed line, which can be widened by the use of different nibs including the italic nibs used for calligraphy. Broad italic nibs give a thick down stroke and a thin cross stroke, depending upon the angle at which the pen is held. This effect is fine for certain types of drawing, but can develop into an obtrusive mannerism leading to all kinds of calligraphic swirls and scrolls which confuse and complicate the drawing.

All the varieties of pen so far mentioned have one characteristic in common, namely that they must be dipped regularly in order to be re-charged with ink. The oldest alternative to the dip pen is the *fountain pen*, in which a flexible sac of plastic or rubber holds enough ink for a considerable period of continuous drawing or writing. Apart from this feature, the fountain pen may possess all the other characteristics of a steel dip pen; however, it is a very important difference which permits and encourages a completely different kind of drawing. In order to prevent clogging of the nib, fountain pens require a special kind of drawing ink which combines the usual qualities of indian ink with a free flow.

Reservoir pens differ from fountain pens in that the ink is poured into a reservoir rather than being re-filled through the nib. They have the advantage that they can take a wide variety of colours of waterproof ink which flows more freely than normal fountain pen ink. One of the most popular is the Rapidograph, which is supplied with a large variety of interchangeable styluses with different line widths, ideal for

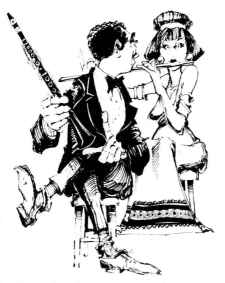

Jack Reaser: Drawing for North Thames Gas Board advertisement. 1981 Pentel 67 fibre tip pen, published size 16 cm × 14 cm *Courtesy of the artist*

a variety of technical and engineering drawing as well as for other purposes.

The *ballpoint pen* was developed during the Second World War, and one of its unique advantages was that it was not subject to changes in performance as a result of abnormal atmospheric pressure and could therefore be used by aircrew at high altitudes. It rapidly gained ground as a general purposes writing implement and also as a drawing medium. Its appeal as a drawing medium has been limited by its tendency to produce a very uniform line with a rather mechanical appearance. Heavily worked areas also tend to develop a rather unpleasant shiny surface as a result of the special kind of ink used.

During the 1970s there has been a phenomenal increase in the manufacture and use of *fibre tip pens*, often popularly referred to as felt tip pens. Their great attraction is the remarkable ease with which they write and draw, in addition to the fact that they can be manufactured in an enormous variety of tip widths and colours. The inks used in fibre tip pens are spirit-based and tend to evaporate quickly if left uncovered. In the cheaper versions they are also very fugitive, and can fade or disappear quite quickly, especially if left exposed to intense light. Because of their brush-like quality of line, fibre tip pens make an attractive medium for draughtsmen who want the fluency of the brush combined with the convenience of the fountain pen.

PENCIL

The so-called 'lead pencil' contains no lead, its chief ingredient being graphite. The confusion with lead probably stems from the fact that when graphite was first used for

Jean-Baptiste Joseph Wicar:
Portrait of Luigi Riva
Pencil, 25 cm × 20 cm
Middlesex Polytechnic

W. B. Rawcliffe: *The Old fort,
Corfu Town.* 1978
Pencil, 25.4 cm × 35.6 cm
Courtesy of the artist

drawing the marks it made resembled those made by lead-point, the method of drawing on a prepared surface with a lead wire according to the same principle as silverpoint. The discovery of a source of high quality graphite in Borrowdale, England, in the 1560s led to its widespread adoption as a drawing and writing medium. At first the graphite was cut into strips and tied or clipped into a *porte-crayon*; later it was pulverised, reconstituted, and set in a wooden container along the lines of the modern pencil.

The opening of the war between Britain and France in 1793 led to the interruption of graphite supplies to the continent. As a result a French inventor named Jacques Louis Conté devised and patented a way of utilising inferior continental graphite by mixing it with clay and other additives. Conté (who gave his name to the **Conté crayon**) was responsible for initiating a series of manufacturing methods according to which the quality and character of the drawing medium was closely controlled by various combinations of additives such as kaolin, lampblack and wax. Coloured pencils were manufactured by combining clay, wax and dyes. Although additional deposits of graphite were found during the nineteenth century, when the Borrowdale source ran out, the production of synthetic graphite soon made mining unnecessary. The chief method of differentiating the modern pencil is according to its 'hardness', determined by the proportional relations of its ingredients, especially clay, and this may range from 8H (very hard) through HB (medium hardness) to 8B (very soft).

The graphite pencil has numerous advantages over almost every other drawing medium. Although it does need occasional sharpening, it does not, like the pen or the brush, need constant re-charging. This enables the pencil draughtsman to maintain a constant speed of drawing and

178

concentration on the subject without the interruptions occasioned by having to dip a pen or a brush. It is omnidirectional in that, unlike most pens and brushes, it will travel easily in any direction in which the hand cares to take it. It is also, one might say, omnipositional, in that it will write on any angle of surface including (as graffiti artists are aware) the walls and the ceiling. It will also write on a wide variety of surfaces; absorption is not necessary, the only requirement being a degree of texture or 'tooth' for the pencil to bite on. It is clean, convenient, and easily portable, a fact which has made it popular with a wide range of users including amateurs, engineers and military draughtsmen. Finally, perhaps its most important artistic quality is that it responds to fine variations of pressure and angle in the draughtsman's hand, producing corresponding variations in the thickness and weight of the line. The expressive range of the pencil can be extended by the use of creative erasure to reveal highlights or to 'draw' with the eraser in an area already worked with the pencil.

It is impossible to lay down any hard and fast rules about the use of the pencil. Some authorities insist that it must at least be sharp. But even this is not completely true, as many draughtsmen work most happily with a blunted point or even one which has forked into two. It has also been suggested that soft pencils draw best on a smooth surface like board, while hard pencils need the bite of a textured paper. There is a certain amount of sense in this idea, but here again it is a case of the individual having to experiment to discover the combination which satisfies his personal needs. If there is one absolute rule, it is that pencils should never be dropped or put down with force, as this tends to fracture the 'lead' inside the wood and will lead to repeat breaking when drawing or sharpening.

The best guide to the use of the pencil is the enormous range of expressive effects which have been achieved by master draughtsmen. In its early days it tended to be used as a substitute for silverpoint, producing fine and even contours supported by equally fine and even hatching. During the seventeenth century we find pencil being used with greater textural freedom in the hands of the Dutch landscape artists such as Cuyp. The potential for extremely precise and clean profiles was exploited by the neoclassical artists of the late eighteenth century, and even more so by nineteenth-century schools such as the German Nazarenes and the English Pre-Raphaelites. The nineteenth-century master of the pencil was Ingres, who set a new standard of economy and expressiveness of line in his acutely observed

J. A. D. Ingres: *Mrs John Mackie.*
1816 Pencil, 17.1 cm × 16.5 cm
Victoria and Albert Museum

See colour plates
Vivian in the morning
by Adrian George and
The artist's life
by Glynn Boyd Harte
between pages 216 and 217

portraits. The pencil was favoured for its speed and spontaneity by turn-of-the-century artists like Rodin and Schiele and continues to be used in a variety of ways at the present time.

When the author was a student in the late 1950s, coloured pencils were regarded as quite inappropriate for a drawing of any artistic quality, and suitable only for infants' scribbles and geography lessons. During the 1970s there has been a surprising revival of interest in the coloured pencil as an artistic medium, and it has been shown to be capable of striking and expressive effects in the hands of contemporary artists and illustrators like Hockney and Adrian George.

The pencil is so convenient, clean, cheap, and flexible of use, that it is not surprising that it is the most misused medium in existence, and responsible for more bad drawing than any other. Many draughtsmen who use the pencil do so not from a position of deliberate choice, but out of habit or sheer laziness, and a reluctance to try or experiment with slightly more complex or demanding media. The result is masses of drawings, especially student drawings, in which the pencil has been stretched quite beyond its potential, producing large areas of laboured hatching, which would

have been better rendered in wash, or vague and confused contours, which would have benefitted from the discipline of the pen. The pencil has become to drawing what the recorder is to music: something with an immense expressive potential which has been obscured by misuse and over-use.

PERCEPTION

Even the most simple of scenes presents the eye with an immense amount of visual information, in most cases so much that it would be beyond human ability to note and record everything contained within it. The psychology of perception has shown quite conclusively that although in physical terms everything which enters the eye is recorded on the retina, only a small proportion of this information is consciously noted and recorded by the brain.

This act of interpreting visual phenomena is known as perception. Given the same visual stimulus, different individuals will perceive quite different things. Presented with a woodland scene, a botanist, a hunter and an artist will seek and mentally record what they are motivated to find, and will ignore much else. Perception, therefore, is not a passive process of absorption, but an active interpretation of sensations which is guided and stimulated by past knowledge and present motivation.

In physical terms, static human vision can take in a horizontal sweep of about $60°$, and rather less than this vertically. Beyond this angle, that is on the fringes of our field of vision, objects become blurred and distorted until, at the extreme limits, they disappear altogether. In life we compensate by moving our eyes from left to right and up and down, or by moving the whole head to bring objects into the centre of our field of vision. A drawing, however, is a static object, and we tend to assume that a drawing from observation represents a scene as viewed from one fixed position. If we do move our eyes and heads substantially while drawing, bringing in objects which are on the margins or outside of our field of vision, the result is likely to include perspectival and spatial anomalies, especially in the drawing of near objects.

Two methods have been used for extending the field of vision represented in a drawing. The first, which is common in early topographical drawings, is to exclude near objects and let the lower edge of the drawing coincide with a point at some considerable distance into the represented scene. Perspectival contradictions are not so acute or obvious in

distant objects, and this permits the artist to take in a horizontal sweep which is much wider than our normal field of focused vision. This technique often results in a high ratio of width to height in the drawing, such as one finds in old panoramas of cities.

The second technique is to record the margins of the field of vision in the drawing, but to give greater definition to the centre of the drawing than to the edges. Hence, we may find the floorboards of a room spreading dramatically as they approach the bottom edge of the drawing, but at the same time losing definition to suggest that they are moving out of our field of vision. The same technique may be used with what are called *coulisses*, the foreground groups of trees which we often find at the sides of landscapes, which may be drawn very broadly while the centre of the scene is given greater definition.

In addition to the area of the field of vision, we must also bear in mind the fact that in normal vision we can only focus at one point in depth at any one time. When viewing near objects, the muscular adjustments required to bring the eyes into focus signal to the brain the distance of the object from the eye. Beyond 20ft (6m) or so, variations in the angle of convergence of the eyes are so small that they may be said to be focused in parallel, and distances are measured in terms of factors such as relations of scale and perspective.

When drawing from observation, even if we keep our heads and eyes more or less static we tend to focus and re-focus quite freely around the area and into the depth of our field of vision. Consequently, what we record is not what may be seen at one moment in time, but what is seen at many moments over a period of time. A more truthful record of our vision would be a drawing in which only one plane in depth were in focus, nearer objects and more distant objects being relatively out of focus. Many draughtsmen have tried to cater for this peculiarity of human vision by varying the degree of definition and detail in different areas of the drawing.

Draughtsmen have long been aware of the contradictions which exist between vision and drawing, between perception and recording, and have developed a variety of ways of coping with it in the light of their artistic motivation and skill. In the drawings and paintings of the Flemish primitives, who first established modern standards of truth to nature in the art work, we often find a field of vision which accords with the laws of vision in terms of the area taken in, but which is treated all over with a high degree of definition and detail. The same meticulous attention to detail is found again

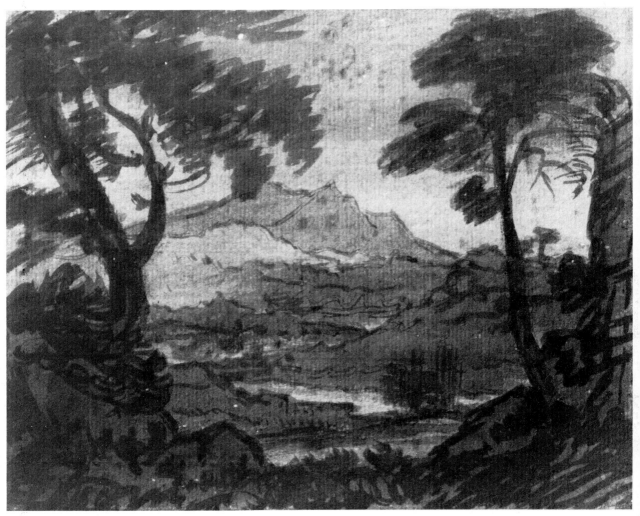

in the work of the English Pre-Raphaelites of the mid-nineteenth century, who seemed to wish to record absolutely everything which could be seen—and often came very close to doing just that.

By contrast, in the seventeenth century we see the development of what might be called 'impressionistic' drawing, in which much is deliberately left indistinct, and many forms are suggested by broad sweeps of tone rather than being precisely delineated. Rembrandt advised his pupils to half close their eyes when viewing a subject for drawing, thereby eliminating irrelevant detail and giving a broad impression of the whole in terms of masses of tone and form. The same approach is found again in the work of the Impressionists of the late nineteenth century, notably in that of Monet.

Alexander Cozens: *Landscape with fir trees* Brush and sepia ink and wash, 13.3 cm × 17.2 cm *Tate Gallery, London*

PERSPECTIVE

The word 'perspective' derives from a Latin word meaning 'to see through' and was coined to denote the idea that it is possible for the artist to suggest to the spectator that he can as it were 'see through' the plane on which an image is drawn or painted and recreate in his imagination depth, voids, and volumes set in space. In normal circumstances the spectator must collaborate with the draughtsman's marks in order to reconstitute in his mind the scene depicted as lying on the other side of the picture plane. It is possible to make a perspectival representation so convincing that it results in **illusionism**, which means that the spectator is no longer aware of beholding a flat surface with an image on it, but believes himself to be witnessing a real scene set in real space. Although this effect, also known as *trompe-l'oeil*, is well known in the art of painting it is a rarity in the art of drawing, which depends so much upon abstractions rather than literal depiction.

There are two basic forms of perspective. Linear perspective provides a set of rules or conventions which govern the way in which objects appear to diminish in size as they recede from the spectator's viewpoint. Atmospheric perspective makes use of the optical fact that because air contains a small proportion of water vapour and dust in suspension, the more distant an object is (ie the more air there is between the spectator and the object), the less tonal and colour strength it will appear to have.

Linear perspective may be further subdivided into several different systems, the principal of which are as follows.

(a) *Parallel perspective.* In the most simple form of parallel perspective lines receding in parallel from the spectator's viewpoint are represented at an angle to the ground but do

Albrecht Dürer: *Artist using a viewing screen* Woodcut, 6.7 cm × 18.5 cm

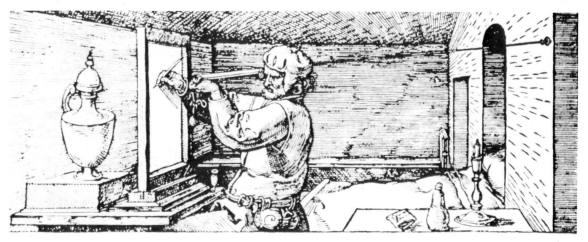

Canaletto: *St Mark's, Venice; view of the interior* Pen and ink over red and black chalk, 36.2 cm × 20.8 cm
Victoria and Albert Museum, London

Chang Tse-Tuan: *Ch'ing ming shang-ho t'u.* Handscroll, early twelfth century Colours on silk, 29.2 cm × 554.4 cm
British Museum, London

not converge to a *vanishing point*. This system of perspective is widely used in Chinese painting and may be related to the concept of 'the travelling eye', which means that the spectator is assumed to be scanning the image in different directions, 'reading' it rather like the page of a book, rather than adopting and holding one fixed viewpoint. In Chinese art this is often combined with the use of a high viewpoint which permits the eye to move backwards and forwards in pictorial depth, rather like walking about in a landscape. It should be remembered that this combination of parallel perspective and high viewpoint was developed to deal with images on surfaces such as scrolls, screens and fans, which present the artist with problems very different from those of the conventional Western exhibition drawing.

The term parallel perspective may also be used, somewhat confusingly, to denote a system common in contemporary technical drawing in which receding parallels converge, but parallels of rectangular objects facing the picture plane do not.

(b) In *angular or oblique perspective* a rectangular form positioned at an angle to the picture plane is represented so that its horizontal parallels recede to a vanishing point, while its vertical parallels are depicted as vertical (ie parallel).

(c) In *three-point perspective* (sometimes known as *inclined picture plane perspective*) all the parallels of a rectangular body, including the verticals, are represented as receding to independent vanishing points.

(d) *Inverted perspective* is a system according to which receding parallels actually diverge, rather than remaining parallel or converging. This system, which might strike the modern eye as illogical or bizarre, is very common in mediaevel painting and has been revived with good effect by some modern 'primitive' artists.

Many students and amateur draughtsmen are convinced that a command of perspective, by which they usually mean geometric, linear perspective, is the key to success. There is some reason for this view, since drawing is often concerned with the attempt to suggest solid volumes in space upon a flat surface. The rules of systematic linear perspective are complex, but with a little patience they can be learned. However, there is no evidence that a command of the rules of perspective alone will make a good or even a competent draughtsman.

There are several reasons for this. First, perspective systems can never be more than an approximation to optical fact. Part of the reason why we find perspectival representations so convincing is that we have been conditioned to

Peter Schmid: Perspective diagram from *Das Naturzeichnen* ('Nature-Drawing') 1828–32, Vol.II, Plate XVII Etching, 17.6 cm × 19.7 cm

believe that nature really does look the way it is represented according to the conventions of perspective. Secondly, most perspective systems assume monocular (one-eyed) vision in relation to both the scene depicted and the spectator's view of the drawing. The fact is that we rarely look at nature, or at a picture, with one eye; and binocular (two-eyed) vision introduces a set of problems which most perspective systems ignore. Thirdly, most perspective systems were devised to cope with the depiction of regular geometric forms, such as we find in the man-made environment. As soon as we depart from these forms and attempt to depict natural or organic subjects such as the human figure or landscape, then the rules of perspective are of little help and can even be something of an encumbrance. Finally, there are many occasions when the use of 'accurate' perspective militates against the real intention of the artist. Perspective may tie the draughtsman to optical reality, to the detriment of psychic, spiritual or symbolic reality. It is significant that the twentieth century has seen a widespread abandonment of perspective conventions in favour of more personal and less rule-bound styles of representation.

Paul Klee: *City interior*
Pen and ink and wash on paper,
45.8 cm × 35.3 cm
Klee frequently made playful and
inventive use of perspective
constructions
Location unknown
Copyright ADAGP, Paris, 1982

What use, then, is linear perspective to the draughtsman? It is possible to suggest two quite distinct approaches which can be explored. First, one should not completely rule out the possibility of employing a perspectival method as a whole rationale for the creation of drawings. When the artists and architects of the Renaissance developed the modern concept of perspective it was not only as an auxiliary to painting and drawing, but partly as a fascinating procedure in its own right. For artists like Uccello and Piero della Francesca perspective represented a unique and miraculous synthetis of science and art which could be exploited as an inexhaustible source of pictorial invention. Approached in this light, perspective can be compared with the composition of music according to strict contrapuntal rules which, far from impeding the creative impulse, give it inspiration and form. This kind of pictorial perspective can be described as *conceptual*, since it is concepts, or ideas, which determine the form of the drawing, rather than direct experience of reality. If perspective is used creatively in this way, then the rules must be learned and understood.

Secondly, one may approach perspective from an *empirical* standpoint, that is to say depending upon direct observation of the optical behaviour of lines and forms in reality. This demands a close and sensitive observation of the length and direction of lines and planes as seen from the spectator's viewpoint. Through constant practice and self-checking it is possible to develop a command of perspectival representation which is every bit as convincing as theoretical perspective but at the same time flexible and adaptable to kinds of subject matter which are not susceptible to the rules of geometric perspective.

Atmospheric perspective

Atmospheric perspective, otherwise known as aerial perspective, is one of the ways in which the draughtsman can suggest distance, space and depth. In nature, it results from the fact that air contains a proportion of water vapour, dust and other impurities which form a translucent veil between the eye and distant objects, reducing tonal contrasts and colour intensity. It is particularly useful in landscape, where the distances involved are considerable and where there is often little content of an obviously geometric nature or with human scale which would permit the artist to provide clear visual information in terms of linear perspective. It is rarely of value when drawing indoors, since the distances involved

John Sell Cotman: *Chateau Gaillard.* 1818–19 Pencil and grey and brown wash, 26.3 cm × 42 cm *Tate Gallery, London*

are relatively small. In exceptional circumstances an interior scene might be affected by atmospheric perspective, especially if the room is very large or if the air is unusually humid, dusty or smoky.

There are three basic means of representing atmospheric perspective. The most common consists of reducing the tonal strength and contrast of more distant objects and this is especially useful for the draughtsman working in brush and wash. The second is to reduce the strength of distant linear contours. This technique is often employed by the draughtsman in pen and ink or pencil to depict distant profiles in an undulating or hilly landscape. Finally, it is possible to reduce the quantity and weight of the internal detail of more distant forms, for example in relation to the drawing of foliage. It should be stressed that these suggestions are clues to the interpretation of what is actually seen, and not 'tricks' of drawing which may be applied to any scene regardless of whather it corresponds to nature and the visual information it provides.

Atmospheric perspective became a common feature of Western painting and drawing in the fifteenth century and has always been strong at times of increased interest in

Chao Ling-Jan: *Spring dawn by the lakeside*. Hanging scroll, late eleventh century Ink on silk, 47.3 cm × 76.5 cm *British Museum, London*

landscape. Many draughtsmen of the Chinese schools have made brilliant use of it.

There is no set of rules governing atmospheric perspective comparable with those which may be applied to linear perspective. The only answer is therefore sensitive observation of tone and colour, both in nature and in the drawing itself.

PHOTOGRAPHY

See **Aids**.

PICTURE PLANE

The picture plane is the notional surface behind which the content of the drawing is depicted as located in space. The whole concept of the picture plane grew out of Renaissance theory and Alberti's advice that the painter should think of his surface as a window-like aperture giving a view on to objects and events disposed behind it. Hence a wall at right angles to the artist's angle of vision might be described as 'parallel to the picture plane'. Because of the long tradition of assuming that the artist viewed his subject from a more or less horizontal angle of vision, it was generally accepted that

the picture plane was roughly vertical. Many draughtsmen have broken with this convention by adopting acute high- or low-angle views of many of their subjects, implying a similarly angled picture plane.

It is mistaken to assume that the picture plane is synonymous with the surface of the picture. It is possible to take a drawing with a picture plane which is off vertical and hang it vertically on a wall, just as it is possible to view a drawing with a vertical picture plane while it is lying horizontal on a table. In these cases the mind is capable of adjusting to changes in the angle of the drawing whilst maintaining the conception of the picture plane.

PRINTMAKING

Drawing has always played a central role in the production of prints, to such an extent that an artist's print is often referred to as an example of his drawing. Moreover, because of their relative commonness in comparison with original drawings, prints have played an important part in the communication of drawing styles from one artist to another, from one region to another, and from one age to another. The technical characteristics of print processes have certain important implications for the kinds of drawing which they permit or favour. Before looking at some of these, it should be noted that there is a distinction to be made between prints in which the printing surface has been prepared by the artist's own hand, which are called *autographic prints*, and those in which the printing surface has been prepared by a professional print maker or engraver following an artist's drawing, which are called *allographic prints*. With a few notable exceptions, until the nineteenth century it was fairly rare for an artist to engrave his own plate or wood block, this task normally being done by a professional engraver or craftsman.

One of the oldest techniques for making prints is the woodcut. This is executed on the side (or 'plank') grain of a piece of wood of medium softness, such as cherry or pear. After transferring the drawing to the wood, the woodcutter proceeds to cut away all the undrawn sections of the image, leaving the image itself standing up in relief. When the block is inked up, the uncut areas of wood accept the ink, which is then transferred on to paper either in a press or by rubbing the paper face down on the block. Soft wood tends to tear or splinter while being cut, and for this reason the woodcutter must work in broad, bold movements, either pulling a sharp

Anon: Illustration from *De Claris Mulieribus*. Printed by Zainer in Ulm, 1473 Woodcut, 8 cm × 11 cm

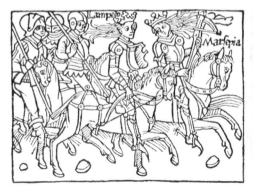

191

Emil Nolde: *Portrait of an Italian.* 1906 Woodcut, 28.1 cm × 23.4 cm *Albertina, Vienna*

Thomas Bewick: *Winter landscape* Wood engraving, 4.5 cm × 7.5 cm

knife towards him or pushing a gouge away from him. The woodcut is not suited to the rendering of fine detail or delicate textural effects, and it favours a style of drawing which features large, simple areas of tone with fairly hard edges. As it was used in books and popular prints in Europe up until the nineteenth century, the woodcut produced a rather bold and earthy style of drawing, although it was at time used with great sensitivity. The Japanese print makers produced a style of great delicacy and finesse which at the same time suited the intrinsic qualities of the medium. Woodcut was revived in the twentieth century by the German Expressionists, who admired the 'primitive' qualities of its imagery.

Wood engraving, which dates from the late eighteenth century, is like woodcut a 'relief' process. The principal difference is that while the woodcut is executed on the long grain of a softwood, the wood engraving is made on the end grain of a hardwood, such as box. This enables the wood engraver to cut out microscopic bundles of wood fibres with an engraving tool, creating the potential for fine detail and delicate textural effects which are quite beyond the range of the woodcut. The wood engraving permits the artist to experiment with a much more varied range of drawing styles, and although it has been predominantly used as an allographic process many fine draughtsmen have also engraved their own drawings.

Woodcut, wood engraving and lino cut are all what is known as relief processes, that is to say the surface which accepts the ink and transmits the image to the paper stands up in relief from the rest of the printing block. A second major family of printing techniques are those in which the image is cut or bitten into the printing surface, and these are called the *intaglio* (Italian: cut into) processes. The principal intaglio processes are engraving in metal, often referred to as 'line engraving', and etching. In the case of line engraving, the image is cut into a plate of suitable metal, such as copper, with a metal burin under the pressure of the engraver's hand. In the case of etching the image is bitten into the plate by immersion in an acid bath (see below).

Both the engraving and the etching employ the same printing process. The plate is covered with printing ink, which enters and fills up the grooves and recesses of the image. The plate is then polished, the action of polishing removing the ink from the undrawn areas, but permitting the ink to remain in the recessed areas of the image. It is then covered with paper, which may be dampened in order to soften it and enable it to follow the contours of the plate, and

192

School of Andrea Mantegna: Four women dancing. Late fifteenth century Engraving *P & D Colnaghi & Co Ltd, London*

Rembrandt van Rijn: *Christ returning from the temple with his parents.* 1654 Etching, 9.5 cm × 14.5 cm *P & D Colnaghi & Co Ltd, London*

passed through a press. In the press, the ink retained in the grooves of the image is forced out on to the paper, which is at the same time pressed into the grooves of the image to accept the ink.

In spite of their technical similarities, the engraving and the etching have very different implications for the draughtsman and print maker. In engraving, a great deal of skill is required to push the tool across the surface of the metal to produce an even, controlled line, and it is not surprising that very few artists of distinction have been prepared to spend the time necessary to acquire the skills of the competent engraver. The engraver on metal can control the thickness of his line by varying the pressure on the tool and hence the depth and thickness of the printed line. He cannot, however, make sudden changes of direction, and the

graphic character of the engraving is a continuous and controlled line with gentle variations in thickness which curves slowly rather than turning abruptly.

These characteristics of line engraving on metal may be contrasted with those of the other major intaglio medium, etching. In the etching process, the metal plate is first covered with a protective surface of acid-resistant varnish. The artist draws his image in the varnish with a needle-like tool which exposes the plate wherever it is applied. When the plate is placed in an acid bath the acid attacks the exposed surface of the plate, creating a pattern of incised lines and leaving the remainder of the surface intact. After being cleaned, the plate is inked and printed in the same way as an engraving. Unlike the engraver, the etcher does not need to apply any noticeable pressure on his stylus, and the etching needle can be used with a speed and flexibility which is impossible in line engraving and is almost identical to the use of a fine pencil—except for the fact that when he is drawing the etcher sees his image appear as light on dark. It is in fact possible to 'scribble' in an etching, but not in an engraving. The absence of any complex technical requirement in drawing for etching has made it a popular medium for autographic prints.

Jan Möller: *Lot and his daughter*
Engraving after B. Spranger
P & D Colnaghi & Co Ltd, London

OPPOSITE **G. B. Piranesi:** *Carcere (Prisons)*, Plate VII Etching and engraving, 54.4 cm × 40 cm
P & D Colnaghi & Co Ltd, London

195

Goya: 'Que viene el coco' ('Here comes the bogey-man'), Plate 3 of *Los Caprichos*, *c* 1793–8 Etching and aquatint, 21.5 cm × 15 cm

Charles Keene: *Landscape – Dunwich, sea to left* Etching, 14 cm × 17.6 cm *Private collection*

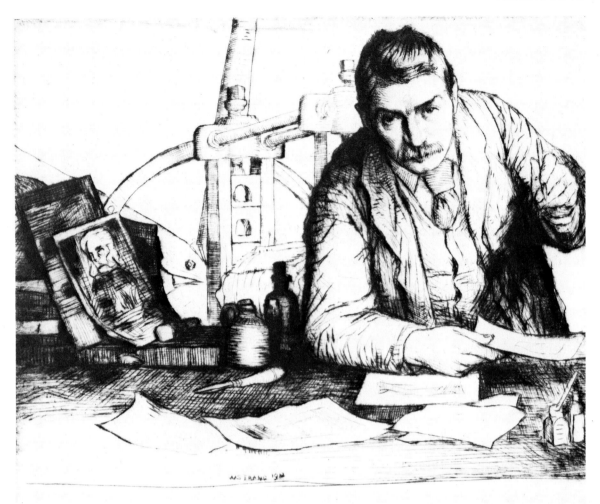

The third major family of print processes is what are known as the 'planographic' (literally, 'surface-drawing') processes. The most important of these, lithography, was invented in 1798. The principle of lithography is that the image is drawn with a greasy crayon or ink upon a smooth surface of limestone. The stone is dampened with a sponge and then rolled up with an inky roller. The greasy drawn areas reject the water and therefore accept the ink from the roller, while the wet areas of undrawn limestone reject the ink of the roller. Consequently the stone can be repeatedly dampened and re-charged with ink to produce a large number of prints. Nowadays the use of lithographic stones has been superseded by the use of metal plates, but the principle remains the same.

William Strang: *The etcher.* A portrait of the artist Drypoint, 16 cm × 19 cm
Victoria and Albert Museum, London

197

Honoré Daumier: *L'acteur des funambules* (*The tight-rope artist*). 1839 Lithograph
30 cm × 24 cm
Private collection

James McNeill Whistler: *Gants de suède*, 1890 Lithograph,
21.5 cm × 10.1 cm
Private collection

Lithography permitted the artist-printmaker to draw in a way which closely resembled traditional drawing media such as pencil and chalk, including the fact that, unlike etching, the draughtsman saw his image appear on the stone in black upon white. Another advantage of the lithograph was that the surface of the stone could be ground to simulate the textural effects of different grades of paper, and these could be worked upon in a variety of lithographic crayons and ink. In view of its attractions as a medium, it is not surprising that lithography attracted an unbroken series of fine draughtsman-printmakers, including Daumier, Lautrec and Bonnard.

It is not possible in the present context to deal with all the many variations of print techniques, but one may mention in conclusion the monotype, in which the drawing is executed in a fluid medium on a sheet of glass and then directly off-set on to paper. Here the image tends to fade rather rapidly and needs constant re-charging, but the monotype is capable of exciting textural effects which result from the squashing of the medium between the glass and the paper.

PROCEDURE

In a sense almost everything which appears in this book relates in some way to the question of procedure—the sequence and manner in which a drawing is created. In this section I shall attempt to summarise and compare what appear to be the main options open to the working draughtsman in relation to the strategy for making a drawing. It is important to appreciate that although most experienced draughtsmen evolve a personal procedure for executing a drawing, this will probably contain many variations in response to the requirements of each individual drawing and the problems it poses. Nothing good can come from the creation of an unthinking routine in which each new drawing is always tackled according to exactly the same procedure. Furthermore, a comparison of the drawings of a master draughtsman done at different stages in his life will almost always reveal that procedures change with the changing sensibilities and intentions of the artist. Drawing procedures can be roughly divided into two broad areas of interest, first in relation to the mental attitude which is cultivated and maintained, secondly in relation to the physical procedures adopted such as the hold on the drawing tool, the manner of perception of the subject, the priorities given to different sections of the image, the sequence of execution, and the speed of drawing.

198

To illustrate the range of possibilities in relation to mental attitude or 'set', one need only compare the classical Oriental drawing technique with the Western norm. The traditional Japanese calligrapher and draughtsman begins by preparing his materials, disposing them simply and conveniently, and thinking himself into a state of serene receptivity. The whole mind is concentrated upon a level of psychic unity with the surrounding creation, so that the life-force of nature can flow unimpeded down the draughtsman's arm to his brush and on to the paper. This is, of course, partly a necessity imposed by the nature of the materials: working with a brush and jet black ink on paper or silk does not allow for errors and corrections, and the intention must be to get things right first time. In order to permit the life-force to flow freely into the image, the brush is held high up on the handle, well clear of the paper, and the hand is not rested on the paper as is the practice with so much Western drawing. It would be unthinkable for the Japanese draughtsman to begin in a bad temper or a distracted mood, any more than a surgeon would want to perform an operation whilst drunk, and in contemporary Japan the art of writing and drawing with the brush is widely practised as a form of relaxing ritual and mental recreation.

The tradition of Western drawing, if we may accept such a broad generalisation, has on the other hand tended towards an improvisatory constructive approach in which the draughtsman observes, records, revises, and observes again in a continuing cycle of perception, statement and re-statement. There is some truth in the view that Oriental

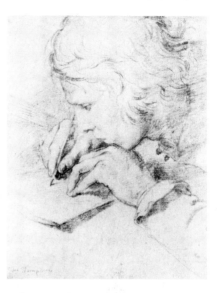

Bolognese, formerly attributed to Domenichino: *A young man drawing*
Red chalk, 24.6 cm × 19.3 cm
Albertina, Vienna

Utamaro: *First writing of the year*
Woodcut, 12.7 cm × 10.2 cm
British Museum, London

199

drawing aspires to a lyrical mode of expression, Western drawing to a dialectical mode. The contrast is illustrated in Ruskin's advice to the student of drawing: 'It is a good thing to accustom yourself to hew and shape your drawing out of a dirty piece of paper.' Such a notion would be completely alien to the Japanese graphic tradition. The Western attitude to drawing is perhaps typical of a group of cultures which have in general shared the view that nature is to be probed, explored, questioned and exploited; that the design of artefacts should never stand still, but should constantly be changed and improved to satisfy man's material needs. Art, too, has been swept along by this desire for change and progress, and resignation to the eternal laws of the mutability of nature and existence is a foreign or even repugnant notion.

Nevertheless, one can detect lines of development in the history of Western drawing which have some relationship to the Oriental ideal. Many draughtsmen and drawing teachers have encouraged the student to cultivate a special state of mind by contemplating the motif and allowing its character to take possession of his mind before commencing drawing. This sounds rather melodramatic, but what is being suggested is that, for example, in contemplating the model one should attempt to feel in one's own body the nature of the pose, the position of the limbs and torso, and even the mental state of the sitter. In the process of establishing a sense of empathy with the model, one may shut out surrounding distractions and irrelevant details.

A more extreme approach to drawing was cultivated by the Surrealists, according to which the draughtsman attempted to suspend all rational and deliberate thought and allow the psyche to communicate directly through the chosen medium. This technique, known as **automatism**, is in fact very difficult to achieve and can only be sustained for limited periods of time before the conscious mind takes over again and mundane considerations and distractions crowd in. It should also be remarked that whereas the Oriental tradition tends to cultivate a mental attitude in which the draughtsman is serenely absorbed into the flow of life-forces, Surrealist automatism may be characterised by a mood of self-obsession bordering on hysteria, and what is expressed are aspects of the artist's unconscious mental life which are normally repressed as a result of social norms and conventions. The results are manifested in works which, in the former case, console and satisfy, and, in the latter, disturb and shock.

The physical procedure for executing a drawing may be

broken down into a number of component parts, such as the hold on the drawing tool, body position, sequence and speed. There are grounds for believing that it is a mistake to become too preoccupied with questions such as the precise nature of the hold on the drawing implement. The draughtsman who is clearly aware of what he has seen or thought and what he wishes to express on paper will soon find a way of getting it down. Conversely, no amount of attention to hand-hold will compensate for deficient observation and muddled intuitions. The physical set-up for drawing can have a considerable negative influence, in the sense that a bad drawing position can impede execution and expression, but provided there is a basic command over the physical procedures the rest depends upon the quality of vision and a sensitive response to the developing image.

There are two broad strategies in the execution of a drawing, which one may refer to as 'whole-to-parts' and 'parts-to-whole'. In the whole-to-parts procedure, the draughtsman begins by working rapidly over the whole area of the drawing, setting up broad relations of form and tone. He continues by repeating this process several times, on each occasion bringing the whole drawing to the same level of completion until, if he so desires, he is working in quite fine detail. Viewed at any stage in its development, the drawing gives the impression that it has been brought to the same level of completion throughout, without either unworked sections or isolated patches of detail. The parts-to-whole technique does not preclude a preliminary attempt to establish the broad structure of the image, but this tends to be perfunctory, and the draughtsman proceeds as soon as possible to a section of the drawing which is developed in relative detail. While the whole-to-parts strategy proceeds by progressively reducing the scale of the decisions and the forms in a series of subdivisions of the area of the drawing, the parts-to-whole approach tends to establish a unit of scale early in the drawing process and work slowly away from this starting point whilst constantly maintaining the unit of scale. This difference of approach is not always easy to detect in a finished drawing, but a study of unfinished drawings suggests that there is a wide variation on this aspect of technique, an observation which is further corroborated by unfinished paintings.

To a certain extent independent of this aspect of procedure are the techniques which artists have used in order to progress across the surface of the drawing. The unit of scale, mentioned above, can take the form of the length of a nose, the distance between the eyes, or the height of a piece of

furniture. It should be fairly centrally placed in the drawing and easily identifiable for purposes of comparison. The unit or module should lie on either the vertical or the horizontal, so that comparisons can easily be made in terms of the two coordinates. Having firmly established the basic module, the draughtsman can plot systematically away from it in all directions.

There is a long tradition of aiding this process of plotting by the use of measuring devices such as the plumb line and the rule, or, on a more sophisticated level, viewing grids and screens. In recent years this highly 'judgemental' method of drawing has seen a notable revival, including the use of mechanical aids for measuring and establishing directions. A word of warning in this connection is that an excessive preoccupation with the location of points in terms of vertical and horizontal coordinates can result in a dry map-like image. One must never forget that one of the most vivid features of our perceptual experience is not merely the disposition of objects as flat patches of tone and colour, but the way in which these patches make themselves felt as volumes and voids moving in depth. Another risk of the

Mattia Preti: *Group of artists drawing*
Red chalk, 24.8 cm × 36.5 cm
Victoria and Albert Museum, London

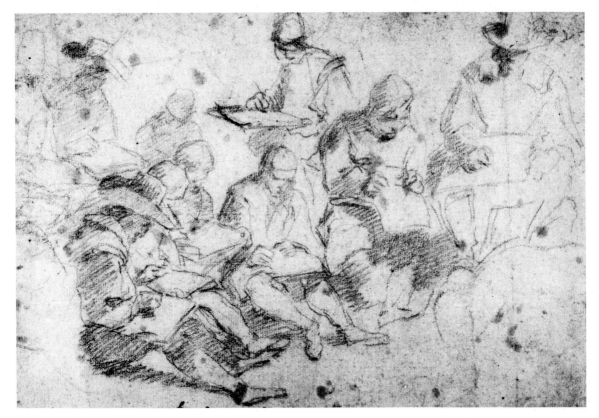

202

plotting technique is that it can result in a puritanical obsession with accuracy in the sense of literal precision. As Matisse put it, in matters of artistic expression: 'Exactitude is not truth.'

In addition to the process of surface plotting mentioned above, there are three widely used methods of constructing a drawing, which take as their basis the axis, the ovoid, and the plane respectively. Drawing according to axes is frequently recommended in connection with life drawing, and consists of establishing the principal directions of each part of the figure in terms of a central core or axis which is deduced from what is perceived. What the draughtsman does is to construct a sophisticated kind of pin-man, which he subsequently clothes with flesh, muscles, and, where appropriate, clothing. Drawing with ovoids is rather similar in approach, except that instead of seeking out the internal direction of each form, the draughtsman summarises each part of the figure as a shorter or longer sausage shape. As the drawing develops, this collection of ovoids is related and modified to take account of nuances and details of form. When drawing according to planes, the draughtsman attempts to establish the principal planes which constitute the subject, later working into these with increasing detail.

At first sight there is not a great deal to choose between drawing according to ovoids and drawing according to planes. In the former the preliminary drawing tends to look like a chain of sausages, in the latter the figure might look like a pile of wooden blocks. However, there are two reasons why drawing according to planar structure may be regarded as preferable to drawing according to ovoids. The first is that although ovoids are well adapted to drawing the human figure and similar free-standing volumetric subjects, they have very limited relevance to subjects like plant life, which has a pronounced planar character, and landscape, which is much more a question of dealing with relations of large, open planes and voids. The second is that ovoid forms have a distinctive and complex character of their own which all too easily imposes itself on the final character of the drawing. It is often the case that figures constructed on the basis of ovoids generate a spongy, over-modelled look whilst at the same time appearing flaccid in construction.

An advantage of conceiving the subject in terms of planes is that drawing itself normally consists of the graphic modification of a plane, the support, by means of marks, and it is relatively easy to think of the subject as a series of planes moving in space, sometimes parallel to the surface, sometimes advancing, sometimes receding in depth. Not

John Bratby: *Susan Ballam*
Black chalk, 132 cm × 49.5 cm
Tate Gallery, London

203

Walter Crane: Methods of construction using ovals and right angles. From *Line and Form* 1900, p.11 Line Drawing for photomechanical reproduction, 11.5 cm × 12 cm

only can the perceived surface of the motif be interpreted as a series of plane constructions, but planes can be hypothesized as the internal structure of objects—for example, the plane which moves vertically through the torso from the line of the shoulders. It is clear from the work of many master draughtsmen, Cézanne being a case in point, that a procedure of graphic construction according to planes has much to recommend it.

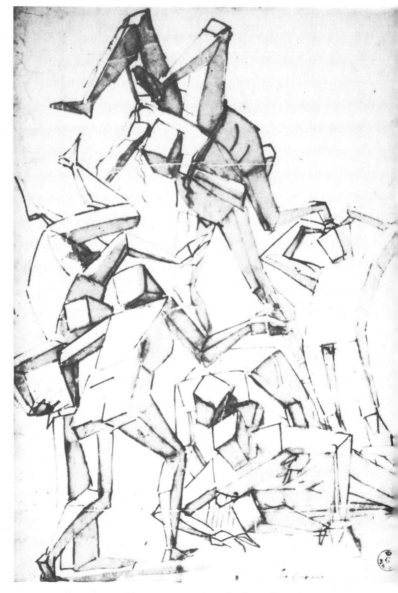

Luca Cambiaso: *Tumbling men* Pen and ink and wash, 34.9 cm × 24.5 cm *Uffizi Gallery, Florence*

204

Paul Cézanne: *Self portrait* Pencil, 22.2 cm × 12.7 cm *Art Institute of Chicago*

REALISM

The words 'realism' and 'realistic' are often popularly applied to works of art to mean something analogous to **naturalism** and 'naturalistic'. However, when used in the context of art literature, the noun Realism (usually spelt with a capital R) and its associated adjective Realist are usually intended to mean something quite different from naturalism. Realism is the tradition of art in which the artist not only confines his attention to the concrete, existing world which surrounds him, but deliberately selects subject matter from that world which represents a criticism of or comment upon social, moral or political values. The father of modern Realism was the painter Courbet, although many of his works are far from Realist in the sense of the word which is given above.

OPPOSITE **Gustave Courbet:** *Man with a pipe* (Self-portrait)
Black chalk, 27.9 cm × 20.6 cm
Wadsworth Atheneum, Hartford

Käthe Kollwitz: *Woman sleeping at a table* Charcoal on Ingres paper, 40.6 cm × 57.2 cm
Los Angeles County Museum of Art

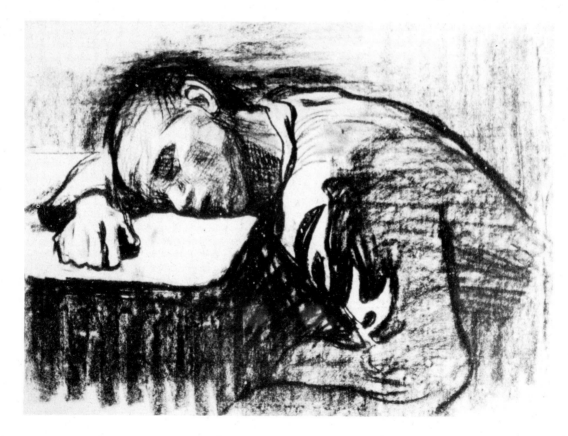

206

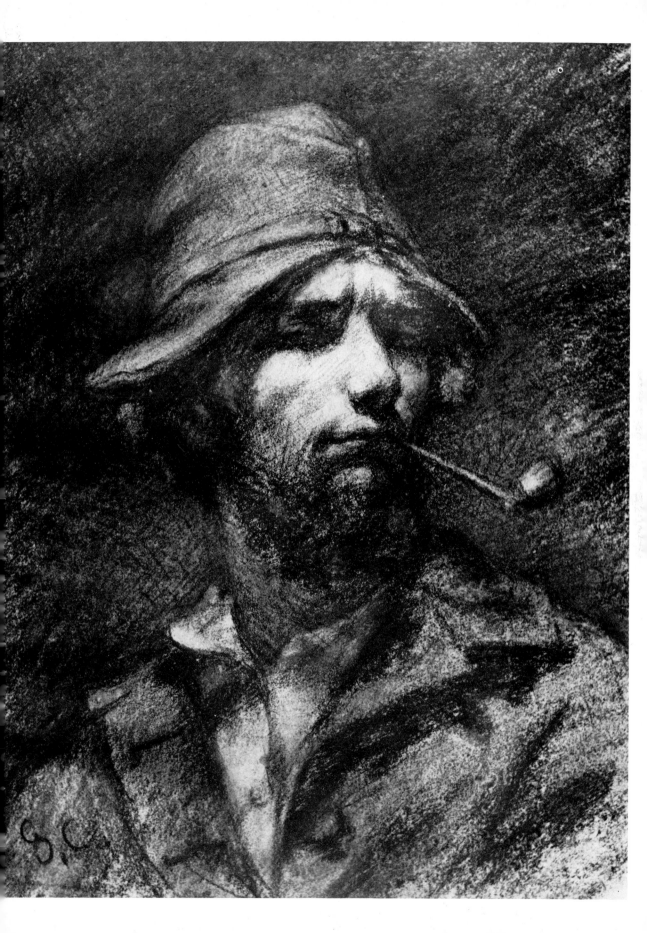

SCALE

The scale of a drawing done from observation may be defined as the relationship between the true size of the thing being drawn and its image on the paper. It is possible to draw an object to the scale of its actual size, or even to enlarge it beyond life size; but in general drawings are done on a scale considerably less than life size. This is because the objects we observe about us are by definition viewed at a certain distance from the eye and can not make the impact of their full size without being in direct contact with the eye, in which case they would of course blot out everything else. In a nutshell, we see everything about us smaller than it in fact is.

It is very instructive to establish just how small things are as we really see them. This can be done by viewing a subject through a sheet of glass which is held at a normal drawing distance from the eye (about 18in. (45cm)) and, using something which will draw on glass such as a Chinagraph pencil or thickly mixed gouache, marking out the broad relations of the subject as they are seen. Anyone doing this for the first time will be surprised by just how small the subject is when measured in this way. The same exercise may be done more simply by holding one's drawing board or pad at a normal drawing distance from the eye so that one vertical edge bisects the subject, and ticking off some simple relations such as the height of a head or tree. The scale of a subject arrived at in this way is known as 'sight size'.

What we learn from the exercise is that we are constantly seeing things very much smaller than we tend to imagine. This is compensated for by the fact that we develop the habit of focusing in on selected details of our surroundings and allowing them, psychologically speaking, to fill our minds, even if they do not fill our field of vision.

The question now arises as to what relation if any a drawing should have to sight size. The scale of a drawing is fixed at a very early stage in its development, and very often in the haste which arises from a desire to make progress a scale is chosen which is out of keeping with the needs of the drawing and which in the long run makes it impossible to produce a satisfactory result.

What points should be borne in mind when establishing

Claes Oldenburg: Stripper with battleship: Preliminary study for Image of the Buddha Preaching. 1967 Pencil, 76.5 cm × 65.2 cm Oldenburg's drawings, like his sculpture, make vivid use of contrasts of scale *Collection, The Museum of Modern Art, New York* Gift of Mr and Mrs Richard E. Oldenburg

208

the scale of a drawing? The first has already been mentioned, namely the size which the subject appears to the eye. One must add to this the total size of the drawing (ie the size of the image on the paper) and its intention (whether, for example, it is being used as a working drawing). A third important factor is the nature of the medium and the scale of the marks it makes. Very large pencil drawings tend to look thin and laboured; excessively small charcoal drawings may appear congested and clumsy. Finally one should bear in mind the context in which the drawing is likely to be viewed, whether it will be framed and hung, or left in a folio or notebook.

Tony Dyson: *Bridge* Etching and aquatint, 30.5 cm × 20.3 cm The contrasted scale of architectural units such as the columns and windows creates a sense of depth *Courtesy of the artist*

Bearing all these factors in mind, I believe it is true to say that student and amateur draughtsmen almost always err on the side of making the scale of their drawings too large—sometimes so large that it immediately frustrates any hope of success. A head, for example, may be drawn in pencil to fill a half imperial sheet. The result is a drawing in which the medium is stretched beyond its potential, and in which there is insufficient information to fill the excessively large areas of internal form. A drawing which is too large in scale for the available content or observed detail is rather like a musical idea which would pleasantly fill five minutes being extended and padded out to an hour.

It is appreciated that this advice conflicts with the views of many drawing teachers, perhaps the majority, who advocate large 'free' drawings and deplore small 'fiddly' ones. They recommend drawing on a large scale because it permits gestural freedom and, when using a broad medium like brush or charcoal, can result in something eye-catching for the walls of the annual exhibition. These may be worthwhile motives, but they should not be allowed to override all the other qualities of drawing.

If we study the drawings of draughtsmen of quality we find a widespread tendency to work on quite a modest scale. One need only look through a series of drawings by, for example, Leonardo, Rembrandt, Watteau, Ingres, Degas and Picasso (in the original, of course) to learn that they are more likely to draw a head the size of a thumbnail or a walnut than a teaplate. If we admire their work and follow their example in so many things, then surely we need to pay attention to their use of scale.

SCHEMA

A schema (plural, *schemata*) is a formula image which is repeatedly used to represent an object regardless of variations in the object's real appearance. A schema is therefore a kind of conventional graphic sign, similar in character to those used in maps, which can be employed within the imagery of an individual or, indeed, of a whole artistic culture. Typical schemata are the lozenge-shaped eye form which one finds in Egyptian art, in early Cubism, and in the art of children, and the 'stick and ball' tree schema which is almost universal in young children's drawings.

The desire for **naturalism** in drawing entails a shift away from the use of schemata, since objects as they are perceived in nature rarely conform to any preconceived shape or

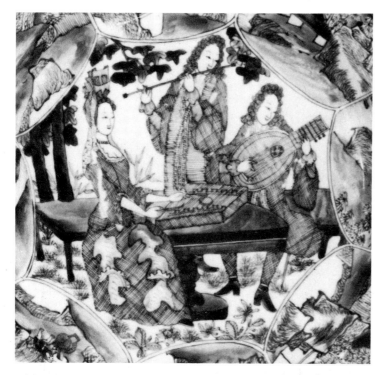

K'ang Hsi: Plate with scene known as *The Music Party*, after a French print. Early eighteenth century (detail) Diameter 34.2 cm
In copying the European print, the artist has incorporated facial schemata derived from Chinese art
British Museum, London

configuration. It is nevertheless possible to detect schemata in many drawings which purport to be based upon observation. This is particularly noticeable in the drawing of textural effects such as hair, leaves, grass, etc. On a more philosophical level, one may question whether a clear distinction can be made between the use of schemata and drawing from observation, or whether drawing from observation consists of matching a highly sophisticated range of schemata to what is perceived.

SCULPTOR'S DRAWING

The value of drawing for the painter hardly needs stating; and it is not surprising that a high proportion of painters have been prolific and brilliant draughtsmen. Both drawing and painting are concerned with the subdivision and articulation of a flat surface, albeit with a variety of media and differing objectives. The relationship between drawing and sculpture is more tenuous, since sculpture, unlike drawing and painting, is concerned with the expressive manipulation of actual three-dimensional space and form. Drawing can only symbolise and hint at depth: the sculptor must learn to deal with real volumes and voids.

211

Until the fifteenth century sculptors, unlike painters, did not normally draw unless they had to deal with some aspect of two-dimensional design such as the engraving of decorative forms on the surface of a three-dimensional object. Since the painters and sculptors of the mediaevel and Renaissance periods often worked as craftsmen in a variety of decorative media, this was not so uncommon as one might imagine. Preparatory studies for sculpture tended to take the form of small clay or wax models which could be rotated and viewed from many positions to ensure that the final sculpture would be effective in the round – something which would be extremely difficult by means of drawing. If an early sculptor needed a drawing in order to make a scheme clear to a prospective patron, he usually hired a draughtsman and paid him to execute the drawing from his instructions and models.

When Renaissance art theory and taste began to attach increasing importance to the idea as distinct from the physical substance of the art work, sculptors began to draw more regularly; and so developed the long tradition of sculptors' drawings which continues unbroken down to the present day.

A sculptor is never one hundred per cent unadulterated sculptor, any more than a husband is one hundred per cent husband or a cobbler one hundred per cent cobbler. There is nothing to prevent the sculptor thinking, behaving and drawing as a painter or designer, and it is interesting to note how the early paintings of Maillol (1861–1944), one of the most important sculptors of the turn of the century, are as richly painterly and colourful as one can imagine. The sculptor's vision is enriched by paying attention to the planar qualities of painting and drawing, just as the painter may benefit from thinking for a while in three dimensions or even modelling and constructing his scenes, as did Poussin and Gainsborough.

However, there are certain drawings which are so clearly and specifically associated with sculpture that they could be fairly described as 'sculptors' drawings' in the most complete sense of the term. Sculptors who draw with the intention of evolving and rehearsing the forms of a forthcoming sculpture tend to think in terms of tactile rather than visual values. That is, they are more concerned with the sense of touch and physical intervals between the parts of the sculpture than with purely pictorial values derived from one aspect of the work. This leads to a predominant stress on contour, which indicates the precise location in space at which a solid mass of matter – flesh, stone, wood, or

whatever – terminates and is replaced by air, the point at which a volume becomes a void. The drawings of Michelangelo, who drew and even painted with a sculptor's eye and imagination, reveal his concern for the tactile properties of form rather than its purely pictorial potential. Even his hatching is used to suggest the lines described by the chisel as it strikes its way through the resistant stone to reveal the form hidden within it.

A sculptor's drawing often suggests light and shade; but it should be remembered that while the painter has a high degree of control over the depiction of light and shadow relationships in his painting, the sculptor is normally at the mercy of all the variations in the direction and intensity of light which result from diurnal, seasonal and meteorological changes. Unless he is working for a location which is completely lit by artificial light, the sculptor cannot depend upon constant illumination to animate his work: it must be designed to be effective in a wide variety of illumination. Consequently, in his drawings the sculptor is normally less concerned with the precise behaviour of light and shade.

Turning to the relationship of the drawing with its support, it is generally true that sculptors are not so preoccupied as painters with the precise location of the image upon the page, or with what the French call the *mise en page*. Painters tend to think of the drawing as a totality, a graphic image upon the surface on which it is executed. All the elements of the drawing, including the spaces between forms, and those between the forms and the edge of the support, must be brought into play in order to produce a controlled pictorial design. Unless he is working for a confined architectural setting which determines the setting for his piece, the sculptor cannot define its 'context' in the same way. A free-standing sculpture in an open space must create its own environment: there is no boundary at which the surroundings of the sculpture may be said to terminate.

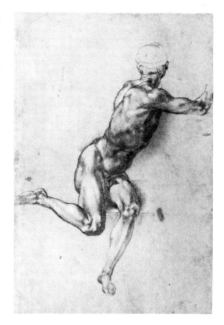

Michelangelo: *A nude man, seated and turning to the right* Red chalk, 42.1 cm × 28.7 cm *British Museum, London*

Don Judd: Untitled. 1966 Pen, 43.5 cm × 55.9 cm The economical nature of minimalist sculpture demanded a correspondingly laconic style of drawing *Collection, The Museum of Modern Art, New York* Purchase

213

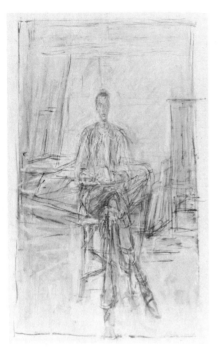

Consequently, the sculptor-draughtsman tends to regard each image as a discrete unit with its own internal logic, and related only rather arbitrarily to the paper upon which it is executed.

Finally, one can detect a difference of approach between the drawings of sculptors who are predominantly carvers, and those who are predominantly modellers. Carving is a reductive process, beginning with a piece of stone, wood, or other material, and reducing it by removing sections by carving or abrasion. Modelling is an additive process, consisting of joining one piece of clay, wax, or whatever, to another until the form is built out to its intended shape and dimensions. Michelangelo, a carver, drew reductively, cutting into the form from the outside; Rodin, a modeller, drew in an additive way, building the form out with wash and ink in a fluid and animated way. Sculptors do not have to work reductively (ie by carving) in order to reveal a reductive approach in their drawing. Giacometti modelled most of his forms on an armature, but his drawings reveal a pronounced reductive mode of thought. His lines hack, at times savagely, into the forms, suggesting the way in which the surrounding air bites into the hollows and interstices of the subject, producing the curious emaciated and stick-like figures which are typical of his work.

Sculptors have revealed immense variety and imagination in their use of drawing materials, often resulting in unique graphic effects. Notable examples of this are Rodin's use of water colour wash combined with fluid pen line and Moore's use of wash, pen and wax crayons in his grease-resist drawings.

SGRAFITTO

See **Grafitto**.

SHADING/SHADOW

Shading is the process of adding tone to selected areas of a drawing. Very often the intention of shading is to indicate the presence of a shadow, but it should be noted that this is not always the case. The expression 'shading' has come to mean any reduction in the tone of an area of a drawing, whether it is applied to the depiction of shadow, local tone, local colour interpreted as tone, or simply the creation of an abstract motif of a tonal nature. In a sense, shading means the reduction of the tone *of the drawing*, regardless of whether that reduction is intended to denote the presence of a shadow. These distinctions are dealt with more fully under **tone**.

Shadows in nature are created when matter is deprived of light, and drawing can reproduce this phenomenon by reducing the tone of selected parts of the image. Since most drawing is done with a dark medium on a light surface, the procedure is to work most heavily into the shadows, leaving the light surface of the support to represent illuminated areas of the subject. Shadows in nature behave in a relatively predictable way. Since light travels in straight lines, it is possible to imagine the existence of a light source without being able to see it, provided we can see how objects behave when illuminated by it. In fact, it is only in a tiny minority of drawings and paintings that there is any attempt to depict the light source itself as distinct from its effect upon objects.

Furthermore, it is possible to distinguish between natural light, which travels in more or less parallel rays, and artificial light, the rays of which radiate from one point in space. To illustrate this difference, one need only imagine the difference between a group of figures on the one hand lit by direct sunlight, and, on the other, by a lantern just outside the field of vision. In the first case the shadows would be parallel; in the second they would radiate.

OPPOSITE ABOVE **Alberto Giacometti:** *Seated man.* 1949 Oil on canvas, 80 cm × 54 cm The strongly linear character of much of Giacometti's work places it on the border line between drawing and painting *Tate Gallery, London*

OPPOSITE BELOW **Henry Moore:** *Pink and green sleepers* Pen, wash and gouache, 38 cm × 55.5 cm *Tate Gallery, London*

215

In the earliest recorded drawings and in cave paintings shading tended to be used, if at all, to represent local tone rather than shadow, and the evolution of Western art has been in terms of the development from a predominant use of outline combined with local tone to progressively more sophisticated methods of depicting shadow. In late mediaeval drawing indications of shadow were introduced in a limited way to support the suggestion of volume. During the Renaissance the behaviour of light and shadow was studied scientifically and, at the same time, exploited artistically to render volumes and voids more convincingly.

The artistic use of shadow rose to a position of unprecedented importance in the seventeenth century, and led to the coining of an Italian name for the painters for whom it appeared to be a leading preoccupation—the *tenebrosi* ('shadow-men'). Another Italian word, **chiaroscuro** ('bright-dark'), was used to denote the phenomenon of the relation between light and dark in drawings and paintings. There are few gains without some kind of corresponding loss, and the excessive exploitation of shadow led in time to a decline in the integrity of the picture surface as a flat design. It is significant that in art forms where design is at a premium, such as the drawings and prints of the Japanese school, shadow plays little or no part.

There are two basic kinds of shadow, namely attached shadow and cast shadow. Attached shadows form on planes of a lighted object which turn away from the light source, hence they are 'attached' to the object. Cast shadows form when one object interrupts the fall of light on to another. The most rudimentary way of suggesting an attached shadow consists of thickening or doubling the contour of a form which is farthest from the light source. This so-called 'shadowed line' has enjoyed periods of immense popularity with engravers and with draughtsmen who worked under the influence of engraving. Shadowed line may well have some relation to the observed behaviour of shadows, especially when the light falls flatly on to the motif from behind one of the spectator's shoulders. We find this effect in the drawings of Manet, who did not like excessive modelling of the form. However, it is easy for shadowed line to degenerate to a formula technique with little or no relation to observation, in which case it becomes a mere cliché.

A more constructive form of attached shadow consists of observing and depicting the darkening of planes on the edge of a volume as they turn away from the light source. A narrow, intense band of shadow suggests a sudden turn of the plane away from the spectator; a broader, more gradual

Charles Keene: *Lady reading a book.* About 1860 Etching, 16 cm × 12.5 cm *Private collection*

216

Hans Holbein: *Mrs Pemberton,*
aged 23 Water colour on vellum,
diameter 5.3 cm
Victoria and Albert Museum, London

Nicholas Hilliard: *An unknown youth leaning*
against a tree among roses. About 1588
Water colour on vellum 13.6 cm × 7 cm oval
Victoria and Albert Museum, London

Deccan artist: *Two girls in diaphanous saris dancing on the grass.* Early eighteenth century
Gouache and gilt, 19 cm × 16.5 cm *Private collection*

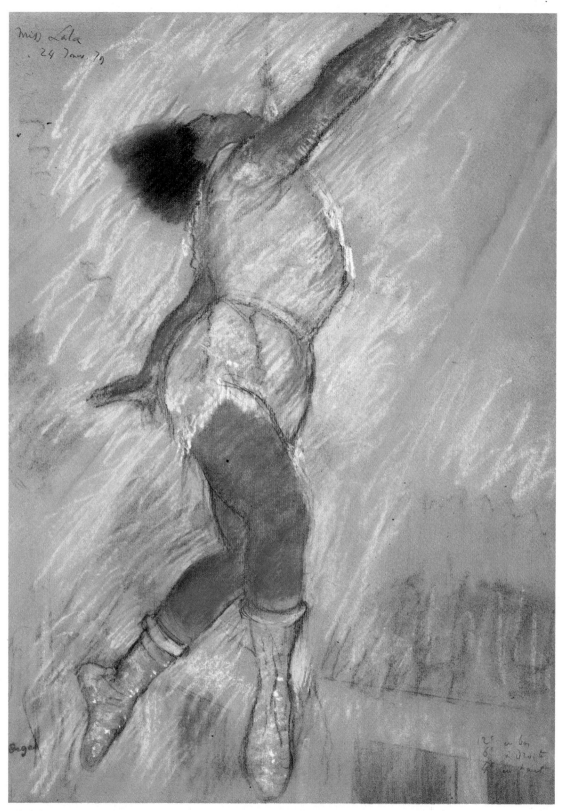

Edgar Degas: *Miss Lala at the Cirque Fernando.* 1879 Pastel, 61 cm × 52.7 cm *Tate Gallery, London*

Adrian George: *Vivian in the morning.*
1981 Coloured crayons,
68.6 cm × 61 cm
Francis Kyle Gallery, London

Glynn Boyd Harte: *The artist's life.*
1980 Coloured crayons,
78.4 cm × 56.4 cm
Francis Kyle Gallery, London

Japanese, Kamakura period: *Paradise of Yakushi.* Hanging scroll, thirteenth century Colours on silk, 183 cm × 122 cm *Victoria and Albert Museum, London*

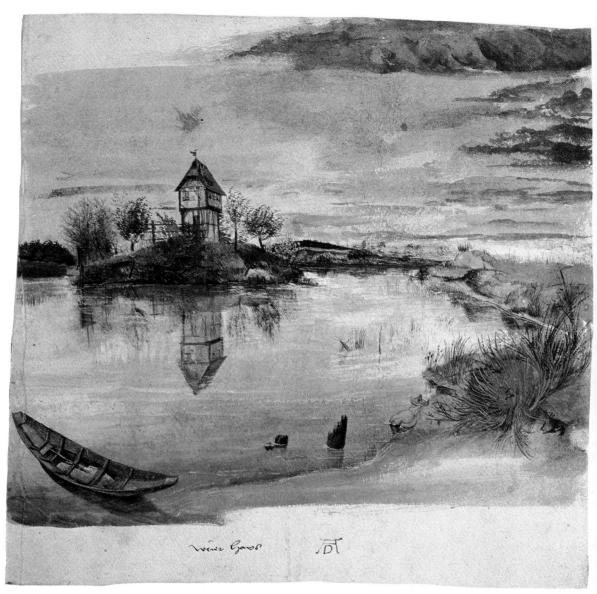

Albrecht Dürer: *Das Weierhaus* Water colour and gouache,
21.5 cm × 22.5 cm *British Museum, London*

John Constable: *Stonehenge.* 1836 Water colour. 38.7 cm × 59 cm
Victoria and Albert Museum, London

John Sell Cotman: *Wooded landscape with a winding river* Water colour,
21.3 cm × 31.5 cm *Victoria and Albert Museum, London*

Gerhard Gutruf: *Prata, near Suvereto, Tuscany.* 1977 Water colour, 34 cm × 48 cm
Private collection

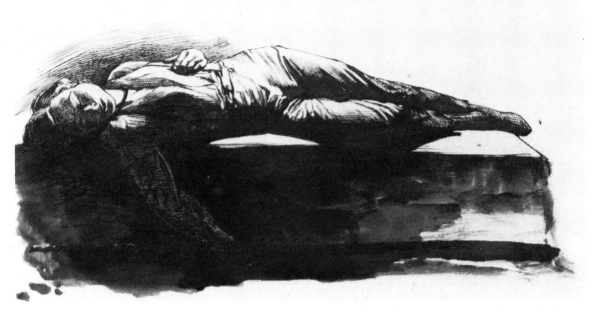

Henry Wallis: Study for *Death of Chatterton* Pen, sepia ink and wash, 19.4 cm × 25.2 cm
Tate Gallery, London

band suggests a slow turn from the facing plane to the receding one. The further the light source moves to one side or the other, the larger and more complex the attached shadows will tend to become. Here they are no longer confined to the edge of the form, but develop into complex modulations of light and dark within the form. To continue this line of thought, when the light source is on the other side of the object being observed, most of its form will naturally be taken over by attached shadow, with perhaps only one edge catching much light. This effect, when most of the object is immersed in shadow and only a narrow band of light breaks over the edge, is known in French as **contre jour** ('against the light').

Cast shadows are formed when one object interrupts the fall of light on to another. Whereas attached shadows are determined by two factors, the nature and position of the light source and the form of the shadowed object, in the case of cast shadows a third is added: the nature and form of the object upon which the shadow falls. Cast shadows take the recognisable form of the object casting the shadow when they fall on an even surface which is at roughly 90° to the angle of the light. When the surface does not face the light source in this way, the shadow will be correspondingly elongated or otherwise distorted. Cast shadows which fall on to a very uneven surface may take the form of the surface on to which they fall so completely that the form of the object

217

casting the shadow is no longer discernable. To grasp this point one need only imagine the shadows cast by clouds as they move across an irregular landscape.

The above discussion of attached and cast shadows has assumed the existence of one light source, but this is often not the case. When there is more than one light source the play of both attached and cast shadows may be greatly enriched and complicated. For example, when an object is lit by two sources placed on either side, the attached shadow tends to accumulate in the centre of the form rather than at either edge. The deliberate use of two or more light sources is widely exploited by portrait photographers, who can use backlighting and cross-lighting to animate an otherwise uninspiring physiognomy or to minimise the breadth of a portly form by eroding it with light on both sides.

It should be remembered that in addition to sources of direct light, much light is given out by reflecting surfaces. The moon itself is, scientifically speaking, a source of reflected light. On a smaller scale, almost any light-toned surface is capable of reflecting light and thereby modifying the shadows on nearby objects. A good case in point here is a white collar which bounces light back to the shadowed side of the jaw or throat with the result that there is a slight lightening of the shadowed surface at the contour. This effect is particularly evident in seventeenth-century portrait drawings of sitters wearing a large white ruff. Much the same

Honoré Daumier: *The montebank*
Pen and ink, tinted with colour,
33.5 cm × 39.6 cm
Victoria and Albert Museum, London

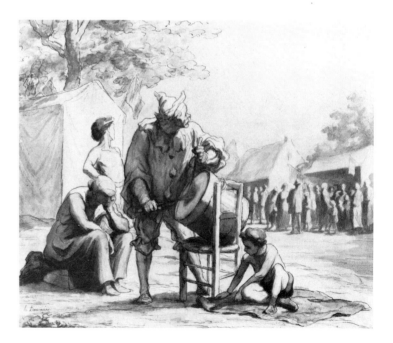

218

Henry Tonks: Study of a nude girl Pencil and pen and ink, 39.1 cm × 20 cm The attached shadows are modified by reflected light *Victoria and Albert Museum, London*

effect of reflected light can be seen on a life model posed with the legs together, when the illuminated plane of one leg bounces light on to the shadowed plane of the other.

Shadows may be drawn in two basic ways. In the first the drawing medium is used to reduce the tone of the shadowed area in relation to the size and shape of the shadow, but with no special attention to its internal structure and detail. This consists of a kind of mapping process of the shadowed areas, and is best executed in a medium without a strong directional element, such as brush and wash. If a point medium is used, it may be hatched in straight, parallel lines or applied in a scribbling technique which reads as a general reduction in tone. In this way, no special indication need be given of the form or texture of the surface in shadow apart from its total area and boundary.

The second method is to reduce the tone of the shadowed area whilst at the same time providing additional graphic information as to its internal form and character. For example, attached shadows can be built up with sequences of lines which follow the section of the form, such as bracelet shading used on limbs or tree trunks. This manner of drawing shadows is capable of enormous development and sophistication, so that at the same time as drawing the shadow the draughtsman is providing all kinds of additional information about the form, structure and texture of the shadowed object.

There can be no visual perception without light, and light can be suggested by the depth and distribution of shadow. However, it should be remembered that shadow is only one way in which light can be made manifest. An equally important factor is the variation in the local tone of objects, regardless of whether any attached or cast shadows are perceptible. Local tone is determined by the reflectivity of the surface of the object, hence a black jacket will tend to read as darker than a white collar whether or not there is any question of shadows. This point is demonstrated very well in the drawings of Manet and Seurat. In perceiving and depicting shadows, it is important not to override the effects of variation in local tone, especially when the light source is weak or diffused.

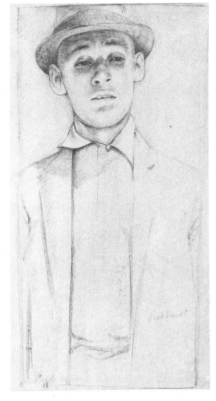

Carl Pickhardt: *Young man in the sun* 1935 Pencil, 38.4 cm × 27.9 cm *Collection, The Museum of Modern Art, New York* Ethel R. Scull Fund

OPPOSITE **Stanley Spencer:** *Self portrait* Pen and ink, 47 cm × 35.6 cm In addition to reducing the tone of an area, Spencer's pen strokes provide a great deal of information about the form of the head *Location unknown*

SILVERPOINT

See **Metalpoint**.

221

SIZE

The size of a drawing is intimately related to a number of factors such as its purpose, the medium employed, the scale of the image, and the creative intention of the draughtsman. We tend to overlook the fact that before the invention of modern methods of paper manufacture drawing supports, which included handmade paper, parchment and vellum, were relatively expensive. Even a draughtsman of the stature of Leonardo da Vinci was prepared to squeeze several drawings on to the same sheet, together with written notes and observations. It was also common practice repeatedly to erase drawings to make way for new ones.

Nowadays perhaps the last thing which would strike the draughtsman as a limitation is the question of the size of paper, and in educational practice this has led to a tendency to draw at a **scale** which is frequently too large for the motif and the medium. The inclination to work at a size which is too large for comfort has been fostered by two features of educational theory and practice. The first is that the conventions of timetabling which are administratively convenient for the conduct of schools and art schools, lead to a situation where the student is often required to work for too long at the same drawing. The student selects a large sheet of paper which will absorb the sheer quantity of work which can be generated over the course of several hours of drawing activity.

The second factor is the view that drawing can be regarded as a kind of beneficial form of physical exercise: 'freedom of expression' is interpreted in terms of large and bold sweeps of the hand and arm, which can only be accommodated on correspondingly large sheets of paper. Like most educational ideas these approaches have their virtues, but the use of large drawing supports frequently results in overstretched, thin and vacuous imagery.

SKETCH

The practice of sketching has been cultivated by artists and designers for many centuries. Traditionally, it has served two purposes. On the one hand it has been used as a means of capturing transitory events and effects, observations and impressions; on the other it has been employed as a way of stating first thoughts for more elaborate projects. During the late eighteenth century the artistic tastes of the Romantic movement tended to attach a considerable—and perhaps

Philippe Louis Parizeau: *The draughtsman G. Müller in the country* Red chalk, 19 cm × 13.5 cm *Albertina, Vienna*

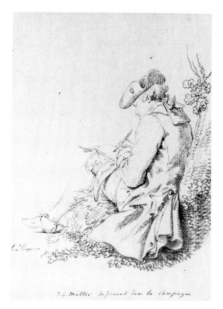

222

Henri Gaudier-Brzeska: Studies of
birds Pen and blue ink,
25.5 cm × 38 cm
Tate Gallery, London

inflated—importance to the role and significance of the
sketch as a way of gaining insight into the spontaneous
thoughts of the artist. Conversely, drawings which were
highly finished became regarded as overworked and of less
intrinsic interest. Conforming to the tastes of the period,
armies of well-to-do young ladies and gentlemen migrated
about the landscapes of Britain and Europe, armed with
sketch books and intent on rendering the intensity of their
personal response to nature.

Perhaps as a result of the excessive reverence for the
sketch during the nineteenth century, it has since fallen into
a position of quite unjustified suspicion or even contempt, so
that the term 'sketch' is widely taken to denote something
superficial and trivial, but at the same time pretentious. Its
role as a rapid recorder of the transitory has been taken over
by the more convenient photograph. This is unfortunate,
since there can be no doubt that the practice of capturing
transitory effects with the pen or pencil is an invaluable and
fundamental training for the eye and the mind; and, with all
its strengths, photography is characterized by a degree of
passivity which disqualifies it as a complete substitute.

Furthermore, it could be argued that the qualities of
spontaneity and freshness which we associate with the
sketch should be an integral part of every work of art,
however complex or elaborate. Students in the Parisian
ateliers of the nineteenth century were advised: 'ébaucher
toujours', (always sketch) meaning that even in the last
stages of a major painting one should attempt to retain the
vigour and spontaneity of the sketch. If we review the works
of artists like Titian and Delacroix, we find that their
paintings and drawings became more 'sketchy' as their
careers advanced and as they progressively discovered how
much could be omitted without losing the essential
characteristics of a work.

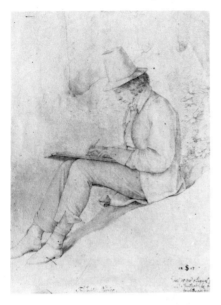

Julius Schnorr von Carolsfeld:
*Friedrich Olivier on an expedition from
Salzburg* Pencil, 26.1 cm ×
19.1 cm *Albertina, Vienna*

Because of the need for speed, sketching is normally undertaken with materials which are convenient to carry and quick to respond, such as the pen and crayon, and on surfaces which are small in scale, such as the pocket sketchbook. There are numerous devices to simplify or ease the process of sketching, including the small drawing board with a strap attached to two corners which can be passed around the back of the neck. Many such aids were originally developed for the requirements of military sketching, which was often undertaken under difficult or hazardous circumstances, or whilst mounted on horseback. However, there is an inverse relationship between the amount of equipment one attempts to carry and the likelihood that it will be made full use of, and there is no substitute for the pocket-size sketchbook which can be carried at all times without inconvenience.

STATION POINT

The station point of a drawing is the point at which the artist stands in relation to the subject or, in the case of a drawing from invention or imagination, the position of the draughtsman implied by the character of the depiction. The selection of a station point has enormous significance both in terms of the nature of the image and also the possible success or failure of the drawing. A common error is to decide upon a station point too early, before giving full consideration to all the implications of the view chosen.

When the subject has strong perspectival content, as in the case of architectural vistas, the station point of the draughtsman may be strongly implied. In such cases it is often important to view the drawing from a position which more or less replicates the original station point of the artist. This phenomenon is most clearly demonstrated in relation to illusionistic architectural decoration, when the desired effect can only be fully perceived from one position in the building.

STYLE

The term 'style' is derived from the object known as a stylus, a metal implement which in ancient times was used to write upon tablets of wax or clay. A man's 'style' was his personal manner of writing or expressing himself, and the term was often used to refer to the spirit and manner of his performance as a public orator. In the course of time the

concept of style has grown to acquire a much broader meaning, including not only techniques of communicating through speech and writing, but modes of musical composition and artistic expression.

The style of a drawing is determined by a cluster of characteristics which it might possess. These include factors such as the fullness or economy of the image, the character of lines in terms of length, intensity and variety of direction, and the general disposition of forms in the composition. Hence one might say that Forain had a very economical style and the Pre-Raphaelites an elaborately detailed style; Delacroix's drawings present a rich variety of linear directions, while Picasso's Cubist drawings confine themselves to a limited range of linear directions; Watteau's style favoured the disposition of figures along a curve in pictorial depth, while Neoclassical draughtsmen like Flaxman tended to dispose their forms parallel to the picture plane.

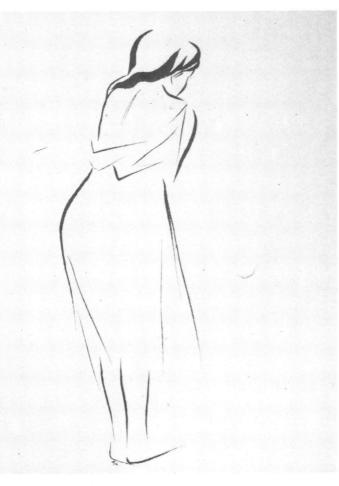

Jean Louis Forain: Study in line
Line drawing for *The Studio* Vol. XIV,
1898, 28.5 cm × 20 cm

225

One must confess however that the whole concept of style is a very problematic one which is far from resolved in modern art theory. The term may be applied to the grouped characteristics of a national school, a period, or to the work of an individual, and many art historians would claim that they can identify demonstrable features of style which one can associate with terms such as Renaissance, Mannerist, Baroque, Rococo, Impressionist and Expressionist.

It is popularly believed that in his mature drawings every artist of distinction works in a personal and identifiable style which is the result of a synthesis of his artistic personality with all the trends and influences which surround him. The fact that galleries, museums and art historians tend to cream off what they regard as the best in any period in order to present it to their public exaggerates the uniqueness of personal style, since we may as a result know only one artist as an example of any one period or national school. A more comprehensive knowledge might reveal several other artists who worked in styles which are to us indistinguishable from the one example we know.

This distortion by selection has led many contemporary artists to believe that they must at all costs avoid any stylistic resemblance to any other artist, past or present. Ironically, this often leads to an exaggerated preoccupation with style which can only be satisfied by an eclectic approach to the work of others rather than the cultivation of the individual's personal vision. In the quest for a personal style, the artist sets out to borrow an idea here, and another there, in the hope that the fancy dress which results will not look too much like the result of a tour of the second-hand clothes shops. The result is not a style, but a disguise, which only serves to obscure the artist's own creative identity.

SUBJECT

A saying, attributed to the great *Punch* illustrator Charles Keene, which is often repeated is: 'If a man can draw a thing, he can draw anything.' John Ruskin said the same thing in another way when, after advising the beginner to draw a stone selected from the street, he continued: 'Now, if you can draw that stone, you can draw anything: I mean, anything that is drawable.' If there is any truth in these claims, it is strangely unconfirmed by history; for when we review the careers and the work of fine draughtsmen (including, incidentally, Keene and Ruskin) we find that the majority imposed strict limitations on the subject matter which they

were prepared to tackle, and in many cases the range of subject matter is remarkably narrow. This truth is sometimes obscured by the fact that we tend to encounter great drawings in contexts such as large collections, galleries and illustrated books which surround the work of one draughtsman with a diversity of work by other artists and of other subjects. There is no more truth in the views of Keene and Ruskin stated above than the claim that if a singer can sing something, he can sing anything; and there are many cases of singers who have found success only when they have identified the kind of music which suited their voice or have even moved into a different vocal range and stayed there.

Almost everything which is drawable has, at some time, been drawn. We can explain some aspects of the choice of subject in terms of the values of the artistic culture in which the draughtsman lived. We should not be surprised that Raphael made the figure his chosen subject rather than, let us say, landscape. The culture in which he studied and worked regarded the figure as the supreme medium of

Jacob Van Oost: *The artist's studio* Oil on canvas Casts of antique statuary were regarded as the most valuable subjects for the cultivation of taste and the inculcation of drawing skills *Groeningen Museum, Bruges*

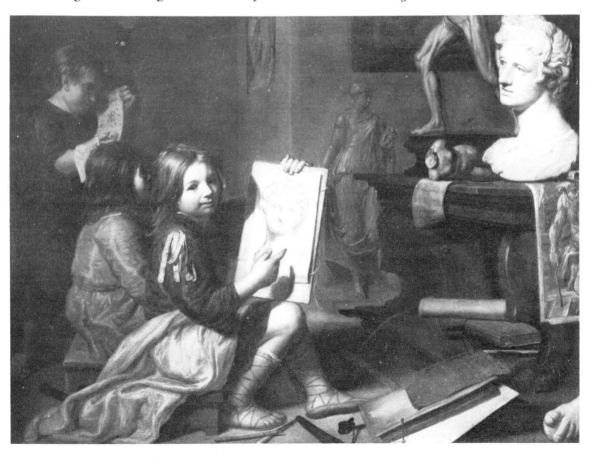

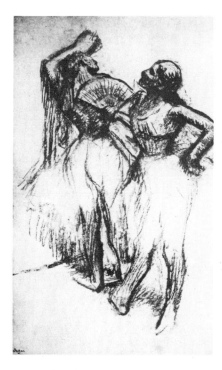

Edgar Degas: *Two dancers, one holding a fan.* About 1905–12 Charcoal, 61 cm × 38.1 cm
Location unknown

artistic expression and attached a relatively lowly status to the landscape. Similarly, the waning of religious convictions and authority during the twentieth century helps to explain why we have seen few draughtsmen of importance tackling religious subject matter.

However, apart from these cultural limitations imposed by the shared values of the day, individual artists often select quite rigorously within the range of what is considered to be legitimate subject matter. In some cases, subjects have been partly determined by the condition of the artist's physical health. During the latter part of his life Cézanne spent a great deal of his time drawing and painting water colours of still life. Although he preferred landscape, he was often too ill or the weather was too bad for him to work out of doors, and still life was the subject nearest to his first love. A more obvious case is that of Degas, who rarely tackled the Impressionist subject *par excellence*, landscape. Part of the explanation lies in the fact that Degas' sight deteriorated very early in his working life, to such an extent that at the end of his life he was almost blind. He found distant vision particularly difficult and was forced to confine himself to subjects with few complications of distance and detail, such as interiors containing a limited number of forms.

In addition to these personal physical limitations, one must also consider the important psychological implications which subjects can have for the individual draughtsman. The fine German artist Käthe Kollwitz was profoundly moved by the hard life of the poor which she saw around her. She felt inspired to feature this in her drawings, and had no interest in subjects which did not convey her powerful criticism of the social injustices of her day. However, to say that a draughtsman is 'attracted' by certain subject matter is not enough. Indeed, the fact that subject matter is 'attractive' can present as much of a problem as an opportunity, for we can be excited or inspired by subjects which offer little or no useful starting point for a graphic image. This is why intrinsically beautiful subjects so often lead to drawings which either completely fail to capture what we see as their intrinsic beauty, or result in something insipid or pure kitsch.

It is for this reason that one must learn to select subjects for their graphic visual qualities, and not only for their connotations in real life. This does not prevent us from making subjects of things we admire or are moved by, but admiration and emotion is not enough if it is not informed by the perception of visual qualities. We may find that our real subject is not the landscape, the figure or flowers as such,

but, let us say, shadows, rhythms of line or relationships of pattern. In good drawing one often finds both: a strong emotional identity with the subject, together with an instinctive grasp of the graphic qualities which it possesses.

P. G. Hamerton, an etcher and a perceptive art theorist of the nineteenth century, distinguished between a 'subject' and a 'motive'. A subject, he argued, is what literally confronts the artist when he commences his drawing; a motive is, he said, 'a certain condition of the mind, produced by the subject, and which the artist, in rendering that subject, desires to reproduce in the minds of spectators.' Hamerton believed that: 'Almost anything is a subject, but it only becomes a motive when an artist is moved by it.'

A modern writer, Philip Rawson, takes a position similar to Hamerton's when he distinguishes between the literal subject of a drawing, which he refers to as its *tenor* (literally, 'what is held on to'), and the configuration of lines and forms which constitute the drawing itself together with their spiritual and psychological connotations, which he calls the *topic*. Rawson's distinction of tenor and topic is somewhat difficult to grasp, but it would probably be true to say that a drawing's tenor is what could be conveyed to a blind man merely by describing its content, whereas its topic is the physical embodiment of that subject in terms of lines, tones and specific forms together with their power to evoke sensations through the medium of visual perception. Hence, many drawings have as their tenor the reclining female nude, but every fine drawing of a reclining female nude will have its own topic, its own graphic identity together with its aesthetic and psychological meaning.

It is curious that a theme supposedly as straightforward as the choice of subject matter should lead us on to such abstruse reflections. During the early years of the present century there was a tendency to belittle the importance of subject matter. Theorists and critics who supported the development of abstraction argued that subject matter was purely incidental; what was important was, as Roger Fry put it, 'significant form'—that is, the purely formal qualities of lines, tone, shape, pattern, etc. There is a degree of truth in this view, to the extent that an exciting subject is not necessarily capable of making a fine drawing; but with the passage of time it has been recognised that the emotional and psychological significance of subject matter cannot be ignored.

One might conclude with some tentative generalisations. First, the draughtsman should not be perturbed by feeling attracted repeatedly or exclusively to a limited range of

Jim Dine: Untitled from Seven Untitled Drawings (5 bladed saw) 1973 Charcoal and graphite, 65.1 cm × 50.2 cm Pop artists extended the range of subject matter to include subjects previously thought too banal for the artist's attention *Collection, The Museum of Modern Art, New York* Gift of the Lehman Foundation

subject matter, provided that this range is consistent with his artistic personality and creative intentions. Secondly, although certain subjects might possess a strong psychological attraction for certain draughtsmen, they should be selected on the basis of their visual qualities and graphic potential, and not only for their identity as components of the real world. Finally, subjects should always be selected and treated in terms of the graphic potential of the media available to or favoured by the artist.

SUPPORT

The support of a drawing is the surface upon which the drawing is executed, whether it be paper, cloth, wood, stone or any other material. Although the term is not in common use amongst laymen, it is worth employing in preference to 'surface', since when we talk of the surface of a drawing we may well be referring to the final result achieved by the application of the drawing medium to the support. Hence, drawings in wax crayon may be described as having a glossy surface, regardless of the support upon which they are made.

It is unfortunate that there is at present a tendency to regard the support of a drawing as of less importance than the drawing implements used or the drawing procedure. Many draughtsmen gravitate almost automatically to what is most easily available, namely white paper with a machine-made surface which is already cut into certain standard sizes. This is mounted on a flat drawing board, again of a standard size, and if the drawing eventually reaches the stage of being exhibited, it will be enclosed in a frame of a standard moulding, under glass of perfect consistency and a rectangular format. Most of these decisions are arrived at not from choice, but from habit and convenience; and in matters of artistic creativity, habit and convenience, because they are more difficult to detect, have an even more deadening effect than perversity or sheer stupidity.

When we glance with admiration through a collection of reproductions of fine drawings of all ages and cultures, we tend to forget that although we are seeing them printed upon paper of a consistent quality and size, their real physical character is often completely different. We must not overlook the fact that the support on which a drawing is created is an *object*, with its own independent existence. This assertion is not contradicted by the fact that most supports have been specially made for the purpose of being drawn upon: one of the problems of drawing upon a beautifully finished, pristine

sheet of white paper is that its inherent identity as an object is so strong that we find the mere sight of it intimidating. Putting a pencil to the middle of a sheet of cartridge paper can feel like being parachuted into the middle of an arctic waste without a map.

Many supports derive their identity from the fact that they retain strong connotations of their origin. Animal skins, hides, bark, stone and ivory, common as supports in non-industrialised societies, not only provide a rich variety of surface textures and colours, but are often selected because they have associations with the occult or spiritual identity of their source of origin.

North American Indian: Buffalo robe, the interior decorated with equestrian figures in colours Obtained from Crow Indians, Fort Custer, *c* 1880 Length 249 cm *Museum of Mankind, London*

231

In the case of drawing on cave walls, not only is the location fixed, but the support does not provide the draughtsman with any clear indication of size or format: the walls tend to merge imperceptibly with ceiling and floor and it is not obvious where the area of the drawing is intended to terminate. In all cases of drawing on stone, the support has a

Bull and horses. Cave painting of the Magdalenian period
Lascaux, France

Bushman stone painting: *Two deer.*
From a cave near King William's Town, Cape Province, South Africa
Length approx. 46 cm
Museum of Mankind, London

232

strong identity of its own, manifested in terms of surface irregularities, protrusions, indentations, variations in colour and relief, which can be integrated into the image. It would be possible to multiply these remarks *ad infinitum*; the important point is to recognise that drawing on a natural support like stone completely frustrates many of the assumptions and procedures which would be relevant to more conventional supports. Much the same can be said of drawing on animal skins, wood, leaves, or even the human body, which in tribal societies is often regarded as the most important support of all.

We can classify supports in terms of three characteristics, namely constitution, size and format. The constitution of a support is its physical and chemical structure as manifested

South African: Block of greenstone with design of a zebra cut into the surface Width, 46.8 cm
Museum of Mankind, London

LEFT Aboriginal body decoration, Arnhem Land, Northern Australia.
1972 *Axel Poignant*

233

SUPPORT

Australian aboriginal: Bark sheet decorated with a fish, Arnhem Land, Northern Territory, Australia
Colours on bark, length 62 cm
Museum of Mankind, London

Mexican picture-writing: Page from the *Codex Nuttall*. Before 1519
Colours on skin, 19 cm × 26 cm
Museum of Mankind, London

in its surface texture, its smoothness or roughness, its inherent colour, its durability, its capacity to absorb or reject marking materials, and so on. The size of a support may be determined by its source, as in the case of a whole animal skin, or may be varied according to the desires of the draughtsman, as is the case with paper, which can be cut, or if needs be, joined to make a large variety of sizes. Some supports, such as the wall of a cave, do not have a definite format, and it is impossible to say where the area of the drawing is intended to begin and end. In other cases, the format, like the size, is determined by the fact that the drawing is applied to a man-made artefact, such as a pot. The vast majority of Western drawing has been done on one preferred format, namely the flat rectangle in all its infinite variations of height to breadth.

Drawing on stone presents the draughtsman with certain obvious problems and possibilities. If the stone is an

234

independent rock or boulder he is normally obliged to come to terms with its existing size and format. This is particularly true of cultures which do not possess implements for the effective cutting of stone, and it is these cultures which, by definition, tend to be ones which are not conversant with the manufacture of more adaptable drawing supports. In the case of a large boulder, the location of the drawing will be permanently fixed by the position of the boulder, and it will be necessary to visit the support in order to see the drawing rather than, as we tend to assume, being able to carry the support together with the drawing to wherever we wish to contemplate it. This apparently incidental fact is of the utmost importance, since it reinforces the notion that an image can have a special identity with the spirit of a certain place and can relate to ritual and ceremony associated with that place. A certain amount of the magic of imagery has been lost to the so-called 'advanced' cultures as a result of the fact that they tend to regard most art works as objects which are infinitely transportable, to be uprooted, shifted thousands of miles, and re-located in an environment which is completely foreign to their natures.

From the process of drawing upon supports which occur naturally, we may move on to drawing upon supports which are man-made, but not for the sole purpose of being drawn upon. These include all kinds of functional artefacts such as clothing, tents, furniture, weapons, personal possessions and vessels. Almost every conceivable artefact has at some time been used as the support for a drawing, and in the present context I shall confine my remarks to one very good representative example, namely pottery.

A certain amount of ceramic ware has been manufactured from flat units or 'slabs', and objects built according to the principles of slab construction present the potter-

Eskimo: Walrus tusk engraved with scenes of birds, canoes and wickerwork objects Scratches filled in with black paint, length 53.3 cm
Museum of Mankind, London

Chinese: Porcelain vase, decorated in underglaze blue and red. Early eighteenth century with ling chih mark Height 45.2 cm
British Museum, London

draughtsman with a series of flat surfaces, each in its own way rather similar in area, format and surface to other flat supports such as paper or card. However, the potter is never permitted to ignore the fact that even in the case of a slab construction the tendency will be for the spectator to rotate the object (or, in the case of a large piece, walk around it) thereby bringing two or more surfaces simultaneously into view. Consequently he cannot treat each of the surfaces as an independent unit, but must consider how each of the flat planes will relate to its neighbours. In a way, his task is complicated by the fact that the joint between the surfaces will normally take the form of a right-angle, which makes connections and continuities more difficult to achieve than they are on concave or convex surfaces. One way of overcoming this particular problem is to accept and reinforce the abrupt junctions of sides by converting them into frame-like or architectural units, thereby suggesting to the spectator that although he is able to see more than one surface at a time he should attempt to read each surface as a more or less independent pictorial unit.

Most drawing on pottery has been applied to round vessels, which present either an external, convex surface, or an internal, concave surface. In the case of external surfaces, the eye is not permitted to see the whole design simultaneously, and it is necessary for the spectator to rotate it,

Hsang Te-hsin: Fan decorated with scene of moonlight on a waterfall. Mid-seventeenth century
Ink on gold paper, width 48 cm
British Museum, London

236

reading off the image section by section. This presents the potter-draughtsman with the problem that only one segment of the design is fully visible from any one point of view, the rest turning away from the spectator until, at the contour, it disappears completely. An interesting difference in the case of internal, concave surfaces is that normally the whole of the design is visible simultaneously, although, as in the case of external surfaces, presenting different angles to the spectator's line of vision.

It is possible to detect two broad distinctions in the way in which world cultures have attempted to deal with the problems of drawing on pottery. The mainstream of the Western tradition, with its origins in ancient Egypt and pre-classical Greece, has tended to treat the pot as a firmly defined geometric object, and subdivided its surface into a series of manageable pictorial or decorative bands, running like parallel friezes around its exterior. These bands are often treated in a processional style, with the figures standing upon the lower edge of a band representing a ground line and moving from left to right, or vice-versa, around the body of the pot. The tendency in classical Greek pottery was towards absolute clarity of expression, often in the form of a narrative event supported by labelling of the chief personalities with their names. One is left in no doubt that one is regarding a man-made object in which every detail has been the result of deliberate choice and decision. This is generally true of the successive conventions of Western pottery, subject to variations such as the introduction of vertical enclosures to create a sequence of discrete but related pictures.

In contrast to this predominant Western tradition, there is an ancient Oriental approach to drawing on pottery which reflects a completely different view of the artefact as a drawing support. In ancient Chinese culture the doctrine of the Tao represented the view that existence was part of an infinite cycle of change and transformation in which there were no abrupt beginnings or sudden ends, but in which all things, including human life, was constantly in the process of being translated into other forms of existence. This cultural view favoured objects which appeared to express the notion of obscure ancient origins, gradual change, and continuing transformation. As a result, the imagery on pottery influenced by this doctrine tends to be less geometrically determined in form, and makes rich use of apparently hazard effects such as diffused and irregular glazes, assymetric forms, and loose, atmospheric brushwork. The special beauties of this tradition of drawing on pottery were not fully appreciated in the Western world until the

Sudan: Composite bowl with everted rim decorated with geometric designs in rust, black and white. Kadaru, Nuba, Kordofan Diameter approx. 28 cm *Museum of Mankind, London*

237

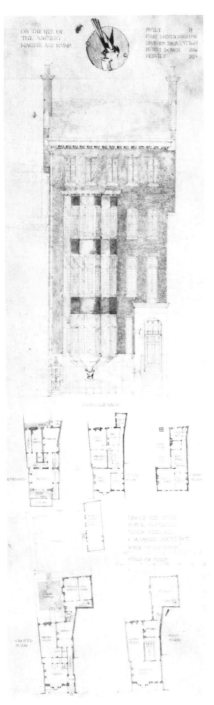

C. R. Ashbee: Elevation drawing of The Magpie and Stump. 1894 Pen and ink and water colour on vellum, 82.5 cm × 26.9 cm Ashbee's choice of vellum as a support reflects the revivalist tendency in Arts and Crafts work *Victoria and Albert Museum, London*

present century, but since their introduction into the West they have had a considerable impact upon the way we think about drawn imagery on pottery.

The number and variety of supports prepared from natural materials is very large indeed, and in the present context one can do no more than refer briefly to three of the most important, namely parchment, cloth and paper. Parchment derives its name from the ancient city of Pergamum, where it was believed to be first used, and is made from the skins of domestic animals such as calves, goats and sheep. After being cured in lime the skins are stretched over a frame and scraped to remove all traces of flesh and hair. The process of stretching and scraping continues until a support is produced which is both fine in quality and durable in use. Parchment became the leading drawing support of the mediaeval world, and individual parchments were often used, erased and re-used, producing what is known as a palimpsest. With the rapid spread of paper after about 1400 parchment became increasingly regarded as a support of special status and value, being used for documents and drawings of a state, religious or ceremonial nature. In time its relative expensiveness made it almost prohibitive as a support for general purposes.

It is difficult to chart the history of the use of cloth as a support for drawing, since it is one of the least durable of materials and leaves little evidence of its use. It is reasonable to assume from available evidence and survivals that cloth has had a long history of use in the Far East and Central Asia, and there are fine examples of drawings on cotton and silk from, for example, India and Japan.

A peculiarity of cloth which is one of its special attractions as a drawing support is the tendency of a fluid medium like ink to spread along its fibres away from the point of application, creating a delightful smoky edge to lines and areas of tone. Also, the pronounced sense of structure in much cloth makes itself felt in both drawn and undrawn areas, imparting a rich atmospheric texture to the whole drawing. It is however fair to say that this is one of the reasons why cloth has not met with universal approval as a drawing support, since it reduces the degree of control which the draughtsman has over the character of the image, and at the same time imposes its own strong surface identity upon the drawing. With the revival of unusual materials as supports in the twentieth century, combined with a renewed interest in exotic art forms, there has been a return to cloth as a drawing support. Generally speaking, this has expressed itself in work on coarser materials such as canvas and

238

sacking rather than upon the traditional fabrics such as cotton and silk.

Paper is of such overwhelming importance as a drawing support that it is dealt with separately under a separate heading. See **paper**.

See colour plate
Japanese, Kamakura period
between pages 216 and 217

TECHNICAL DRAWING

See **Architectural drawing, engineering drawing**.

TEXTURE

Considered in relation to drawing, texture may be defined as surface quality independent of form and colour. Texture is normally created by a consistent pattern of tonal variation and it may be produced either by the marking medium or by the nature of the support, or by a combination of both. Many supports, such as heavily textured antique paper, have an inherent sense of texture which results from the fact that light passing across the surface creates a pattern of microscopic shadows and highlights. Although texture might be used to *fill* a form in a drawing, it is not perceived *as* a form but as a general quality of surface. It has strong associations with the sense of touch.

Not all draughtsmen have shown interest in texture; indeed, its conspicuous presence is not essential to the art of drawing, which can be predominantly formal in character. For example, the draughtsmen of the early and high Renaissance in Italy were completely preoccupied with problems of the depiction of form, and consequently texture plays only a minor or negligible role in their work. It received more attention from the draughtsmen of the Low Countries, and this tendency corresponded to a general interest in all the information available to the senses, including the sense of touch. We can trace the development of interest in textural effects as it develops through the art of the seventeenth century, in the work of, for example, Rubens and Rembrandt, and reaches its peak in the drawings of the Rococo period, notably those of Watteau, Boucher and Fragonard.

Franciabigio: *Head of a young man*
Black chalk with touches of white on laid paper, 25.1 cm × 20.6 cm
Victoria and Albert Museum

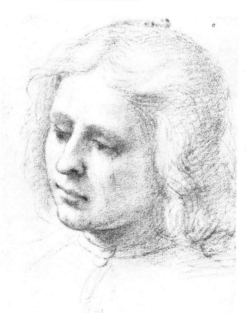

239

The drawings of Watteau represent a climax in the attempt to capture the most elusive of textures, such as flesh, hair, stone and varieties of cloth, in a graphic language which was immensely varied and flexible.

Texture in drawing can consist of one of two kinds, which I shall refer to as *inherent texture* and *constructed texture*. Inherent texture is created by selecting materials which have an intrinsic textural quality and working them in a manner which permits this quality to manifest itself. Heavily textured papers, conté crayon, chalk, etc, all possess certain intrinsic textural qualities which are easy to exploit, and might well be impossible to suppress. Seurat's drawing in black conté crayon on strongly textured paper make full use of the inherent textural possibilities of the medium. But Seurat was equally adept at constructing textures. For example, in his pen and ink drawings he often employed a fine pattern of dots

RIGHT **Georges Seurat:** Figure study for *La Grande Jatte*, 1884–1886 Conté crayon, 42.2 cm × 62.8 cm *British Museum, London*

Mark Gertler: *Head of a woman.* 1910 Sanguine, 24.7 cm × 16.5 cm *Victoria and Albert Museum, London*

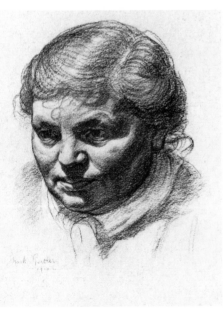

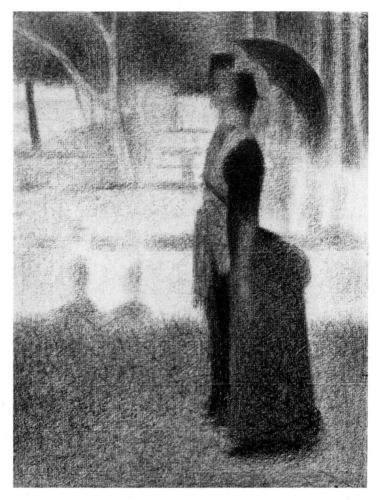

240

which was quite deliberately constructed, and which cannot be regarded as an intrinsic or inevitable characteristic of the medium. On the contrary, in different hands pen and ink takes on quite different textural qualities. The drawings of Aubrey Beardsley represent the acme of the technique of constructed textures. Beardsley rarely showed interest in the inherent textural qualities of paper or ink, but preferred to build up each texture in the drawing in a deliberate and highly controlled manner. The attraction in this technique was that it gave him a textural repertoire of infinite possibilities, whereas texture which is tied to the inherent qualities of the medium is inevitably limited to the possibilities of that medium.

When we talk about texture in relation to drawing, we might mean one of two things, namely the texture of the drawing itself, whether inherent or constructed, or the

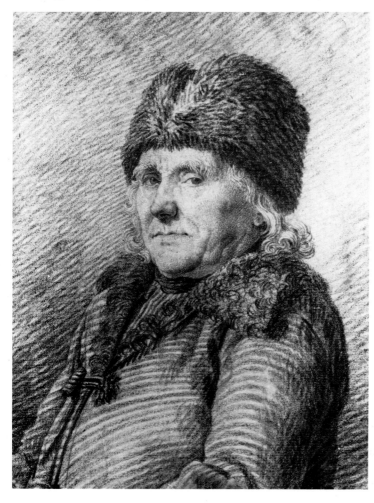

LEFT **Caspar David Friedrich:** *Portrait of the artist's father* Chalk, 23.5 cm × 18.5 cm *Oskar Reinhart Foundation, Winterthür*

Mark Tobey: *New York.* 1944 Tempera on paperboard, 83.7 cm × 53.2 cm *National Gallery of Art, Washington*

TEXTURE

Tony Dyson: *House in Torcello*
Etching and aquatint, 20.3 cm ×
20.3 cm *Courtesy of the artist*

suggested texture of whatever is being represented. It is significant that although Seurat's drawings are highly textural, they pay little or no regard to the textures of the things being represented as such. Conversely, the drawings of Watteau are not only highly textural as drawings, but tell us a great deal about the texture of the subject. Hence, it is possible to read back textures not only as cloth, hair, flesh, etc, but even as varieties of cloth, different qualities of flesh, and so on.

The pursuit of explicit textural effects can constitute a threat to the integrity of the drawing. The hallmark of the great draughtsman is that his use of textural effects never degenerates into cheap illusionism: the drawing always retains its identity as a drawing. Looked at from this point of view, it can be seen that the exploitation of texture is capable of two completely opposed tendencies. The use of an overall texture which originates in the character of the medium tends to impose a uniform quality across the drawing, regardless of the local textures of individual objects represented in the drawing. Hence, the texture of many of Seurat's drawings is so assertive that it frustrates any attempt to read back sections of a drawing as the local textures of the things being represented. Conversely, texture can be used to differentiate and heighten the individual qualities of whatever is being represented, as is the case in the drawings of Watteau.

242

TONE

Together with **line**, tone may be regarded as one of the two elements which characterise the art of drawing. This is not to say that all drawing must be both linear and tonal: there are many excellent drawings which make little use of line; and others which make good use of colour. But a graphic work which depends heavily upon fully gradated areas of colour with little or no evident use of line or tonal contrast will lose its identity as drawing and enter the realm of painting.

One of the most difficult and fundamental skills which the draughtsman (and the painter) must acquire is the ability to distinguish with confidence between differences of tone and colour. All colour has tone; and, paradoxically, all tone has colour of a kind; but whereas 'colour' refers to the chromatic hue of a surface as measured in terms of the *wavelength* of the light which it reflects, the tone of an area is determined by the *amount* of light reflected, regardless of its colour. Another way of putting it is that low-toned surfaces—of whatever hue—absorb more light than high-toned surfaces, which bounce light back to the spectator. Tone, therefore, is the quality of a surface as measured purely in terms of its position in the scale between black and white; or, in the case of a record of a natural scene, what one could capture with a black and white photograph.

Colour does have an effect upon tone to the extent that some colours, such as Ultramarine, have an inherently lower tonal value than others, like Lemon Yellow. Making a purely tonal rendering of a scene which included these colours would necessitate making a distinction between their inherent tonal differences. On the other hand, it would not entail distinguishing between colours of the same tonal value, such as identical shades of Cobalt Blue, Raw Umber and Cadmium Red. Even the most experienced eye can be deceived in the attempt to 'read' tonal values accurately, perhaps mistakenly interpreting a patch of intense colour as a strong low tone.

An interesting distinction which can be drawn between line and tone is that when used as a contour, line is an abstraction: it denotes not so much something seen as a visual code to represent something tactile or felt. Tone, on the other hand, can have a very strong relation to empirical fact—what is physically seen—since the order of tones in a drawing from observation can follow exactly the same order in the motif. Their absolute *intensity* might well be different— for example, the lightest part of the motif might well be much lighter in fact than the lightest part of the drawing—but their

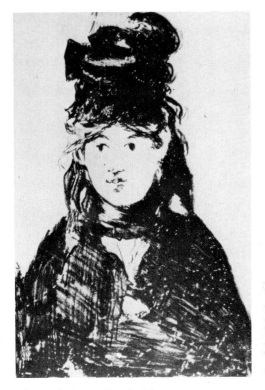

Edouard Manet: *Berthe Morisot.*
1872
Lithograph, 20.3 cm × 14 cm
Bibliothèque Nationale, Paris

George Francis Carline: *Head of a putto.* 1881–2 Black and white chalk on toned paper worked with stump, 45.7 cm × 31.8 cm A good example of a student drawing of the nineteenth century, done while the artist was attending Heatherley's School of Art, London *Private collection*

Franz Kline: *Meryon ZP20.* 1960 Oil on canvas, 233 cm × 196 cm *Tate Gallery, London*

sequence in the tonal scale could be exactly the same and could even be verified scientifically.

The draughtsman will probably not be very concerned with this fact while in the act of drawing, but it does help to explain why artistic traditions which emphasize spiritual abstraction, such as the mediaeval, tend to make more use of line than tone, and why traditions like Impressionism, which pay more attention to the material world, tend towards tonal mass rather than line.

For a number of reasons, including the availability of materials, most of the world's drawing traditions have tended to work in terms of black on white rather than white on black. Hence the introduction of tone consists of the positive creation of areas of dark on a light field rather than the building-up of high tonal areas on a dark field. Exceptions to this rule include, for example, working in white chalk on black paper, or with both black and white on toned paper. This last named technique would seem to possess special advantages for the draughtsman, enabling him to work in both direction away from an intermediate tone, but it is worth commenting that it is in fact very difficult to control and easily leads to a drawing which looks overloaded and fussy.

It is possible to distinguish three manners in which tone can be used, in some ways but not completely related to the distinctions drawn in the use of **line**; these are *object tone, local tone* and *shadow tone.* Object tone consists of reducing the tone of a section of a drawing regardless of whether it corresponds to any purely visual perception. This is common in Oriental art, where tone is often employed to suggest a powerful spiritual presence in what is depicted rather than a literal transcription of a dark-toned object or a shadow. Perhaps an even more obvious example of object tone is the use of tone in non-figurative works of art, in which the tonal area serves as a compositional mass rather than as a depiction of some identifiable thing or phenomenon.

The term 'local tone' is used to denote the inherent tonal value of objects in nature, irrespective of the directional fall of light. To take an extreme example, a figure in a black suit walking across a snow-covered landscape with an overcast sky will normally read as black (figure) on white (snow) and grey (sky). Most of our visual experience is not as extreme as this: the tonal scale is much narrower and the steps between tones more gentle. A head viewed in a diffused light will often read in terms of high tones (flesh) medium tones (clothing) and low tones (hair). The same figure viewed in strong directional light will present a completely different tonal

Dick Field: *A drawing class.* Pen and ink and wash, 39 cm × 57 cm
Private collection

scheme, creating strong contrasts between planes facing the light (forehead, cheeks) and planes facing away from the light (eye sockets, underside of the jaw). It is important to stress that such suggestions are very hypothetical: a blonde, sun-burned man in a dark suit will completely upset these preconceptions. The only answer is a constant alertness to what is seen and a willingness to respond to the unexpected.

This leads us on to the third use of tone, namely as shadow. The practice of interpreting areas of shadow as they are seen in nature in terms of patches of tone in a drawing does not strike us as very complex or sophisticated, but it is significant that the development and acceptance of this convention took a very long period in the history of art. On the whole, the draughtsmen of the ancient and mediaeval worlds regarded the play of shadow as a kind of optical illusion which deceived the eye and interfered with accurate perception. To suggest shadows in a drawing by creating tonal patches on figures and their surroundings would have been seen as a kind of perverse confusion of the issue, and a distraction from the important ideas to be conveyed. This view is characteristic of the art of the Near and Far East, which tends to regard the use of tone as shadow as a kind of wilful disfiguring of the image and an impediment to the more important use of tone as the indicator of entities of spiritual or psychological importance.

Western artists did not take an interest in the systematic use of tone as shadow until the period of the Renaissance, and even then its introduction was far from universal. Artists like Uccello and Botticelli continued to maintain a strongly heraldic or linear conception of visual imagery in which tone

245

as shadow was allowed to play a very minor role. It was not until the late Renaissance that artists like Tintoretto fully accommodated tone as shadow to a new system of composition in which it played the principal structural role. This development reached its full flowering in the art of the Baroque in the seventeenth century and led to drawings in which the whole compositional scheme was based upon the coordination of areas of tone as shadow.

Tonal areas can be created in many different ways. Since drawing is predominantly done with a linear medium, one of the most obvious is repeated hatching of a part of the surface, providing it with a general reduction in tone. In order to avoid the strong directional implications of hatching, the same tonal reduction can be achieved by a kind of omnidirectional scribbling, or better still, wash applied with a fairly broad brush. A variety of tonal textures can be achieved by, for example, dragging a dryish brush across a textured paper, or by spattering the surface of the paper with an old toothbrush charged with ink. Finally, although they were until recently regarded as exclusively for use in commercial drawings, an increasing number of draughts-men are making use of mechanical tints which can be applied by dry adhesion.

OPPOSITE **Rembrandt van Rijn:** *Abraham's sacrifice* Red and black chalk, wash in indian ink, heightened with white on greenish yellow paper, 19.4 cm × 14.6 cm *British Museum, London*

G. B. Tiepolo: Study for *The Banquet of Anthony and Cleopatra* Pen and bistre wash over black chalk on laid paper, 23.5 cm × 33.5 cm *Victoria and Albert Museum, London*

247

In the same way that it is advisable to identify a few simple forms to provide the compositional basis for a drawing, so if the drawing is to have a pronounced tonal character it is helpful to identify a limited number of key tones which constitute its tonal scale. Depending upon the motif and the medium this could consist of a dark near black, a medium dark, a medium light, and the white of the paper. Keeping the tonal gamut simple and clear in this way increases the possibility of producing a drawing which is tonally harmonious and integrated. Excessive tonal modulation and variety destroys the surface design of the drawing and tends to lead to an over-articulated, jumbled effect.

TOPOGRAPHICAL DRAWING

Topographical (Greek: place-depiction) drawing is concerned with the accurate recording of a given location. In addition to natural scenery, topographical artists have been employed in recording cities and architectural monuments, partly as a form of scientific record, and partly as a way of enabling those who stay at home to enjoy vicariously what the artist has seen. Traditionally, topographical drawing has been distinguished from landscape proper, since the latter has implications of self-expression and invention which are inimical to the former. Nevertheless, many works regarded as topographical have been far from truthful and accurate records of the place represented, either because the artist could not resist a degree of self-expression, or because the subject was so foreign to his previous experience that he was simply incapable of capturing it on paper.

Although photography has now taken over many of the functions of the topographical artist, there is still a role to be played by drawing in the recording of places, and a small number of draughtsmen continue to make a living from what could be truthfully described as topographical drawing. An important related area of drawing is the work produced by war artists, which often presents a more vivid and evocative record of the subject than could have been captured by a camera. This is because whereas the photograph is shackled to one moment in time, the draughtsman, like the human eye, can scan, select and synthesize impressions gained over a period of observation, thereby creating a record which is in fact closer to actual experience.

OPPOSITE ABOVE **Paul Sandby:** *View of Worcester.* 1772 Aquatint, 32.4 cm × 51.4 cm
Victoria and Albert Museum, London

OPPOSITE BELOW **John Nankivell:** *The Central Shrine to Shiva, Prambanan, Java.* 1976 Pencil, 91.5 cm × 121.9 cm *Private collection*

248

WATER COLOUR

Materials

The technical principles underlying water colour painting are quite simple. Pure pigment is ground to a fine powder and mixed with certain additives, chiefly gum arabic. The mixture is re-constituted as either a paste, normally stored in a tube, or in cake form. Both can be dissolved in water and spread on paper or other suitable surface. The strength of the solution determines the intensity of the colour and also, in

Peter de Wint: *Potter Gate, Lincoln* Water colour, 28.8 cm × 39.8 cm *Victoria and Albert Museum, London*

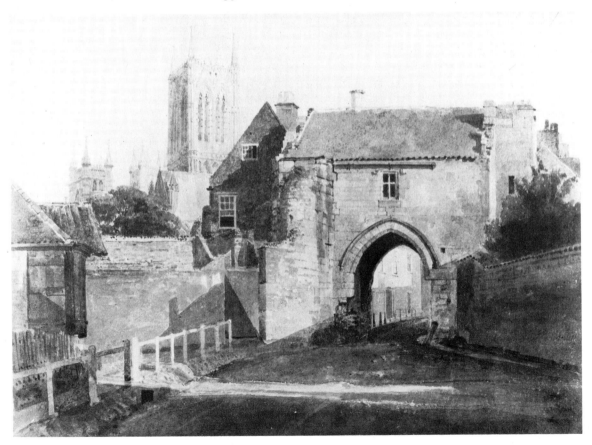

certain cases, the hue. When the solution dries out the gum enables the particles of pigment to adhere to the paper in microscopic particles. The paper shining through between the particles gives water colour its characteristic luminosity, which is further enhanced by the fact that the dried gum acts as a kind of light varnish. Colour and tone are controlled by relative proportions of paint and water, and the paint should be used with sufficient transparency to permit the paper to show through, together with any under-drawing in pencil or pen. If water colour is mixed and applied too thickly the result is a dull, lustreless paste.

See colour plate
Das Weierhaus by Dürer
between pages 216 and 217

Although water colour can be used on a wide variety of surfaces it is for artistic as well as economic reasons most suited to paper. The chief requirement of a water colour paper is that it should be able to take a thorough soaking without buckling or 'cockling', which results from uneven expansion of the wet fibres. When this happens, the paint tends to settle in unsightly puddles and continuous working becomes impossible. There is a wide variety of papers suitable for use with water colour, perhaps the best known being de Wint, David Cox and Crisbrook. Papers vary considerably in weight, surface texture and colour, and there is no substitute for buying a small range of these and experimenting with them over a period of time.

Water colour used in broad, generous washes works best on a fairly textured paper such as Fabriano. If it is to be used more selectively or combined with fine detail in pencil or pen, then a smoother paper is more suitable. Some papers have a distinctive colour which can be used in establishing an overall harmony; this can, however, prove to be a problem by determining the colour harmony in one direction or another against the wishes of the artist.

The problem of cockling of paper can be overcome by stretching it before use. To do this, soak the paper for a few minutes in clean water. Remove it from the water and remove the excess by letting it drain off. Lay the paper while still wet on a drawing board, allowing a margin of at least two inches of board all round. Stick the paper down at its edge with gummed paper—the kind of thing used on large parcels. This can be reinforced by pushing drawing pins through the corners, pinning the paper and the gummed strip to the board. As the water evaporates, the paper will shrink and pull tight, providing a pleasant, taut surface to work on and reducing the risk of further cockling to the minimum.

Varieties of water colour paints are as numerous as papers, and most are available in both tube and cake form. It

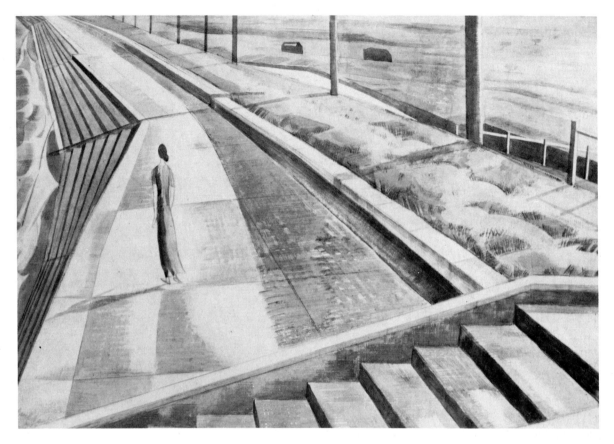

Paul Nash: *Promenade.* 1922
Water colour on paper, 36.8 cm ×
69.9 cm
Arts Council of Great Britain

is advisable to avoid water colour boxes with a very large
selection of colours, as this will encourage the owner to
attempt to seek out the exact equivalent for each colour he
sees before him, rather than attempting to mix it from a small
number of key colours. Colour harmony is most likely to be
achieved by permutations of a small 'family' of colours, and it
is advisable to become at first thoroughly familiar with not
more than two yellows, two reds, two blues, and perhaps one
green and one black. A sound palette might consist of the
following:
Cadmium Yellow (bright, high key; good for mixing greens)
Yellow Ochre or Raw Siena (subdued, low key; suitable for
warming shadows)
Cadmium Red (bright, high key; good for mixing oranges)
Alizarin Crimson (low key red, cool; with blue makes violets
and purples)
Cobalt Blue (bright, high key blue)
Ultramarine (deep blue, cool; good for deep greens)
Viridian
Lamp Black.

The beginner in water colours should try to produce as many varieties of colour as possible by mixtures of this basic palette. In addition to the obvious mixtures, such as combinations of blues and yellows to make greens, a large number of browns can be mixed from red plus either black or blue. Many greens are obtainable from yellow plus minute quantities of black. Rather than buying a grey, try making grey from dilute black or from mixtures of complementaries such as green and red. Greys can be moved to the warm end of the colour scale by a touch of Raw Siena, or cooled with a touch of blue. One soon learns that the quantities must be judged very finely. Some colours have a dominant tendency far in excess of others, and will swamp any mixture if not closely controlled. One needs a fairly large number of palette compartments for mixing colours, and the rule is always to mix up much more than is needed; this sounds extravagant, but in the long term will prove to be an economy.

For most purposes the best water colour brush is a fairly large one (No. 7 or larger) with a full flame-like body of hair which will carry a generous quantity of paint in solution and will at the same time come to a neat point. This permits the paint to be deposited either in a fine, long line, or, by pressing the brush slightly to the paper, a broad full stroke. These requirements are best satisfied by the red sable, which is very expensive, but ox and camel hair are quite satisfactory. It is advisable not to work with very small brushes unless you have a good reason to do so, and not to work with too many brushes at the same time. Just as a limited range of colours provides a better basis for establishing a colour harmony, so repeated use of a small range of brushes will result in a pattern of related marks and help give the painting an overall structure and unity. Brushes should always be thoroughly washed in clean water immediately after use, re-shaped to a point by wiping them in the palm of the hand, and stood to dry with the hairs pointing upwards.

In addition to the materials recommended above, the water colour artist should build up a collection of miscellaneous items which will all be of use as his technique develops and diversifies. These include a couple of small sponges, a pen knife, a tooth brush, a few pieces of soft but hairless rag, and a couple of pieces of white candle. The reasons for this bizarre little collection will become clear in the following section on technique.

Technique

The above section on materials can be summarised in the following way: the great strength of water colour is transparency of colour and tone; choose a paper which suits

253

See colour plate
Stonehenge by Constable between pages
216 and 217 and *Wooded landscape* by
Cotman and *Prata* by Gutruf facing
page 217

your style of working; place firm limits on the number of colours used in any one painting; concentrate on handling a small selection of mainly largish brushes.

Turning now to more specific aspects of technique, the first point to be made is that the cornerstone of water colour painting is the wash. Laying a good wash demands a great deal of practice and patience. The area of the wash must first be dampened all over, using either a brush loaded with clean water or a piece of sponge. Before the water has begun to dry, the same area should be covered again, this time with a fairly large brush carrying a full load of the mixed paint solution. The paint should be applied in long, broad strokes, and if the surface is kept at a slight angle the merging of successive strokes will be aided by gravity as the paint from one stroke runs down into the next. If the wash is to terminate in a precise but irregular edge (for example, a sky coming down to end in a profile of roof tops), invert the board and begin from the irregular edge, keeping the unpainted area away from you. In this way it will be possible to see the point of the brush while drawing the edge. The first ribbon of paint can then be merged with the continuation of the wash while it is still wet.

If sufficient paint is applied, or if the board is kept at a steep angle, there will be a tendency for the wash to run down and accumulate at its lower edge. In some cases this might be desired, and it can be allowed to dry off as it lays. If it is not desired the surplus can be lifted off or reduced selectively by squeezing out the hair of a wet brush and gently touching it on the area to be reduced. Used in this way, the brush will absorb surplus paint quickly and cleanly.

There are innumerable variations on the wash. The flat wash produces an even, unmodulated area of colour. By increasing the amount of paint applied to various parts of the wash, it is possible to produce a graduated wash, which is often used to suggest the tendency seen in many skies to change from deep blue high up to a paler blue nearer the horizon line. It is equally possible to use more than one colour mixture in the same area of wash, producing what is known as a variegated wash. This permits the painter to introduce a variety of colours which can be graduated smoothly into one another, and once again is of special value in the painting of skies.

Since water colour is a transparent medium, colours can be combined by allowing one wash to dry thoroughly and then working over it selectively in another colour. These overlaid washes have the special advantage that it is possible to create clear boundaries at the edges of successive areas of

OPPOSITE **John Sell Cotman:** *Chirk
aqueduct* Water colour,
31.7 cm × 23.2 cm
Victoria and Albert Museum, London

254

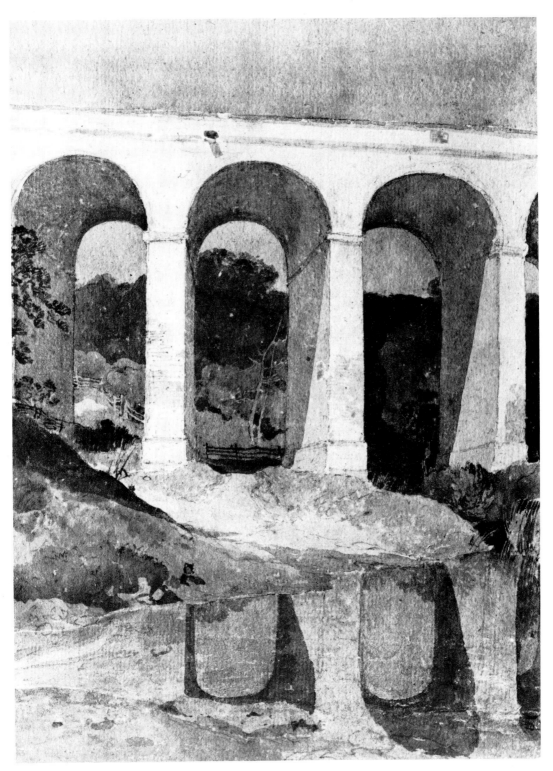

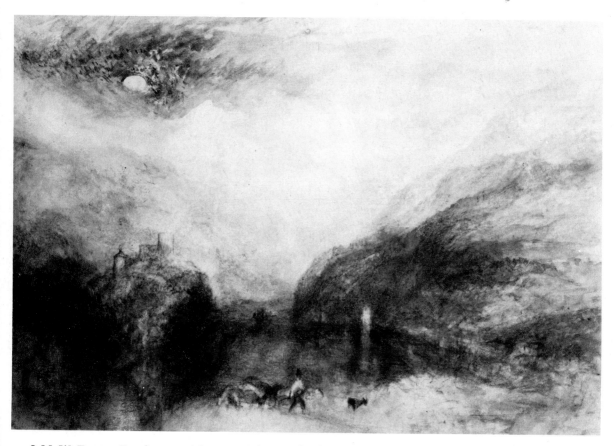

J. M. W. Turner: Landscape, perhaps Lake of Brienz Water colour, 37.5 cm × 54.4 cm
Victoria and Albert Museum, London

colour, which can be used effectively in the painting of, for example, cloud banks.

The tradition of using large brushes and working the paint in a very fluid state was common in British water colour painting of the late eighteenth and early nineteenth centuries, and is particularly useful in capturing atmospheric effects and aerial perspective. But there is an alternative and equally valid tradition of water colour technique in which the paint is used sparingly and applied in relatively small blocks of colour with numerous overlays. The master of this technique was Cézanne, who tended to play down the atmospheric and fluid character of water colour in favour of its employment as a controlled, structural medium used in combination with pencil and normally leaving large areas of paper completely untouched.

An issue of major importance in water colour painting is its relation to drawing with a point medium such as pen or pencil. As oil paint and gouache are normally opaque, they obscure any preliminary drawing which may be done on the paper or canvas. Water colour, on the other hand, is

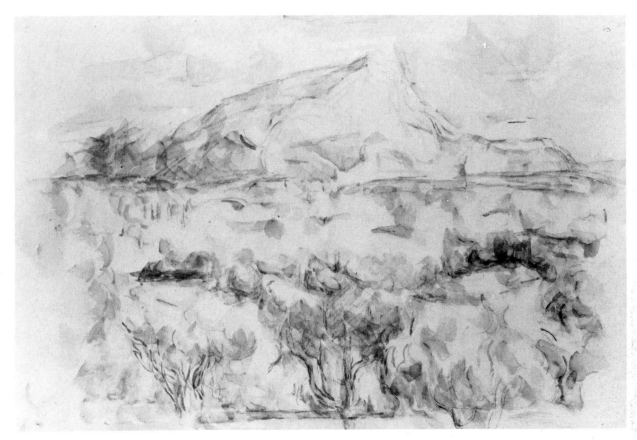

transparent, so anything drawn on the paper, even quite lightly, is likely to show through when the painting is finished. Preliminary drawing for water colour should be done in a medium which will not be dissolved by the subsequent application of water, such as a fairly hard pencil or a thoroughly water proof ink. If ink is used, it must be completely dry before proceeding to over-paint with water colour, so when a painting is to be continued immediately, pencil is preferable.

It is advisable not to allow the underdrawing for water colour to become too detailed or emphatic, or the act of painting is likely to come dangerously close to the 'filling in' of predetermined forms. The underdrawing may provide no more than the merest skeleton and disposition of forms, and the water colour should be handled not only as a painting medium but as a medium which can be used to draw as one paints. There are exceptions to every rule, and it should be recognised that there is a tradition of topographical drawing in which water colour was superbly used as a kind of tinting medium applied to quite detailed pencil drawings of

Paul Cézanne: *Le Montagne Sainte-Victoire.* 1905–6 Pencil and water colour on paper, 36.2 cm × 54.7 cm *Tate Gallery, London*

257

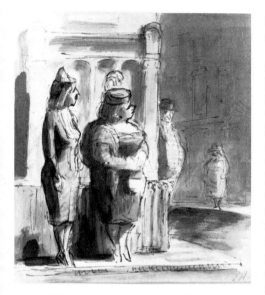

Edward Ardizzone: *A possible client.* 1955 Pen and ink over wash, 26.7 cm × 24.1 cm *Private collection*

architecture and landscape, but this manner of use can be dangerously inhibiting in inexperienced hands.

Additional line work can be used at subsequent stages of the painting's development. Pencil is not ideal for this, first because if the painting is at all wet it will not grip effectively, and secondly because it tends to leave a shiny surface deposit which is incompatible with the surface of water colour. Much more suitable for drawing over water colour are coloured waterproof inks, which if desired can be diluted with water. Line work over water colour, like preliminary line work, should be used with great discretion and economy, as there is the same risk that the line will be used to overstate the profile of each area of water colour and produce a tired, laboured result. A general rule worth considering is that the line applied over water colour should never replicate the form of the underlying brush mark, but should have some life of its own, adding information which is not already available in the paint.

There are innumerable subsidiary techniques which can be employed with water colour, and a persistent water colourist will soon find himself using methods which he has devised himself and which are not recorded in any manual. Sponges (preferably natural) can be used for laying washes instead of brushes. The advantage of the sponge is that unlike the brush it has no directional element. A sponge, like the brush, can be squeezed out and used to reduce areas of wash or to introduce new gradations of colour in variegated washes. It can also be tamped in dryish colour and pressed on to the paper to produce a pleasant textural effect.

A sharp pen knife can be used to erase lines or areas of paint by gently scratching the surface of the paper. In addition to lightening the tone of an area, the pen knife can be used as a drawing tool, for example by dotting in a few reeds in a darkish lakeside shadow. Water colour can even be thinned or erased by using a suitable eraser, but care should be taken not to create unsightly or fussy 'scrubbed' areas of paper, or to thin the paper until it blisters or tears.

Stippling can be produced either by dotting areas lightly with a fine brush, or by dipping an old toothbrush in paint and drawing a matchstick along its hairs, thus projecting a fine spray of paint on to the paper. An area of 'splatter work' can be limited by laying pieces of paper over sections of the painting which you wish to remain untouched. This kind of splatter work, like so many other aspects of technique, must be carefully controlled and used with discretion if it is not to become an obtrusive mannerism.

A good water colour paper must have at least one

property, namely to be able to absorb water-bound paint. Any grease on the surface of the paper will tend to have the effect of repelling water or water paint. It is therefore advisable to place a small piece of paper under the hand when working on a water colour painting, avoiding the deposition of grease which occurs naturally in the skin. However, the tendency of grease to repel water can be used to good effect in the so-called grease-resist method. Here, areas of the paper are drawn upon with a greasy substance such as white candle, if desired sharpened to a point. When the drawing is worked over in water colour, the grease will resist the application of the paint and the drawing will show through as white surrounded by the wash. A variation on this is to begin by laying a wash, allowing it to dry, and then working over it with candle grease. Subsequent washes will be repelled by the drawn areas, so permitting the underlying wash to show through. The same principle can be used with even greater sophistication by drawing with a greasy coloured crayon. In this case, the crayon will not only throw off water colour laid over it, but will come through in its own colour.

Andrew Wyeth: *Lobsterman's ledge.* 1939 Pen and wash, 37.8 cm × 57.8 cm *National Gallery of Art, Washington*

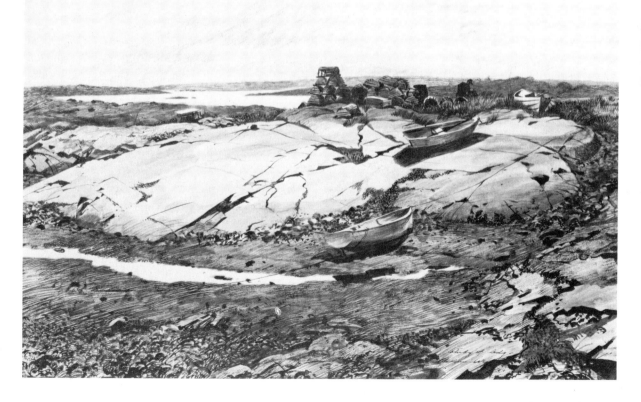

259

Keith Vaughan: *Landscape with tractor.* 1945 Gouache on paper, 11.8 cm × 16 cm
Arts Council of Great Britain

Masking tape can similarly be used to preserve areas of paper—or areas of dried wash—during subsequent applications of paint. Masking tape will naturally tend to leave precise, straight boundaries, but this effect can be successfully employed in the right circumstances. When the overpainting is dry, it should be peeled off slowly and with great care so as to avoid any tearing or damage to the paper.

Finally, **gouache** is chemically highly compatible with water colour and can be used effectively in small quantities. Purists tend to argue that the water colour painter must depend entirely upon the paper to give him his highlights and his whites, by leaving areas free of paint or by using paint in very thin dilution. There is a degree of sense in this, but gouache or body colour can be used with great effect on details and highlights provided that it does not obliterate too much of the surrounding water colour.

Index to artists

INDEX TO ARTISTS

INDEX TO ARTISTS